中国出土壁画全集

徐光冀／主编

科学出版社

北京

版 权 声 明

图书在版编目（CIP）数据

中国出土壁画全集／徐光冀主编．—北京：科学出版社，2011

ISBN 978-7-03-030720-0

Ⅰ．①中...　Ⅱ．①徐...　Ⅲ．①墓室壁画-美术考古-中国-图集

Ⅳ．①K879.412

中国版本图书馆CIP数据核字（2011）第058079号

审图号：GS（2011）76号

责任编辑：闫向东／封面设计：黄华斌　陈　敬
责任印制：赵德静

科 学 出 版 社 出版

北京东黄城根北街16号
邮政编码：100717
http://www.sciencep.com

北京天时彩色印刷有限公司印刷
科学出版社发行　各地新华书店经销

＊

2012年1月第 一 版　　开本：889×1194　1/16
2012年1月第一次印刷　　印张：160
印数：1-2 000　　　　　字数：1280 000

定价：3980.00元

（如有印装质量问题，我社负责调换）

THE COMPLETE COLLECTION OF MURALS UNEARTHED IN CHINA

Xu Guangji

Science Press

Beijing

Science Press

16 Donghuangchenggen North Street, Beijing,

P.R.China, 100717

Copyright 2011, Science Press and Beijing Institute of Jade Culture

ISBN 978–7–03–030720–0

《中国出土壁画全集》编委会

凡　　例

1. 《中国出土壁画全集》为"中国出土文物大系"之组成部分。

2. 全书共10册。出土壁画资料丰富的省区单独成册，或为上、下册；其余省、自治区、直辖市根据地域相近或所收数量多寡，编为3册。

3. 本书所选资料，均由各省、自治区、直辖市的文博、考古机构提供。选入的资料兼顾了壁画所属时代、壁画内容及分布区域。所收资料截至2009年。

4. 全书设前言、中国出土壁画分布示意图、中国出土壁画分布地点及时代一览表。每册有概述。

5. 关于图像的编辑排序、定名、时代、尺寸、图像说明：

编辑排序：图像排序时，以朝代先后为序；同一朝代中纪年明确的资料置于前面，无纪年的资料置于后面。

定　　名：每幅图像除有明确榜题外，均根据内容定名。如是局部图像，则在原图名后加"（局部）"；如是同一图像的不同部分，则在图名后加"（一）（二）（三）……"；临摹图像均注明"摹本"。

时　　代：先写朝代名称，再写公元纪年。

尺　　寸：单位为厘米。大部分表述壁画尺寸，少数表述具体物像尺寸，个别资料缺失的标明"尺寸不详"。

图像说明：包括墓向、位置、内容描述。个别未介绍墓向、位置者，因原始资料缺乏。

6. 本全集按照《中华人民共和国行政区划简册·2008》的排序编排卷册。卷册顺序优先排列单独成册的，多省市区合卷的图像资料亦按照地图排序编排。编委会的排序也按照图像排序编定。

《中国出土壁画全集》编委会

中国出土壁画全集

— 9 —

甘肃 宁夏 新疆
GANSU NINGXIA XINJIANG

甘 肃
主 编：杨惠福　副主编：郭永利　王　辉
Edited by Yang Huifu, Guo Yongli, Wang Hui

宁 夏
主 编：罗　丰　副主编：姚蔚玲
Edited by Luo Feng, Yao Weiling

新 疆
主 编：于志勇　副主编：伊弟利斯·阿不都热苏勒　张玉忠
Edited by Yu Zhiyong, Yidi Lisi·Abuduresule, Zhang Yuzhong

科学出版社
Science Press

甘肃编委会名单

编　委

杨惠福　王　辉　郭永利　徐晓霞　冯　庆　杨国文　马　珑

参编人员（以姓氏笔画为序）

付立诚　李晓峰　杨惠福　张宝玺　郑国穆　南宝生　郭永莉　寇克红

甘肃参编单位

甘肃省文物考古研究所	敦煌市博物馆
兰州市博物馆	高台县博物馆
嘉峪关市文物局	临夏州博物馆

宁夏编委会名单

参编人员（以姓氏笔画为序）

卫　忠　边东冬　罗　丰　姚蔚玲　程云侠

宁夏参编单位

宁夏文物考古研究所	宁夏文物保护中心
宁夏文物局	宁夏固原博物馆

新疆编委会名单

编　委

鲁礼鹏　刘玉生　巫新华　李　肖

参编人员（以姓氏笔画为序）

于志勇　刘玉生　鲁礼鹏

新疆参编单位

新疆文物考古研究所	新疆博物馆

甘肃、宁夏、新疆地区出土壁画概述

郭永利　姚蔚玲　于志勇

出土壁画的年代为汉、魏晋十六国、北朝、隋唐至宋金时期，数量在82处以上，分别为墓葬和佛寺遗址出土，以墓葬为多。现概述如下。

一、甘肃地区

1. 汉代壁画

甘肃境内发现的汉代壁画墓2座。1984年在武威市南的韩佐乡五坝山，发掘清理了1座西汉晚期的壁画墓。墓葬为单室土洞墓，平面长方形，墓道和墓室的顶部被东汉晚期的墓葬破坏，仅余下部。壁画绘于墓室的四壁，面积达16平方米。壁画的绘制，先在四壁抹一层蛋壳薄的细黄土，再施一层石绿色为底，其上绘壁画。画面以墨线绘出物像的轮廓线和结构，平涂着色，色彩有黑、白、青、绿。在墓室四角用绿、白、青三色的复合竖条纹作为四壁壁画的分界线。题材有宴饮、庖厨、坞、舞蹈、狩猎、仙人、神兽等，可以分为表现现实生活与祈求升仙两大类。这是甘肃发现的最早的墓室壁画。与中原汉代壁画墓相比，虽然在表现形式上有着一定的地域性差异，但题材内容与中原汉代壁画墓一脉相承。可以看出张骞通西域之后，中原地区与河西地区文化交流之紧密。1989年在武威市磨嘴子东汉墓群发现1座壁画墓，为横前室双后室土洞墓，前后室之间有甬道相连，为东汉晚期的墓葬。壁画绘在前室后半部的墓壁与顶部，内容有日、月、百戏、羊、羽人、仙人骑象等，题材仍以现实生活与祈求升仙两大类为主，是西汉壁画墓的继续发展。

2. 魏晋十六国壁画

甘肃魏晋壁画墓的发现始于1944年。当时由中央研究院历史语言研究所发起的西北科学考察团历史考古组在敦煌一带进行考古发掘工作，在佛爷庙湾墓群发现了1座单室砖室墓，具高大的照墙，其上绘有不少画像，时代为魏晋时期[1]。20世纪50至70年代又

在酒泉、敦煌、嘉峪关、永昌县东四沟村及民乐县永固乡的八卦营墓群均有发现。迄今为止发现的这一时期壁画墓数量已达49座,分布在河西走廊广大的区域内，在甘肃省东部和中部不见。

这些壁画墓根据其形制和题材的不同，又可以分为酒泉、敦煌两个区域。

酒泉、嘉峪关[2]、高台、永昌及民乐等地的壁画墓有着较多相同的面貌，可以作为一个区看待即酒泉区。这一地区的壁画墓分为二室和三室墓，不见有单室壁画墓。有砖室墓和土洞墓两类，以砖室墓为主流。墓葬具有仿生人居住庭院的特征，墓室多耳室多假门，有仿木结构的屋檐，前室有方坑，在后壁或左右侧壁均砌二层台，与中室和后室的地面相平，墓室四角作有角兽。前室平面方形，多为覆斗顶，个别为券顶；后室平面长方形，有覆斗顶和券顶两类。

酒泉地区壁画墓最具地域性的方面，表现在墓葬大多建有高大的照墙。照墙上以雕刻的双阙和牛首人身、鸡首人身像为主要题材，还有兽面纹、赤帻力士、熊首力士及青龙、白虎等题材。照墙也随着时代的变化而发生变化。

敦煌区包括敦煌佛爷庙湾[3]和瓜州县两个地区。壁画墓有砖室墓和土洞墓两类，以砖室墓多见。按墓室数量可分为双室墓和单室墓两类。墓葬形制，前室平面多为方形，覆斗顶；后室券顶。单室墓均为覆斗顶。单室墓前室置棺床，后壁处置供台，墓葬设耳室和壁龛，耳室模拟庖厨。墓葬均有高大的照墙。照墙形制与题材相比酒泉区则更为华丽高大，壁面上配置着大量的天门、祥瑞图像，绘画和砖雕与酒泉区相比更为精细。墓室内壁画题材却远不如酒泉地区的丰富。显示出此区的地域特点。

两地区墓室壁画的画幅有两种形式，即小幅砖画和通幅式壁画。酒泉区发现的大多数壁画墓为小幅砖画的形式。由多个单独的小幅砖画连续组成完整的题

材，成为该地区壁画墓最为显著的特点。通幅式壁画系在墓壁上通绘壁画内容，在墓室四角绘以褐色宽带，形成分界。敦煌区的壁画墓，则是小幅砖画与大通壁式壁画并行，照墙以小幅砖画为主，墓室内以通壁式为主，并有着各自表现的对象。小幅砖画均表现祥瑞等升仙题材，而大幅壁画则表现墓主人图像。小幅砖画是这一时期河西壁画墓的主要表现形式。

壁画的绘制，小幅砖画，主要是在砖面上涂白垩后再以墨线勾勒出轮廓，在轮廓内进行平涂或点涂。不涂白垩直接在砖面上进行绘画也并不少见。通幅式壁画，则是墓壁的砖面上先施草泥，然后再涂白垩为底，其上进行绘画，以土红色线条起稿，再以墨线绘出轮廓，后于轮廓内平涂色彩。部分通幅式壁画，则是在墓壁上涂一层细黄泥后直接绘画。

这一时期的壁画墓与汉代壁画墓相比，题材内容大幅增加，施画区域也扩大到整座墓室，墓壁几乎都施画。无论二室或三室，在各室内均按一定的配置规则绘上图像。结合照墙壁画、墓室壁画的内容及其分布位置，依图像本来的意义分类进行绘制。大体可以将壁画题材分为天上世界、升仙与仙境，祥瑞，墓主人的世俗生活及财富，镇墓驱鬼厌胜四类，分别绘于相对固定的位置上。壁画风格也呈现出多样性。题材的丰富和绘画风格的多样，表明了这一地区在魏晋十六国时期经济的发达。自魏晋以来，河西地区长期稳定，又有着较好的经济条件，没有受到中原战乱的影响，汉文化在此地扎下了深厚的根，因此壁画墓在此地长盛不衰，一直延续至十六国时期，壁画墓仍然兴盛。在长期的发展过程中还形成了自己独特的壁画形式即小幅砖画形式。

河西魏晋十六国时期的墓室壁画在题材上完全继承了汉代墓室壁画的传统题材，如宴饮、出行、耕种、西王母、东王公、天象、收获、祥瑞等。但在内容上也反映出地方特点，如大量牧畜图像与耕种图像并列于墓室内，在份量上并无轻重，反映了河西农耕与畜牧并重的经济格局。壁画中频出坞的图像，几乎每座墓中均有其形象，坞应为此时期河西非常多见的居所形式。嘉峪关M3中屯营图与牛耕图绘制在一

起，其中兵卒既有回营者也有耕种者，反映了河西地区在魏晋之际"分带甲之士，随宜开垦"（《晋书·食货志》），"戍逻减半，分以垦田"（《晋书·羊祜传》）的军事屯田制度，表现了耕以养战，战以卫耕的军屯状况。在壁画中又有高鼻深目者，还有住在穹庐内用三足鼎煮饭者，还有披发者，等等，这些图像的存在，不仅表现出河西地区居住着众多的少数民族，而且还表明了河西墓室壁画的内容具有与现实生活紧密相连的写实性特点。

河西魏晋壁画墓的绘画，画风自由，以善用弧线为其特点。其用笔流畅简练，线条飞动奔放。色彩艳丽，属于平涂技法，但并不拘泥，而是自由挥写，多为点涂即止，重写意而轻写实，无拘无束，热烈明快，自由洒脱。

河西走廊地区这一时期的墓室壁画，填补了我国美术史魏晋十六国时期的空白，找到了衔接汉画和北朝佛教绘画艺术的中间一环。

3. 宋金壁画

宋金时期的墓室壁画在甘肃省境内发现不多，但涉及到的地区较广，在兰州、临夏、定西、天水等地区都有发现，时代大多为金代。这时期以小幅砖画为主，一砖一画，或在砖雕上施彩绘，做法为先在砖面上涂白粉，然后以墨线勾勒出轮廓，再平涂色彩。题材有墓主人宴饮、孝行故事、吉祥动物和花卉等。这些题材，与当时北方地区的金代墓葬壁画在面貌上大体是一致的，但题材相较其他地区略少。值得注意的是，墓葬中出现的大量孝行故事是此类墓葬中最主要的题材，在甘肃境内发现的金代模印砖墓中也是如此，很可能与当时理学思想影响和北方全真教的流行有关[4]。

二、宁夏地区

宁夏出土壁画主要集中在固原北朝、隋唐墓葬中。北朝、隋唐时期，固原是西魏、北周统治者的根据地，是丝绸之路东段北道的必经之地。这种特殊的地理环境，对该地墓葬产生了重大的影响。自20世纪80年代以来，在固原相继发现并发掘了几十座北朝——隋唐墓，出土了一批珍贵的文物，其中三座北周墓

葬、一座隋代墓葬及两座唐代墓葬出土了百余幅保存较为完整,具有较高历史价值和艺术价值的壁画。

1. 北朝壁画

宁夏出土北朝时期的壁画,主要为固原3座北周壁画墓的图像。这三座墓葬为宇文猛墓[5]、李贤墓[6]及田弘墓[7]。保定五年(565年)宇文猛墓于1993年发掘,位于固原南郊乡王涝坝村,墓主身份为大将军大都督原盐灵会交五州诸军事原州刺史,墓葬为五天井长斜坡式墓道单室土洞墓,在墓道、天井、过洞、甬道及墓室均绘有壁画;因后世进水,壁画遭到严重破坏,只隐约可见零星线条和白、黑、红色块。目前仅存第五天井东壁一幅执刀武士画像。人物侧身而立,头戴小冠,着红色交领长袍,双手挂仪刀。北周天和四年(560年)李贤墓,发现于1983年,位于固原南郊乡深沟村,墓主身份为使持节柱国大将军大都督泾秦河渭诸军事原州刺史河西桓公,墓葬为三天井斜坡式墓道单室土洞墓。墓道、过洞、天井、甬道、墓室都绘有壁画,题材有门楼、挂刀武士、女乐伎等,每幅图均用红色边框分隔。人物均作独幅形式,人物面部及衣纹施晕染。1996年在固原西郊大堡村发现的建德四年(575年)田弘墓,墓主身份为使持节少师柱国大将军大都督襄州总管襄州刺史雁门公,墓葬为五天井斜坡式墓道多室土洞墓。壁画绘于甬道及主室、侧室和后室内,题材为侍卫、侍从人物,画面有边框,框内绘多人。

三座北周墓葬从随葬墓志看,壁画绘制时间仅差十年,但壁画布局与内容却有所不同。从宇文猛墓残留壁画痕迹看,从布局到画法都与李贤墓壁画的风格接近。而李贤墓与田弘墓从墓室、墓道各部位壁画的配置、壁画的构图、绘制手法、服饰看,各自都有明显特征。李贤墓墓道绘侍卫、侍从、门楼,象征邸宅的多重院落;田弘墓墓道不作壁画,墓室北壁、东壁、西壁北侧绘侍卫,西壁南侧绘侍从群像,是以主室象征宅院的想法[8]。李贤墓墓室在安置棺柩的四壁绘侍女、伎乐;田弘墓的棺室是后室,入口处绘有侍卫,棺室只绘简化的木构建筑的梁柱。李贤墓从墓道至墓室壁画内容为单幅正面人物立像,每个单体图

像独立成幅,形成彼此独立的挂轴式格局,属于较早的屏风画;田弘墓为成组人物或群体人物侧身立像,人物群像形成了东魏—北齐那种由群像构成的横卷式壁画布局。群像绘制在东魏—北齐墓中十分常见,北周墓葬壁画中尚属首例。李贤墓着裲裆铠的武士居多,服饰色彩有一个渐变过程;田弘墓侍卫中未见裲裆铠,颜色以红、黑为主,色彩鲜艳。北周墓壁画的布局与主要内容有沿袭旧制的,也有具有自身特征并对后期墓葬壁画风格产生影响的。如李贤墓道绘侍卫壁画,见于河北磁县东魏武定八年(550年)茹茹公主墓[9]和山西寿阳北齐河清元年(562年)库狄迴洛墓[10]。李贤墓道仪卫所沿袭的是北魏旧制[11],隋代史射勿墓壁画中手挂环首刀侍立的武士亦可看作是这种制度的延续。田弘墓人物眉下涂红线,颊部用类似于晕染的手法涂红色圆点,与敦煌西魏288窟供养人像、北周296窟本生图中世俗人像、461窟弟子像的面部画法近似。说明北周原州与临近西域的敦煌地区的画工集团之间存在某种交流[12]。李贤墓在靠近墓主人棺椁的西半部,壁画内容是侍女,面对棺椁的则是伎乐者,墓室壁画如此安排,似未见前例,却与西安三原唐贞观四年(630年)李寿墓[13]、西安羊头镇唐总章元年(668年)李爽墓[14]墓室壁画布局相近。李贤墓每幅壁画都用红色边框分隔;大约在同时,北齐亦流行人物屏风画。类似李贤墓壁画的绘画布局,对以后的隋唐墓室壁画风格的形成有着重要的影响。在墓门上方制作门楼的习俗,在关西地区由来已久[15],但以壁画形式在过洞上方绘制则以李贤墓为最早。这些对以后的隋唐墓葬壁画风格的形成有着重要的影响。固原李贤墓壁画第一次完整展现了北周时期墓葬绘画的风采,填补了我国绘画史北周时期的空白。田弘墓壁画为搞清西魏—北周墓葬壁画的全貌提供了新的重要资料。

2. 隋唐壁画

隋代的出土壁画,主要是1987年在固原县南郊乡小马庄发掘的大业五年(609年)史射勿墓[16],墓主身份为正议大夫右领军骠骑将军,墓葬地下部分为二天井斜坡式墓道单室土洞。墓道、天井、过洞、墓室

都绘有壁画，在墓道天井处绘有武士、侍从图像，过洞处绘有门楼、莲花，墓室内绘侍女。这是极为珍贵的隋代墓室壁画，为隋代考古中所稀见，艺术价值颇高。已知隋代墓葬壁画为数不多，保存较好的是山东嘉祥满硐杨楼村徐敏行墓[17]。史射勿墓的壁画，与李贤墓相比较，其内容和布局相同，明显是受北周壁画墓的影响。但执笏板武士在唐墓壁画中是常见的内容，以史射勿墓为初见。

唐代的出土壁画，见于固原史索岩墓[18]、梁元珍墓[19]。史索岩墓，1985年发现于固原南郊乡羊坊村，为唐麟德元年（664年）墓葬，墓主身份为平凉郡都尉骠骑将军，墓葬由斜坡墓道、5个过洞、5个天井、甬道和墓室组成，墓室四壁上涂白灰，然后绘图像，现仅存墓道第五过洞上方的一幅朱雀图保存完整。朱雀整个形象雄壮威武，有势若腾飞之态，为唐代朱雀壁画中的精品。北朝时期有在墓门上方绘制朱雀的作法，史索岩墓过洞上方出现的朱雀图，应该被看作是北朝时期传统的延续，与长乐公主墓中朱雀图具有相同的意义，其目的主要是导引墓主人的灵魂。1986年发现的固原南郊乡羊坊村唐圣历二年（699年）梁元珍墓，墓主身份为隐士，墓葬由斜坡式墓道、3个过洞、3个天井、甬道和墓室组成。壁画绘于天井、过洞、甬道及墓室内。天井和甬道的壁画没有地仗层，将生土壁面修平后直接绘画，保存情况较好，主要绘有人物牵马图。墓室则是在砖墙上涂抹的草拌泥上绘制，由于草拌泥的附着力差，壁画整体保存情况不好，墓室四壁及顶部均有壁画。墓室东壁和南壁主要绘有男女侍者，西壁和北壁均为人物屏风画树下老人，墓室顶部绘有银河、太阳、月亮、北斗七星等，是一幅较完整的星象图。梁元珍墓墓道天井、甬道两壁绘制的牵马图，其内容与以往唐墓墓道、天井安排的步骑仪卫、众多侍从及列戟等壁画完全不同。这主要是由于其他唐墓壁画的主人往往是中高级官员，而梁氏虽然出身名门，但毕竟是一介布衣。在壁画的内容上当有明显的差异。墓室壁画除侍者图外，围绕棺床还有十扇屏风画，所表现的内容当是魏晋名士"竹林七贤与荣启期"的故事。其年代属唐代墓葬屏风画

中较早者，纪年明确，这对于判定此类屏风画的年代有着重要的参考价值。

三、新疆地区

新疆地区壁画的发现，始自20世纪初国外探险家对新疆以佛教遗迹为主的石窟壁画、佛寺遗址等的调查和盗掘活动。1949年以来，新疆文物考古成果显著，出土了一批重要的壁画，这些发现和研究，推动了对西域古代文明历史文化多元性和文化因素多样性的探索。新疆地区出土的壁画，可以分为两大类：一是墓葬壁画；一是佛寺遗址壁画。

1. 墓葬壁画

新疆地区墓葬壁画的发现，可以追溯至1915年A·斯坦因第三次中亚考察时对吐鲁番阿斯塔那墓地的盗掘[20]。迄今为止，新疆地区墓葬壁画主要发现于吐鲁番市阿斯塔那晋唐时期墓葬、若羌县楼兰古城北LE古城附近的壁画墓、库车县友谊路十六国时期墓葬等。这些墓葬壁画，按照年代划分，可分为晋十六国时期和唐代两个阶段。

（1）十六国时期墓葬壁画

新疆十六国时期的墓葬壁画主要分布地域为吐鲁番、若羌楼兰古城北、库车等地，即古代高昌、楼兰（鄯善）、龟兹地区。吐鲁番、楼兰地区由于特殊的地理条件，墓葬壁画保存较好，库车地区砖室墓因长期地下水浸渍，墓室壁画已基本脱落不存。

吐鲁番地区墓室壁画，主要见诸阿斯塔那墓地前凉至北凉时期墓葬[21]，通常于斜坡墓道洞室墓或砖室墓内，墓室后壁用白灰粉刷做底后，使用黑色颜料为主施绘；有整幅的表现形式，也有分格块表现的形式，还见有直接在多张纸本上绘制不同的内容而拼合为一张壁画的方式（如64TAM64）[22]。壁画的题材内容多是田园生活、生产等内容，还有帷帐内人物生活、宴饮等内容，有器用（如75TKM97）、男女人物（如75TKM98）、牛车、动物、月像（女娲）、日像（伏羲）以及星宿等图案纹样。壁画内容繁简不一，部分较为精致，施绘技法多比较粗拙；一些墓葬壁画有"树"、"蒲陶"、"田"、"月像"和"口

（日）像"、"牛车"、"马"、"北斗"、"三台"（如04TAM408、06TAM605）等汉字榜题。

若羌县楼兰古城北墓葬壁画[23]，位于LE古城附近前后双室洞室墓内。前室中心部位为方形底座的圆形中心立柱，上面满绘莲花纹。前室门右侧壁面，绘两个人物，一为跪坐捧物门吏，一为紫袍坐者；门左侧壁面黑彩绘出狮豸图。前室左壁绘侍从人物、斗驼图，右壁绘有六个人物形象。画面左半部绘有三位女性，右半部绘有三位男性，做两两交谈状，执杯或钵。画面中男性均著圆领窄袖套头衫，腰系玉饰革带；女性上身著偏襟小袖内衣，外罩喇叭口半袖衫，下著褶裙。在左起第三人的头部上方，存有佉卢文字墨书题记。前室后壁绘有两匹前足腾起打斗的马。后室四周壁满绘星团状莲花纹。施绘技法娴熟，色彩鲜艳，人物形象生动。据研究，墓葬的年代为3至4世纪。

2007年，在库车友谊路发掘了近十座十六国时期砖室墓葬[24]，墓葬的形制与甘肃敦煌等地的壁画墓基本相同，在多座墓葬的砖室内部以及一些照墙保存较好的贴砖上，发现有彩绘的残迹，由于墓室处在戈壁砾石层，彩绘已经严重脱落不存。新疆以上地点发现的壁画墓葬，其形制与河西相同，壁画施绘方式、题材内容、风格也受到河西的直接影响，是十六国时期文化融合、汉地（尤其是河西地区豪族）移民的结果。

（2）新疆唐代墓葬壁画

新疆地区唐代墓葬壁画，主要见于吐鲁番市阿斯塔那墓地。壁画均绘于斜坡墓道洞室墓墓室后壁，白灰粉刷做底后，再用彩色施绘。壁画内容多六屏鉴诫图（如72TAM216）[25]、花鸟图（如72TAM217）[26]、生活情景图（如65TAM38）等多屏式表现方式，还有童子骑飞鹤、童子托盘骑飞鹤和飞鹤衔花草等图案。部分主室顶部及四壁上部绘天文图，用白点表现二十八宿，星点间以白色细线相联。东北壁以红色绘内有金乌的圆形日像，以白色绘内有桂树和持杵玉兔的圆形月像，旁有残月。墓顶绘白色线条象征银河的图案。壁画施绘精致，色彩富丽。

2．佛寺遗址壁画

新疆地区是古代丝绸之路的重要地段，是佛教文化东传的必经之地。多年来，喀什、阿克苏、库车、温宿、拜城、和田、于田、焉耆、吐鲁番、鄯善、哈密等市县现存的石窟、佛寺等遗存即是当时文化交流的见证。近年来，考古发现、发掘出土的佛教壁画，主要见诸以下几个地点：

（1）尼雅遗址N5佛寺遗址[27]；

（2）于田县克里雅河下游喀喇墩佛寺遗址[28]；

（3）策勒县丹丹乌里克佛寺遗址[29]；

（4）策勒县托普鲁克佛寺遗址[30]；

（5）策勒县达玛沟喀喇墩1号佛寺遗址[31]；

（6）吉木萨尔县北庭故城西大寺遗址[32]。

上述尼雅遗址N5佛寺遗址、于田县克里雅河下游喀喇墩佛寺遗址壁画的年代，根据初步研究为3至5世纪；策勒县丹丹乌里克佛寺遗址、忙普鲁克佛寺遗址、达玛沟喀喇墩1号佛寺遗址等的年代为6至8世纪；吉木萨尔县北庭故城西大寺遗址壁画的年代，为回鹘高昌时期（9至11世纪）。

注　释

[1] 夏鼐：《敦煌考古漫记》（一），《考古通讯》1955年创刊号。

[2] 甘肃省文物队等：《嘉峪关壁画墓发掘报告》，文物出版社，1985年。

[3] 甘肃省文物考古研究所：《敦煌佛爷庙湾西晋画像砖墓》，文物出版社，1998年。

[4] 宿白、汤池、王仁波：《中国美术全集·绘画编12·墓室壁画》，文物出版社，1989年。

[5] 宁夏文物考古研究所固原工作站：《固原北周宇文猛墓发掘简报》，《宁夏考古文集》，宁夏人民出版社，1996年。

[6] 宁夏回族自治区博物馆、固原博物馆：《宁夏固原北周李贤夫妇墓发掘简报》，《文物》1985年第11期。

[7] 原州联合考古队编：《北周田弘墓》，文物出版社，2009年。

[8][12] 苏哲：《田弘墓几个问题的讨论》第三节，载原州联合考古队编《北周田弘墓》，文物出版社，2009年。

[9] 磁县文化馆：《河北磁县东魏茹茹公主墓发掘简报》，《文物》1984年第4期。汤池：《东魏茹茹公主墓壁画试探》，《文物》1984年第4期。

[10] 王克林：《北齐库狄迴洛墓》，《考古学报》1979年第3期。

[11] [15] 宿白：《宁夏固原北周李贤墓札记》，《宁夏文物》1989年总3期。

[13] 陕西省博物馆、文管会等：《唐李寿发掘简报》，《文物》1974年第9期。

[14] 陕西省文物管理委员会：《西安羊头镇唐李爽墓的发掘》，《文物》1959年第3期。

[16] 宁夏文物考古研究所、宁夏固原博物馆：《宁夏固原史射勿墓发掘简报》，《文物》1992年第10期。

[17] 山东省博物馆：《山东嘉祥英山一号隋墓清理简报——隋代墓室壁画的首次发现》，《文物》1981年第4期。

[18] [19] 罗丰：《固原南郊隋唐墓地》，文物出版社，1996年。

[20] Aurel Stein, Innermost Asia Detailed Report Of Explorations In Central Asia Kan-su and Eastern Iran,Volumes I—III,Oxford Clarendon Press.1928.

[21] 新疆博物馆考古队：《吐鲁番哈喇和卓古墓发掘简报》，《文物》1978年第6期。

[22] 新疆社科院考古研究所：《新疆考古三十年》，图版108，新疆人民出版社，1983年。新疆文物事业管理局：《新疆文物古迹大观》，第136页，图版0334，新疆美术摄影出版社，1999年。

[23] 李文儒：《被惊扰的楼兰》，《文物天地》2003年第4期专辑（总第142期）。张玉忠：《楼兰地区发现彩棺壁画墓葬》，《中国考古学年鉴》（2004年），文物出版社，2005年。

[24] 于志勇、吴勇、傅明方：《新疆库车县晋十六国时期砖室墓发掘》，《2007年全国重要考古发现》，文物出版社，2008年。

[25] 墓216系1972年由新疆博物馆考古队发掘，资料尚未刊布，有关此次发掘的简报，请参考新疆文物考古研究所：《吐鲁番阿斯塔那墓地第十次发掘简报（1972~1973）》，《新疆文物》2000年第3·4期合刊。

[26] 墓M217系1972年由新疆博物馆考古队发掘，资料尚未刊布，有关此次发掘的简报，请参考新疆文物考古研究所：《吐鲁番阿斯塔那墓地第十次发掘简报（1972~1973）》，《新疆文物》2000年第3·4期合刊。

[27] 中日共同尼雅遗址学术考察队：《中日共同尼雅遗址学术考察报告书》，日本京都：中村印刷株式会社，1996~1999年。

[28] 新疆文物考古研究所、法国科学研究中心315所：《新疆克里雅河流域考古调查概述》，《考古》1998年第12期。

[29] 新疆文物考古研究所：《2002年丹丹乌里克佛寺清理简报》，《新疆文物》2005年第3期。中日共同丹丹乌里克遗迹学术考察队：《中日共同丹丹乌里克遗址学术调查报告书》，日本京都：真阳社印刷，2007年。

[30] 中国社会科学院考古研究所新疆队：《策勒县达玛沟佛寺遗址发掘报告》，收入中日共同丹丹乌里克遗迹学术考察队编集《中日共同丹丹乌里克遗址学术调查报告书》，第281—338页，日本京都：真阳社印刷，2007年。中国社科院考古研究所新疆队：《新疆策勒县县托普鲁克佛寺遗址发掘》，《考古学报》2007年第4期。

[31] 中国社会科学院考古研究所新疆队：《策勒县达玛沟佛寺遗址发掘报告》，收入中日共同丹丹乌里克遗迹学术考察队编集《中日共同丹丹乌里克遗址学术调查报告书》，第281—338页，日本京都：真阳社印刷，2007年12月。中国社科院考古研究所新疆队：《策勒县托普鲁克佛寺遗址发掘》，《考古学报》2007年第4期。

[32] 中国社会科学院考古研究所：《北庭高昌回鹘佛寺遗址》，辽宁美术出版社，1991年。

Murals Unearthed from Gansu, Ningxia and Xinjiang

Guo Yongli, Yao Weiling, Yu Zhiyong

To date, about 82 loci of murals, which were painted in the Han Dynasty, the Three-Kingdoms to the Sixteen-Kingdoms Periods, the Northern Dynasty, the Sui and Tang Dynasties to the Song and Jin Dynasties, have been found in Gansu, Ningxia and Xinjiang. These murals are unearthed from burials and Buddhist temple ruins, and the former took the larger proportion.

1. The Murals Unearthed in Gansu Province

(1) The Murals of the Han Dynasty

So far, two mural tombs of the Han Dynasty have been excavated in Gansu Province. In 1984, a mural tomb of the late Western Han Dynasty was excavated at Wuba Hill of Hanzuo Township to the south of Wuwei City. This tomb was a single-chamber cave tomb in rectangular plan, the upper parts of whose passageway and chamber was destroyed by burials of the Eastern Han Dynasty and only the lower parts were preserved. The murals painted on the four walls had about 16 sq m recovered; the way of painting the murals was to apply a layer of fine clay plaster as thin as eggshell on the wall first, then a layer of malachite green color was applied as the base for the murals. The contours and details of the figures and objects were drawn with ink lines and the colors of black, white, blue and green were filled in to finish them. The vertical strips on the four corners of the tomb chamber composed of green, white and blue were the borders of the murals on the walls. The motifs of the murals were Feasting, Cooking, Wu-castles, Dancing, Hunting, Immortals and Mythical Beasts, which could be simply classified into depicting daily life and praying for ascending into the Paradise. This is the early case of tomb murals found to date in Gansu. These murals had some local features different from that of the murals of the Han Dynasty in the Central Plains, but their motifs and contents were directly succeeded from the Central Plains, which showed the close cultural relations between the Hexi region and the Central Plains since Zhang Qian's mission to the Western Regions. In 1989, a mural tomb of late Eastern Han Dynasty was found in the Eastern Han cemetery at Mozuizi, Wuwei City; it was a cave tomb with a transverse rectangular front chamber led to two rear chambers through tunnels. The murals were painted on the walls of the ceiling and walls of the rear half of the front chamber, the motifs of which were the sun, the moon, acrobatics, winged immortal and immortal riding elephant, still in the contents of depicting daily life and imagining afterlife following the subjects of the tomb murals of the Western Han Dynasty.

(2) The Murals of the Three-Kingdoms to the Sixteen-Kingdoms Periods (aka. Wei-Jin Period)

The first discovery of the mural tombs of the Three-Kingdoms to the Sixteen-Kingdoms Periods was done in 1944 by the History and Archaeology Group of the Scientific Expedition to the Northwestern Provinces of China when they were doing archaeological excavations in Foyemiao Wan Cemetery. Their expedition was organized by the Institute of History and Philology, Academia Sinica. That discovery was a brick single-chamber tomb with high brick-built façade over the entrance on which many figures were painted, and its date was the Three-Kingdoms to the Sixteen-Kingdoms Periods[1].In 1950s through 1970s, mural tombs of this period were found in Jiuquan, Dunhuang, Jiayuguan, Dongsigou Village at Yongchang County and Baguaying Cemetery at Yonggu Township, Minle County. Up to now, 49 mural tombs of this period have been found in Gansu Province, all of which were distributed in the vast area of Hexi Corridor but not seen in the middle and eastern regions.

Based on the types and mural motifs, these mural tombs could be assorted into Jiuquan Zone and Dunhuang Zone.

The mural tombs of this period at Jiuquan, Jiayuguan[2],Gaotai and Minle had many features in common; therefore they could

be attributed into Jiuquan Zone. All of these tombs had two or three chambers dug out of earth or built of bricks, and brick chamber tombs took the larger proportion; no single-chamber mural tombs have been found. The tombs were designed with strong implication of imitation to architectural complexes for living people: the tomb chambers usually had side rooms, phony doors, eaves made of bricks imitating wooden structure, square pit in the front chambers with tiers on the back and/ or left and right walls the top of which were at the same level with the floor of the central and rear chambers, and chimeras were set at the four corners of the tomb chambers. The front chambers were usually in square plan and with a square concave ceiling or in few cases a barrel vault ceiling; the rear chambers were usually in rectangular plan and with a square concave ceiling or a barrel vault ceiling.

The most noticeable local feature of the mural tombs in Jiuquan Zone was that they usually had high brick-built gate tower-shaped façade over the entrance on which wooden structure details, figures with bullhead or chicken head and human bodies, as well as animal masks, guardians wearing red headgear, guardians with bear head, Green Dragon and White Tiger, and other motifs were carved or painted. The shapes and motifs of these brick façades were also changing along with the time.

The Dunhuang Zone consisted of two burial areas, which were Foyemiao Wan[3] and Guazhou County. The mural tombs of this zone also had two types -- earthen cave tombs and brick-chamber tombs, both of which could again classified into double-chamber tombs and single-chamber tombs. Of the double-chamber tombs, the front chambers were usually in square plan and square concave ceiling and the rear chambers were with barrel vault ceiling; all of the single-chamber tombs had square concave ceiling. In a single-chamber tomb, coffin platform was set in the front of the chamber, and sacrifice offering altar was set close to or against the back wall, and niches or side rooms were set imitating kitchen. The mural tombs of Dunhuang Zone also had lofty brick-built gate tower-shaped façade over the entrance, which were even much larger and more luxurious than those in Jiuquan Zone; large amounts of heaven gate and other auspicious motifs were carved or painted on the façade, the craftsmanship of which were also much more sophisticated and exquisite than those of Jiuquan Zone too. However, the motifs of the murals in the chambers were not as rich as that in the Jiuquan Zone.

The murals of both zones were painted in two types: single brick mural and full wall mural. In the mural tombs of Jiuquan Zone, most of the murals were painted as single brick murals, and a complete content was composed by many independent scenes each one of which was painted on a single brick laid in shiner position. This is the unique feature peculiar to the mural tombs of Hexi region. Full wall murals, like murals seen in other regions, were painted on the walls of the tomb chambers and bordered by wide brown belts painted at the corners of the tomb chambers. In Dunhuang Zone, single brick murals and full wall murals coexisted in the tombs; the façades were mostly composed of single brick murals while the tomb chambers were decorated with full wall murals, and their motifs were specialized: the motifs of the single brick murals were the auspicious symbols, mythical animals or scenes of ascending paradise and so on, and the full wall murals were usually the portraits and life of the tomb occupants. In the Wei-Jin Period, single brick mural was the main type of tomb murals in the Hexi region.

The painting techniques for the single brick murals were that at first a thin layer of chalk was applied on the brick as color base, then the contours of the figures and objects were drawn with ink lines and colors were brushed or dotted in to finish the work. There were also many cases painted directly on the bricks without the chalk base. For the full wall murals, a layer of clay and straw plaster was applied to the brick wall first, and then the chalk layer was coated as the base for the murals to paint. The contours and details were sketched with ochre lines and redrawn with ink lines, and then colors were brushed in to finish the work. There were also some full wall murals directly painted on the fine clay plastered wall.

The motifs of the murals in the tombs of this period became much richer than that of the Han Dynasty, as well as the scopes of the murals covered: almost every part of the wall of a mural tomb was decorated. No matter a mural tomb had two or three chambers, the arrangement of the motifs followed some given rules and referred to the motifs of the decorations of the façade at the entrance. Generally, the motifs of the tomb murals could be classified into four categories: Life in paradise and ascending to paradise, immortals and auspicious symbols, the daily life and wealth of the tomb occupants,

and the mythical beings for guarding the tomb and exorcising evil spirits, all of which had their relatively given locations. The styles of the murals also showed strong diversity; the rich motifs and diversified styles vividly reflected the highly developed economy in the Hexi region during the Sixteen-Kingdoms Period. Since the beginning of the Three-Kingdoms Period, the Hexi region had been in peaceful situation for hundreds of years without the conflicts and turmoil like that in the Central Plains; plus the friendly economic conditions, the cultures from the Central Plains got deeply rooted in this area and mural tombs had been flourishing here to the Sixteen-Kingdoms Period. During this long time of development, the mural tombs in this area created its unique mural type -- the single brick mural.

The motifs of the murals in the tombs of this period in Hexi region were adopted from that of the mural tombs of the Han Dynasty, such as feasting, procession, farming, Xiwangmu (Queen Mother of the West), Dongwanggong (King Father of the East), celestial bodies, auspicious symbols, and so on. However, many distinct local features were also shown in these murals, such as the sowing and animal breeding scenes painted side by side in the tomb chambers without outstanding proportional differences, which might imply the special subsistence in the Hexi Corridor region that relied upon both agriculture and animal husbandry. The image of Wu-castles were repeatedly seen in the tomb murals, almost every mural tomb had at least one, showing that Wu-castle was a popular residential type in Hexi region during the Three-Kingdoms to the Sixteen-Kingdoms Periods. In Tomb No. 3 of Xincheng Cemetery at Jiayuguan City, the military drilling and ox plowing were painted in the same scene, in which some of the soldiers were in training and some were in farming: this reflected the military colony system in the Three-Kingdoms to the Sixteen-Kingdoms Periods that "the armored soldiers were assigned to open up wasteland for cultivation wherever they felt convenient" and "spare half of the troops from patrolling and garrisoning to farming (both were in The Book of Jin)" and the fact that the troops were supplied with the grains produced by themselves at that time. In the murals, the figures with high noses and deep eye sockets and untrimmed hairs, and cooking with tripod cauldrons in dome-shaped tents could also be seen; these figures clearly not belonging to the people from the Central Plains showed that many ethnic groups other than Han people were living in Hexi region and the tomb murals in this period were tightly linked to the realistic life.

The painting skills of the tomb murals at the Three-Kingdoms to the Sixteen-Kingdoms Periods in Hexi Corridor had very free styles, the feature of which was the using of fluent and smooth curving lines. The outlines and details were drawn with simple strokes and vigorous lines and the colors were applied with even-spreading method but not restrained by the given lines, and the whole style was more expressing the feelings of the artists than mechanically copying the objects.

These tomb murals found in Hexi region filled the gap from the Three-Kingdoms Period to the Western Jin Dynasty in the art history of China and linked the chain from the painting art of the Han Dynasty to the Buddhist art of the Northern Dynasties.

(3) The Tomb Murals of the Song and Jin Dynasties

There have not been too many cases of tomb murals found in Gansu Province, but they were scattered in rather wide area; in Lanzhou, Linxia, Dingxi, Tianshui and other cities or counties, mural tombs of this period have been found, most of which belonged to the Jin Dynasty (Jurchen Jin, 1115-1234 CE). In this period, single brick mural was the mainstream in the tomb murals, in which a scene or figure was painted on a single brick or impressed on a brick and the details were finished with colors. Before the murals were painted, a layer of chalk or lime plaster was coated on the brick as base, and then the contours and details were drawn with ink lines and the colors were evenly applied to finish the work. The motifs of the tomb murals of this period were the feasting of the tomb occupants, the stories of the "Twenty-Four Paragons of Filial Piety", auspicious animals, flowers and birds, and so on. These motifs were similar to that of the tomb murals of the same period in North China but not that rich. It is noticeable that the motifs of the "Twenty-Four Paragons of Filial Piety", which appeared in the tomb murals as well as the bricks with mold-impressed designs in large amount, were the main subject of the tomb murals in this region at this time, and this might reflect the influence of the Neo-Confucianism and the popularity of the Quanzhen (Complete Reality) Sect of Taoism in Northwestern China[4].

2. The Murals Unearthed from Ningxia Hui Autonomous Region

Most of the tomb murals unearthed to date in Ningxia were concentrated in the burials of the Northern Dynasties and the Sui and Tang Dynasties at present-day Guyuan County. Guyuan was the base of the rulers of the Western Wei to the Northern Zhou Dynasties (534-581 CE) and in the entire period (386-907 CE) it was the inevitable passage on the north route of the eastern section of the Silk Road. This special geographic position gave strong impact to the styles of the burials of Guyuan area. Since the 1980s, dozens of tombs of the Northern Dynasties and the Sui and Tang Dynasties have been excavated in this area, yielding many invaluable artifacts; among them, three tombs of the Northern Zhou, one tomb of the Sui and two of the Tang Dynasty yielded over one hundred pieces of murals with high historic and artistic significance.

(1) The Murals of the Northern Dynasties

The most noteworthy cases of murals of the Northern Dynasties were the ones unearthed from the three tombs of the Northern Zhou Dynasty at Guyuan County, which were the tombs of Yuwen Meng[5], Li Xian[6] and Tian Hong[7]. Yuwen Meng's tomb, which was located in Wanglaoba Village, Southern Suburb Township and buried in the fifth year of Baoding Era (565 CE), was excavated in 1993, the occupant of which was General-in-Chief, Area Commander-in-Chief, the Commander-in-Chief of the military affairs of the Yuan, Yan, Ling, Hui and Jiao Prefectures and Inspector of Yuan Prefecture. The tomb was a single-chamber cave tomb with a long ramped passageway linking to the chamber with a tunnel, and on the ceiling of the tunnel there were five ventilating shafts. On the walls of the passageway, the ventilating shafts, the tunnel and the chamber, traces of murals could be seen. Because of the silting in over one thousand years, most of the murals were severely damaged, and only fragmentary lines and color pieces were left; the single intact preserved piece was the figure of a warrior holding a sword on the east wall of the fifth ventilating shaft. This warrior was painted in profile, wearing small cap and red robe with crossing collars, and holding sword with both hands.

Li Xian's tomb, which was located in Shengou (Deep Gully) Village, Southern Suburb Township and buried in the fourth year of Tianhe Era (569 CE), was excavated in 1983. The occupants of this tomb were Li Xian, who was Shichijie [lit: Commissioner Holding (Imperial) Tally, which meant special authorities], Zhuguo Dajiangjun (Pillar of State and General-in-Chief), Area Commander-in-Chief, the Commander-in-Chief of the military affairs of Jing, Qin, He, and Wei Prefectures, Inspector of Yuan Prefecture and Duke Huan (posthumous name) of Hexi region, and his wife. The tomb was a single-chamber earthen cave tomb with a long ramped passageway linking to the chamber with a tunnel, and on the ceiling of the tunnel there were three ventilating shafts. Murals were painted on the walls of the passageway, the ventilating shafts, the tunnel and the chamber, the motifs of which were gate tower, warriors holding swords, female musicians, and so on; each one of the human figures was painted as single figure separated from the other ones with red frame, and the faces and dresses of them were painted with fading method.

Tian Hong's tomb, which was located in Dapu Village, Western Suburb Township and buried in the fourth year of Jiande Era (575 CE), was excavated in 1996. The occupant of this tomb was Shichijie, Shaoshi (Junior Preceptor), Zhuguo Dajiangjun, Area Commander-in-Chief, the Area Commander and Inspector of Xiang Prefecture and Duke of Yanmen region. The tomb was a multi-chamber earthen cave tomb with a long ramped passageway linking to the chamber with a tunnel, and on the ceiling of the tunnel there were five ventilating shafts. The murals were painted on the walls of the tunnel, main chamber, side chamber and rear chamber, the motifs of which were mainly guards and attendants, every scene was surrounded by frames and each frame enclosed more than one figure.

The epitaphs showed that these three tombs were buried within a ten-year time span, but their arrangements and motifs had clear differences: the remaining traces of the murals in Yuwen Meng's tomb showed that they were very similar to the murals in Li Xian's tomb in terms of layouts and painting methods; however, the murals in Li Xian's and Tian Hong's tombs showed features in the assemblages of figures and objects, the structures of the scenes, the painting methods and the dresses and ornaments of the figures distinct from each other. For example, on the walls of the passageway of Li Xian's tomb, warriors, attendants and gatehouses were painted, resembling the courtyards of the residence; no murals were found in the

passageway of Tian Hong's tomb, but the figures of guards were painted on the north, east and north half of the west walls of the main chamber, and the figures of attendants were painted on the south half of the west wall, which showed that the main chamber was used to resemble the courtyard of the residence[8]. On the walls of Li Xian's tomb chamber, maids and performing musicians were painted; as for Tian Hong's tomb, the coffin was set in the rear chamber, in which only stylized columns and beams were painted and figures of guards were painted at the entrance. From the passageway to the chamber, the forms of the murals in Li Xian's tomb were all full-faced single standing portraits independent from each other and on the whole they were seen like vertical scroll paintings hung side by side, belonging to the prototype of screen painting; the figures in the murals of Tian Hong's tomb, on the other hand, were painted in groups or lines standing in profile, forming a horizontal scroll-shaped layout, as those in the mural tombs of the Eastern Wei to the Northern Qi Dynasties, which were contemporary with the Northern Zhou Dynasty but occupying the eastern region. The style of painting human figures in formations or groups was rather popular in the tomb murals of the Eastern Wei to the Northern Qi Dynasties, but in the tombs of the Northern Zhou, Tian Hong's tomb was the single case found to date. In the murals of Li Xian's tomb, most of the warriors were wearing Liangdang armor (a cuirass comprising two pieces, one on the front and one on the back, which were linked by belts or something over the shoulders), and the colors of the dresses were applied in a fading tint; in the murals of Tian Hong's tomb, no Liangdang armor was seen, and the colors were mainly red and black applied in sharp contrast. These two styles showed us that the layouts and motifs of the tomb murals of the Northern Zhou Dynasty had features inherited from the old traditions as well as created on their own and influenced mural styles of the later times. For example, the warrior figures like the ones in the murals on the tunnel walls of Li Xian's tomb were also seen in the tombs of Princess of Ruru Tribe[9] which was located in Cixian County, Hebei Province and buried in the eighth year of Wuding Era (550 CE) of the Eastern Wei Dynasty and of Shedi Huiluo which was located in Shouyang County, Shanxi Province and buried in the first year of Heqing Era (562 CE) of the Northern Qi Dynasty[10]. The formation of the guards of honor in the mural on the passageway walls of Li Xian's tomb was assembled in the rules of the Northern Wei Dynasty[11], and the warrior figures holding sword with ring-shaped pommel were also traces of these rules. The eyebrows of the figures in Tian Hong's tomb were lined with red lines at the bottom, and their cheeks were decorated with red dots painted with fading method, both of which were similar to the painting features of the donor figures in Cave 288 of Dunhuang Caves carved in the Western Wei Dynasty and the secular person in the Jataka tale painting in Cave 296 and the disciple portrait in Cave 461 both carved and painted in the Northern Zhou Dynasty. This situation showed that the artists or craftsmen working in Guyuan area and Dunhuang area during the Northern Zhou Dynasty had interchanges in some way[12]. On the west wall of Li Xian's tomb chamber, which was closer to the coffins, attending maids were painted, and on the opposite wall far from the coffin, musicians were painted; this arrangement did not have precedent in the tomb murals of the Northern Dynasties, but were similar to that of Li Shou's tomb which was located in Sanyuan County, Shaanxi Province and buried in the fourth year of Zhenguan Era (630 CE)[13] and Li Shuang's tomb which was located at Yangtou Township, Xi'an, Shaanxi Province and buried in the first year of Zongzhang Era (668 CE)[14]. Every unit of the murals in Li Xian's tomb was enclosed with red frame resembling screen panel; this style was also seen in the tomb murals of the Northern Qi Dynasty roughly at the same time. The painting layout like that of Li Xian's tomb strongly influenced the tomb mural styles of the Sui and Tang Dynasties. The custom of building gate tower façade over the tomb entrance had long history in the area to the west of Shaanxi Plains[15], but the way of painting gate tower on the wall of ventilating shaft atop the tunnel was first created in Li Xian's tomb, and this also had deep influence to the tomb murals of the Sui and Tang Dynasties. Murals in Li Xian's tomb was the first discovered example displaying the artistic style of the Northern Zhou Dynasty and filled the gap of this period in the painting history of China, and the murals in Tian Hong's tomb provided important supplementary materials for us to make clear the full-view of tomb murals in the Western Wei and Northern Zhou Dynasties.

(2) The Murals of the Sui and Tang Dynasties

The most important murals of the Sui Dynasty unearthed so far in Ningxia were the ones found in Shi Shewu's tomb, which was located in Xiaomazhuang Village, Southern Suburb Township, Guyuan and buried in the fifth year of Daye Era

(609 CE)[16]. The occupant of this tomb was Zhengyi Dafu (Grand Master for Proper Consultation), You Lingjun (Right Commandant) and Piaoji Jiangjun (Calvary General-in-Chief). The underground structure of this tomb was a single-chamber earthen cave tomb with a long ramped passageway linking to the chamber with a tunnel, and on the ceiling of the tunnel there were two ventilating shafts. Murals were painted on the walls of the passageway, ventilating shaft, the sections of tunnel between the ventilating shafts and the tomb chamber. On the walls of the ventilating shafts, warriors and attendants were painted; gate towers and lotus flowers were painted on the walls over the façade of tunnel sections between the ventilating shafts and maids were painted on the walls of the tomb chamber. These are very rare and valuable mural samples of the Sui Dynasty with very high artistic significance. Besides the murals found in Shi Shewu's tomb, the well preserved tomb murals were that in Xu Minxing's tomb which was located in Yanglou Village, Jiaxiang County, Shandong Province[17]. The motifs and layouts of the murals in Shi Shewu's tomb were all similar to that of Li Xian's tomb, reflecting the strong influences of the Northern Zhou's mural art tradition. However, the figures of Officials holding hand-tablet, which were popular in the tomb murals of the Tang Dynasty, were first seen in Shi Shewu's tomb.

The tomb murals of the Tang Dynasty found in Ningxia were also in Guyuan, the main ones were that of Shi Suoyan[18] and Liang Yuanzhen's[19] tombs. The tomb of Shi Suoyan, who was Piaoji Jiangjun (Calvary General-in-Chief) and the commandant of Pingliang Prefecture, which was located at Yangfang Village, Southern Suburb Township and buried in the first year of Linde Era of the Tang Dynasty (664 CE), was composed of a ramped passageway, five ventilating shafts and a tunnel linking the passageway and the chamber and separated into five sections by the ventilating shafts, and the tomb chamber. The walls of the tunnel and tomb chamber were all coated with lime plaster on which the murals were painted. So far, only a Scarlet Bird on the wall of the ventilating shaft over the façade of the fifth section of the tunnel was preserved intact. This Scarlet Bird figure was painted mighty and powerful and like making wings to take off, and could be regarded as a masterpiece of Scarlet Bird mural of the Tang Dynasty. In the Northern Dynasties, the way of painting Scarlet Bird on over the tomb entrance was popular; this Scarlet Bird over the tunnel section could be seen as the remainder of this tradition, which might be used as the guide for the soul of the tomb occupant to the paradise. The tomb of Liang Yuanzhen who was a hermit, which was located also at Yangfang Village and buried in the second year of Shengli Era (699 CE), was composed of a ramped passageway, five ventilating shafts, a tunnel sectioned into three by the ventilating shafts and a chamber. The murals were painted on the walls of shafts, tunnel and chamber; among them, the murals of the shafts and tunnel were painted directly on the flatten loess walls. Because the raw loess wall was smooth and firm, the murals painted on this kind of base were better preserved, which were mostly the scene of "Horse and Groom". The ones in the chamber were painted on the brick wall coated with clay and straw plaster. Because the clay and straw plaster was not adhesive enough, the murals in the chamber were not preserved very well. The four walls and the ceiling of the chamber were all decorated with murals: on the east and south walls were figures of maids and attendants, on the west and north walls were all screen paintings of human figures, especially the "Old Man under the Tree (or Elder under the Tree)", and on the ceiling were the Milky Way, the sun, the moon and the Big Dipper, and other celestial bodies. The scenes of "Horse and Groom" in the ventilating shafts and tunnel were different from the murals in the same positions of other tombs of the Tang Dynasty, which were mainly showing infantry and cavalry formations and attending officials and guards, as well as halberd arrays painted as ceremonial displays; this would be because that the occupants of most of the mural tombs were high-ranked officials, while Liang Yuanzhen, although born in a noble family, was just a hermit, a common person, and the differences in the statuses would be reflected from the motifs of the tomb murals. In the chamber of Liang Yuanzhen's tomb, besides of the figures of maids and attendants, surrounding the coffin platform there were still ten panel of screen paintings showing the "Seven Sages of the Bamboo Grove" of the Western Jin Dynasty and Rong Qiqi, a famous hermit in the Spring-and-Autumn Period. These screen-shaped murals were the earlier cases of this type of mural in the Tang Dynasty with exact dates, which are very valuable for the dating of the screen-shaped murals with this kind of motifs.

3. The Murals Unearthed in Xinjiang

The discoveries of murals in Xinjiang began by the investigations and robberies done by the western explorers in the early 20th century. Their investigations and robberies were mainly to the Buddhist remains, such as grottoes and temples. Since 1949, splendid achievements have been gained in Xinjiang archaeology, including some important murals. These

new discoveries propelled and improved the researches on the cultural plurality and cultural element diversity in the ancient Western Regions. The murals unearthed in Xinjiang could be classified into two main categories: tomb murals and Buddhist temple murals.

(1) Tomb Murals

The earliest discovery of tomb murals in Xinjiang was done in Astana Cemetery at Turfan Basin by Aurel Stein in 1915 during his third exploration to the Central Asia[20].

To date, the tomb murals in Xinjiang are mainly found in the burials of the Western Jin to the Tang Dynasties at Astana Cemetery in Turfan Basin, the mural tombs in the vicinity of ancient city site LE to the north of Loulan ancient city at Ruoqiang (Qakilik) County and the tombs of the Sixteen-Kingdoms Period at Friendship Road, Kucha City, and so on. Roughly, these murals could be dated into two phases: the Western Jin to the Sixteen-Kingdoms Period and the Tang Dynasty.

1). The Tomb Murals of the Sixteen-Kingdoms Period

The tomb murals were mainly distributed in Turfan, the cemetery to the north of Loulan City Site at Ruoqiang (Qakilik) and Kucha, which were Gaochang (Karakhoja), Loulan (Shanshan) and Kucha in ancient times. Because of the special geographic and climatic conditions, the tomb murals in Turfan and Loulan areas were preserved rather well but in Kucha area, the murals in the brick-chamber tombs were almost completely damaged because of the high moisture.

The tomb murals in Turfan area were mainly found in the tombs of the Former Liang to Northern Liang Kingdoms at Astana Cemetery[21], which were mostly earthen cave tombs or brick-chamber tombs, and the murals were painted on the back walls of them. Usually, a layer of lime plaster was applied to the wall as the base first, and then the murals were painted with black color. Some of the murals were painted as a whole scene, and some were painted into grids; moreover, some cases of murals were painted on many pieces of paper and then these pieces were stuck together into a large painting (just like the one seen in 64TAM64)[22]. The motifs of these murals were idyllic life and farming scenes, feasting in tent, utensils (in 75TKM97), male and female figures (in 75TKM98), Ox cart, animals, the Moon (Nüwa), the Sun (Fuxi) and other celestial bodies. The painting techniques were very uneven, some were very skillful and some were rather clumsy. Some murals had inscriptions written with Chinese characters, such as "树 (Tree)", "蒲陶 (Grape)", "田 (Farmland)", "月像 (Image of the Moon)", "日像 (Image of the Sun)", "牛车 (Ox Cart)", "马 (Horse)"、"北斗 (Big Dipper)"、"三台 (The Three Terraces)" and so on (in Tombs 04TAM408 and 06TAM605).

The tomb murals found in Loulan area were in a double-chamber earthen cave tomb nearby the LE city site to the north of Loulan City Site[23]. In the center of the antechamber of this tomb was a central pillar with square plinth, which was fully decorated with lotus flower pattern. On the wall to the right of the entrance of the antechamber, the figures of a kneeling petty official holding an object with both hands and a sitting monk in purple robe were painted, and on the wall to the left of the entrance, the image of a Xiezhi (Unicorn) was painted with black color. On the left wall of the antechamber, figures of attendants and scene of fighting camels were painted; on the right wall, six figures were painted: on the left were three women and to the right were three men, all of whom were holding cup or bowl in the hand and in talking position. All of the men were clad in pullover robe with round collar and narrow sleeves, and leather belts with jade ornaments were tied around their waists; all of the women were wearing underwear with narrow sleeves and diagonal front and jacket with trumpet-shaped short sleeves and pleated skirt. Over the third figure from the left, inscription written with Kharosthi scripts could be seen. On the back wall of the antechamber, a scene of horse fighting was painted. The walls of the rear chamber were all decorated with cluster-shaped lotus flower design. All of the murals in this tomb were painted with perfect skill and brilliant colors, and all of the figures were depicted true to life. This tomb was dated as in the 3rd to 4th centuries CE.

In 2007, about ten brick-chamber tombs of the Sixteen-Kingdoms Period were discovered and excavated on Friendship Road of Kucha County[24]. These tombs were in similar shapes to that of the same period in Dunhuang, Gansu; in the chambers and some remaining veneer tiles of the screen walls, fragments of color-painted murals were found. It is pitiful that because the tombs were dug out of the gravel layers in Gobi desert, no recognizable mural details were kept. The mural tombs found so far in Xinjiang were similar to that of the same period found in Hexi region of Gansu Province in terms of tomb structures, painting methods, motifs and styles, which reflected the cultural fusion and the immigration of the Han

people (especially the noble people ever lived in Hexi Corridor) in Xinjiang during the Sixteen-Kingdoms Period.

2). The Tomb Murals of the Tang Dynasty

The tomb murals of the Tang Dynasty have been found so far mainly in Astata Cemetery at Turfan city. The murals were painted on the back walls of the tomb chambers, before which a layer of lime plaster was usually applied as base. The main motifs of the murals were six-Panel screen-shaped admonishing scene (as in 72TAM216)[25], bird-and-flower motif (as in 72TAM217)[26] , tomb occupant's daily life (as in 65TAM38) and so on displayed as multi-panel screens, and boy riding flying crane (sometimes with dishes in hands) and flying crane holding flower and plant in the beak, and so on. On the ceilings of some mural tombs and the upper parts of the walls, celestial phenomena were painted: the 28 mansions were painted as white dots linked each other with thin white lines. The sun was painted as red circle with a golden crow in the center, and the moon was painted as a white circle with a laurel tree and a rabbit smashing herbal medicine in it, or a crescent. The white lines were painted on the top of the ceiling as the Milky Way. The murals were all painted exquisitely and brilliantly.

(2) The Buddhist Murals Unearthed from Temple Remains

Xinjiang was an important section of the Silk Road and the unavoidable route for Buddhist culture and art to be introduced eastward into the Central Plains. In the past decades, the large amounts of Buddhist remains discovered in Kashi (Kaxgar), Aksu, Kucha, Wensu, Baicheng (Bay), Hotan, Yutian (Keriya), Yanqi (Karashahr), Turfan, Shanshan (Piqan) and Hami were the evidence of these cultural communications. The most important sites of discoveries of Buddhist murals are the following:

1) The remains of Buddhist Temple N5 at Niya Site[27];

2) The Karadong Buddhist Sanctuary remains at the lower reach of Keriya Darya in Yutian (Keriya) County[28];

3) Dandan Oiliq Buddhist Temple remains at Qira County[29];

4) Topulukdong Buddhist Monastery remains at Qira County[30];

5) Karadong No. 1 Buddhist Temple remains at Damago Township, Qira County[31]; and

6) The remains of the West Monastery in the ruins of Beiting Protectorate at Jimsar County[32].

Among these Buddhist remains, the Buddhist Temple N5 at Niya Site and Karadong Buddhist Sanctuary remains at Yutian County were dated in the 3rd to 5th centuries CE; Dandan Oiliq Buddhist Temple remains, Topulukdong Buddhist Monastery remains and Karadong No. 1 Buddhist Temple remains at Qira County were dated in the 6th to 8th centuries CE and the murals of the West Monastery at Jimsar County were dated in Khoco Uighur Period (9th to 11th centuries CE).

References

[1] Xia Nai. 1955. Archaeological Itinerary at Dunhuang. Kaogou Tongxun, 1: 2-8.

[2] Gansu Provincial Archaeological Team et al. 1985. Excavation of the Tomb with Wall Paintings at Jiayuguan. Beijing: Cultural Relics Press.

[3] Gansu Provincial Institute of Cultural Relics and Archaeology. 1998. Pictorial Brick Tombs of the Western Jin Period at Foyemiaowan, Dunhuang. Beijing: Cultural Relics Press.

[4] Su Bai, et al [ed]. 1989. Complete Collection of Chinese Fine Arts -- The Collection of Paintings [vol. 12] -- Tomb Mural Paintings. Beijing: Cultural Relics Press.

[5] Guyuan Work Station, Institute of Cultural Relics and Archaeology, Ningxia Hui Autonomous Region. 1996. Excavation to Yuwen Meng's Tomb of the Northern Zhou Dynasty at Guyuan. in: Collection of Works on Archaeology in Ningxia. Yinchuan: Ningxia Renmin Chubanshe. 134-47.

[6] Museum of Ningxia Hui Autonomous Region, Museum of Guyuan. 1985. Excavation of the Northern Zhou Dynasty Tomb of Li Xian and His Wife at Guyuan, Ningxia. Wenwu, 11: 1-20.

[7] The Yuanzhou Archaeological Joint Excavation [ed]. 2009. Tomb of Tian Hong of the Northern Zhou Dynasty. Beijing: Cultural Relics Press.

[8] Su Zhe. 2009. Discussions on Some Issues about Tian Hong's Tomb. *in:* Tomb of Tian Hong of the Northern Zhou Dynasty. 193-198.

[9] a. Cultural Centre of Cixian. 1984. Excavation of the Eastern Wei Tomb of the Princess of the Ruru Nationality at Cixian in Hebei. Wenwu, 4: 1-9.

 b. Tang Chi. 1984. Notes on the Eastern Wei Wall Paintings in the Tomb of the Princess of the Ruru Nationality. Wenwu, 4: 10-15.

[10] Wang Kelin. 1979. Excavation of the Tomb of Kudihuiluo [sic.] of the Northern Qi Dynasty. Kaogu Xuebao (Acta Archaeological Sinica), 3: 377-402.

[11] Su Bai. 1989. Notes on Li Xian's Tomb of the Northern Zhou Dynasty at Guyuan. Ningxia Wenwu, 3: 1-9.

[12] Su Zhe. 2009. Discussions on Some Issues about Tian Hong's Tomb. in: Tomb of Tian Hong of the Northern Zhou Dynasty. 93-198.

[13] The Shensi Provincial Museum Shensi Provincial CPAM. 1974. Excavation of the T'ang Dynasty Tomb of Li Shou at San-yuan County, Shensi Province. Wenwu, 9: 71-78.

[14] Committee for Preservation of Ancient Monuments, Shaanxi Province. 1959. Excavation of Li Shuang's Tomb of the Tang Dynasty at Yangtou Township, Xi'an. Wenwu, 3: 43-53.

[15] Su Bai. 1989. Notes on Li Xian's Tomb of the Northern Zhou Dynasty at Guyuan. Ningxia Wenwu, 3: 1-9.

[16] Institute of Cultural Relics and Archaeology of Ningxia, Guyuan Museum of Ningxia. 1992. Excavation of the Sui Tomb of Shi Shewu in Guyuan County, Ningxia. Wenwu, 10: 15-22.

[17] The Provincial Museum of Shandong. 1981. Excavation of Sui Tomb No. 1 at Yingshan in Jiaxiang County, Shandong Province. Wenwu, 4: 28-33.

[18] Luo Feng. 1996. Graveyard of Sui & Tang Dynasties in the South Suburbs of Guyuan. Beijing: Cultural Relics Press.

[19] Ibid.

[20] Aurel Stein. 1928. Innermost Asia; Detailed Report of Explorations in Central Asia, Kan-su and Eastern Iran, Carried out and Described Under the Orders of H.M. Indian Government. Oxford: Clarendon Press. Volumes I -- III.

[21] The Museum of the Sinkiang Uighur Autonomous Region. 1978. A Brief Report on the Excavation of the Ancient Cemetery at Halahezhuo, Sinkiang. Wenwu, 6: 1-14.

[22] Institute of Archaeology, Xinjiang Academy of Social Sciences [ed]. 1983. Thirty Years of Archaeology in Xinjiang. Urumqi: Xinjiang Renmin Chubanshe. Plate 108. Xinjiang Bureau for Cultural Relics Management. 1999. A Grand View of Xinjiang's Cultural Relics and Historic Sites. Urumuqi: Xinjiang Meishu Sheying Chubanshe. p. 136, Plate 0334.

[23] Li Wenru [chief ed]. 2003. The Disturbed Loulan. Wenwu Tiandi, 4. Zhang Yuzhong. 2005. Painted Coffins and Mural Tombs Found in Loulan Region. in: Yearbook of Chinese Archaeology 2004. Beijing: Cultural Relics Press. 410-412.

[24] Yu Zhiyong, Wu Yong, Fu Mingfang. 2008. Excavation of Brick-chambered Tombs of the Jin and Sixteen-Kingdoms Periods in Kuqa County, Xinjiang. in: Major Archaeological Discoveries in China 2007. Beijing: Cultural Relics Press. 92-98.

[25] Detailed data have not been published yet; for brief introduction, see Xinjiang Institute of Cultural Relics and Archaeology. 2000. 10th Excavation at Astana Cemetery in Turfan (1972-1973). Xinjiang Wenwu, 3 & 4: 84-167.

[26] Ibid.

[27] Sino-Japanese Joint Investigation Team to Niya Ruins. 1996-99. Report of the Sino-Japanese Joint Investigation Team to Niya Ruins. Kyoto: Bukkyo Daigaku Niya Iseki Gakujutsu Kenkyu Kiko.

[28] Xinjiang Institute of Cultural Relics and Archaeology, 315 Institute of the Scientific Research Centre of France. 1998. A Brief Account on the Archaeological Investigation and Excavation along the Koria River of Xinjiang. Kaogu, 12: 28-37.

[29] Xinjiang Institute of Cultural Relics and Archaeology. 2005. Brief Report on Excavation of the Buddhist Temple in

Dandan Oiliq Site in 2002. Xinjiang Wenwu, 3: 8-19. Sino-Japanese Joint Investigation Team to Dandan Uiliq Ruins [ed]. 2007. Report of the Sino-Japanese Joint Investigation Team to Dandan Uiliq Ruins. Kyoto: Shin'yosha.

[30] Xinjiang Archaeological Team, IA, CASS. 2007. Excavation of Buddhist Temple-sites at Damago in Qira County of Hetian Prefecture, Xinjiang. Kaogu Xuebao 4: 489-525. See also Sino-Japanese Joint Investigation Team to Dandan Uiliq Ruins [ed]. 2007. Report of the Sino-Japanese Joint Investigation Team to Dandan Uiliq Ruins. Kyoto: Shin'yosha, 281-338.

[31] Ibid.

[32] Institute of Archaeology, Chinese Academy of Social Sciences. 1991. Ruins of Buddhist Temple of the Khoco Uighur Period at the Ancient City of Beiting. Shenyang: Liaoning Meishu Chubanshe.

目　录　CONTENTS

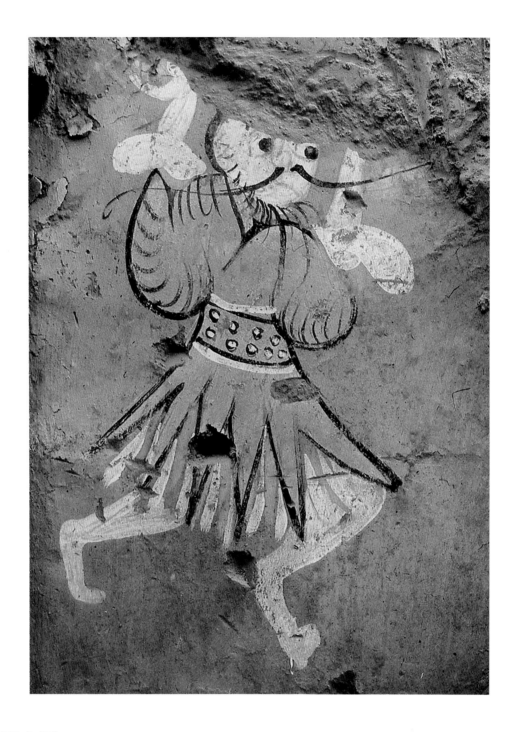

1.羽人图

西汉（前206～25年）

残高100、宽约80厘米

1984年甘肃省武威市韩佐乡红花村五坝山西汉7号墓出土。已残毁。

墓向北。位于墓室西壁南端。在墓壁涂一层极薄的细黄土，再施一层石绿色为底，其上绘画。画中绘羽人，羽人头额上部残缺，双眼黑圆，嘴上有飘动的长须，双手上举，赤足而立，着石青色羽衣。笔致豪放泼辣。

（撰文：郭永利　摄影：岳邦湖）

Winged Immortal

Western Han (206 BCE-25 CE)

Surviving height 100 cm; Width ca. 80 cm

Unearthed from Tomb M7 of Western Han Dynasty at Wubashan of Honghuacun, Hanzuoxiang in Wuwei, Gansu, in 1984. Not preserved.

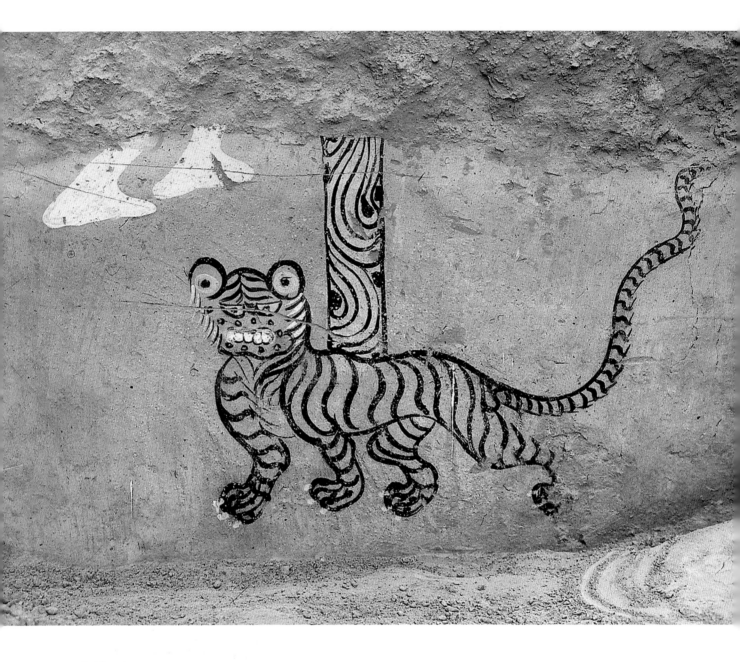

2. 神兽图

西汉（前206～25年）

残高100、宽约200厘米

1984年甘肃省武威市韩佐乡红花村五坝山西汉7号墓出土。已残毁。

墓向北。位于墓葬的南壁正中下部。在墓壁涂一层极薄的细黄土，再施一层石绿色为底，其上绘画。神兽为虎的形象，立姿，昂首长尾，全身有黑色条纹，双目和爪尖为绿色，双耳为黄色。神兽背后为一直立的树干，上部残缺，以黑色弧线表现出树皮纹路。

<div align="right">（撰文：郭永利　摄影：岳邦湖）</div>

Mythical Animal

Western Han (206 BCE-25 CE)

Surviving height 100 cm; Width ca. 200 cm

Unearthed from Tomb M7 of Western Han Dynasty at Wubashan of Honghuacun, Hanzuoxiang in Wuwei, Gansu, in 1984. Not preserved.

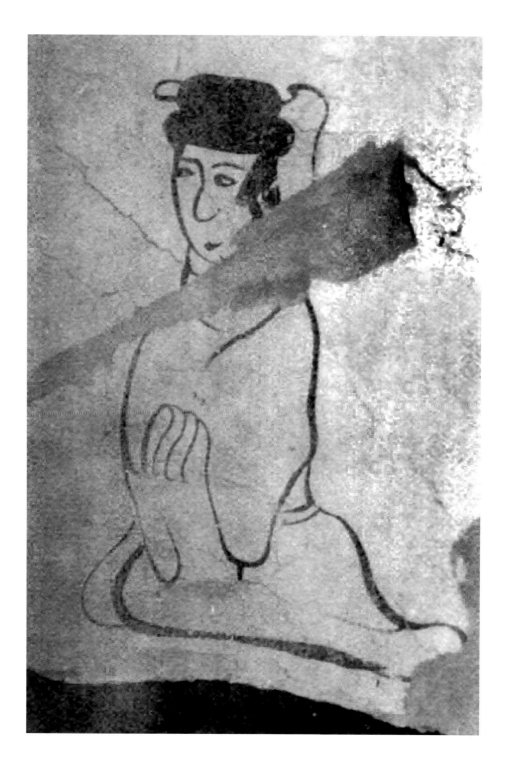

3. 观百戏图

东汉（25～220年）

高约70、宽约20厘米

1989年甘肃省武威市磨嘴子东汉墓出土。已残毁。

墓向东。位于墓室西壁。墓壁涂一层白垩，然后于其上绘画。整壁平列绘五人，中间二位为女性，席地而坐，两侧为表演百戏的人物。此图为其中的一位女性，正在观赏表演。

（撰文：郭永利 摄影：党寿山）

Watching Performance

Eastern Han (25-220 CE)

Height ca. 70 cm; Width ca. 20 cm

Unearthed from Eastern Han tomb at Mozuizi in Wuwei, Gansu, in 1989. Not Preserved.

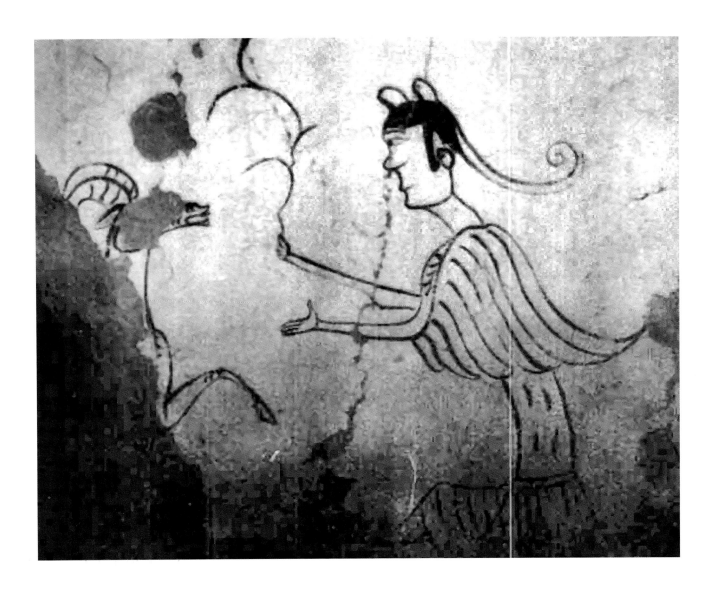

4.羽人戏羊图

东汉（25～220年）

高184、宽130厘米

1989年甘肃省武威市磨嘴子东汉墓出土。已残毁。

墓向东。位于墓室南壁。墓壁涂一层白垩，然后于其上绘画。画中绘一立姿羽人，头顶有双耳，脑后长发，肩生羽翼，手持芝草面向羊站立。羊仅有头部和前肢，其他部分残缺。

（撰文：郭永利 摄影：党寿山）

Winged Immortal Playing a Goat

Eastern Han (25-220 CE)

Height 184 cm; Width 130 cm

Unearthed from Eastern Han tomb at Mozuizi in Wuwei, Gansu, in 1989. Not Preserved.

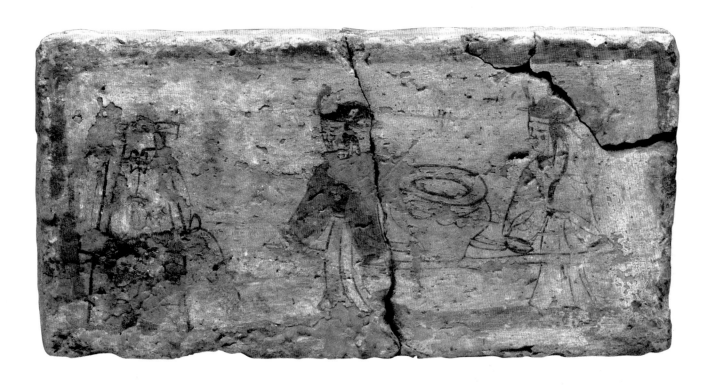

5.二女抬水图

三国·魏甘露二年（257年）

高17.5、宽36.5厘米

1972年甘肃省嘉峪关市新城1号墓出土。现存于嘉峪关长城博物馆。

墓向340°。位于墓葬前室东壁。先于砖面上涂白垩再绘画。画面中二女婢一前一后，抬着水罐向井台走去。二人身着交领短衣，下着长裙，梳高髻，上结红色发饰，面上点妆。

（撰文：郭永利 摄影：张宝玺）

Two Women Carrying a Jar

2nd Year of Ganlu Era, Wei Kingdom (257 CE)

Height 17.5 cm; Width 36.5 cm

Unearthed from Tomb M1 at Xincheng of Jiayuguan in Gansu, in 1972. Preserved in Jiayuguan Museum of the Great Wall.

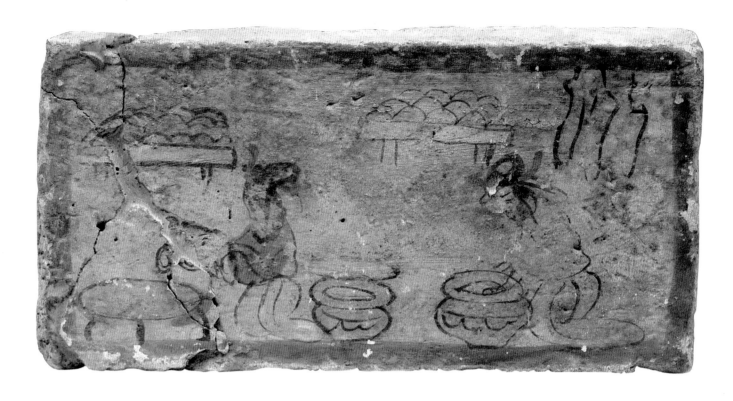

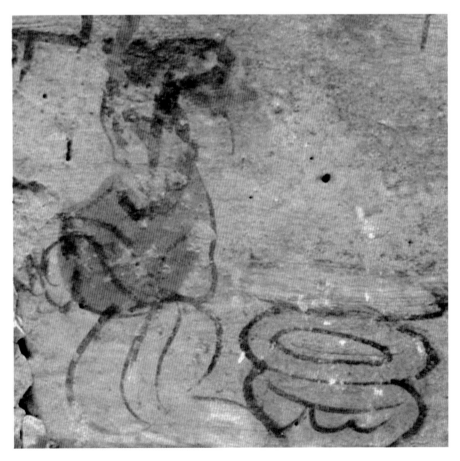

6.庖厨图（一）

三国·魏甘露二年（257年）

高17.5、宽36.5厘米

1972年甘肃省嘉峪关市新城1号墓出
土。现存于嘉峪关长城博物馆。

墓向340°。位于墓葬前室东壁。先
于砖面上涂白垩再绘画。画面中二女
婢跪在地上，一位在和面，一位在三
足镬前操作。上方有木案，木案上成
层叠放着做好的食物。

（撰文：郭永利 摄影：张宝玺）

Two Women Working in Kitchen (1)

2nd Year of Ganlu Era, Wei Kingdom (257 CE)

Height 17.5 cm; Width 36.5 cm

Unearthed from Tomb M1 at Xincheng of Jiayuguan in Gansu, in 1972. Preserved in Jiayuguan Museum of the Great Wall.

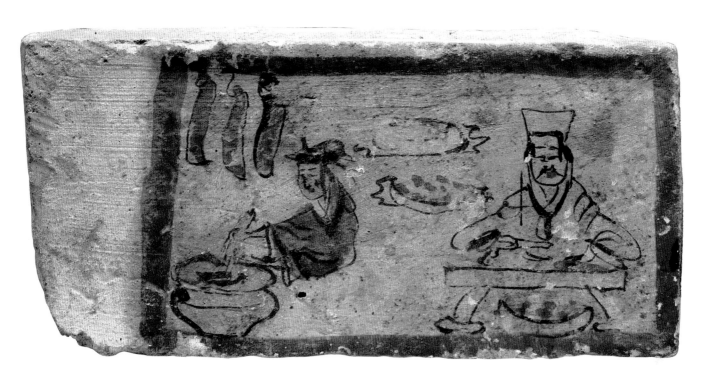

7. 庖厨图（二）

三国·魏甘露二年（257年）

高17.5、宽36.5厘米

1972年甘肃省嘉峪关市新城1号墓出土。
现存于嘉峪关长城博物馆。

墓向340°。位于墓葬前室东壁。先于砖
面上涂白垩再绘画。画面中一男仆正持
刀在长俎上切肉，女婢正在清洗宰好的
鸡。上方有悬肉和盘。

（撰文：郭永利 摄影：张宝玺）

Cooking Scene (2)

2nd Year of Ganlu Era, Wei Kingdom (257
CE)

Height 17.5 cm; Width 36.5 cm

Unearthed from Tomb M1 at Xincheng of
Jiayuguan in Gansu, in 1972. Preserved in
Jiayuguan Museum of the Great Wall.

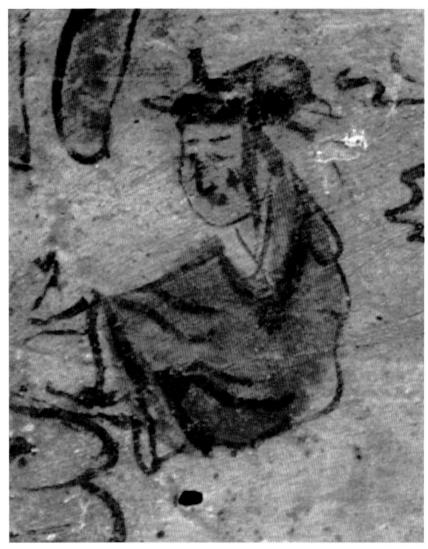

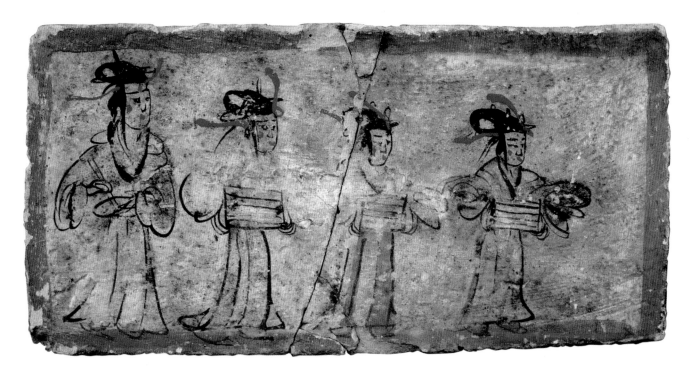

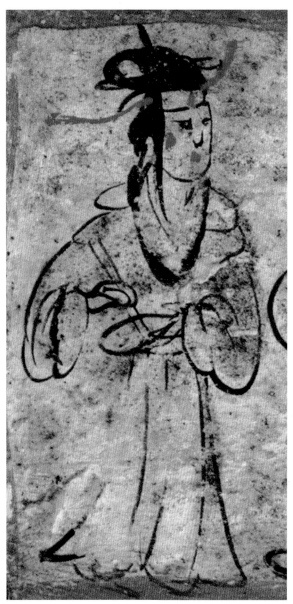

8.进食图

三国·魏甘露二年（257年）

高17.5、宽36.5厘米

1972年甘肃省嘉峪关市新城1号墓出土。现存于嘉峪关长城博物馆。

墓向340°。位于墓葬前室东壁。先于砖面上涂白垩再绘画。画面中四位女婢并列而行，捧樽进食。女婢均为高髻，面上点妆，着长裙，衣饰华丽。

（撰文：郭永利 摄影：张宝玺）

Serving Dinner

2nd Year of Ganlu Era, Wei Kingdom (257 CE)

Height 17.5 cm; Width 36.5 cm

Unearthed from Tomb M1 at Xincheng of Jiayuguan in Gansu, in 1972. Preserved in Jiayuguan Museum of the Great Wall.

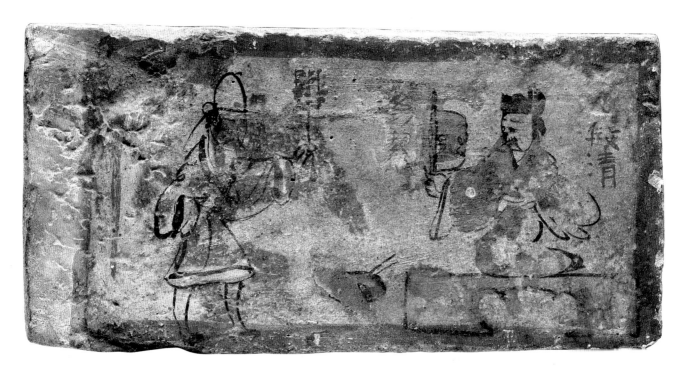

9. 墓主人宴饮图

三国·魏甘露二年（257年）

高17.5、宽36.5厘米

1972年甘肃省嘉峪关市新城1号墓出土。现存于嘉峪关长城博物馆。

墓向340°。位于墓葬前室南壁。先于砖面上涂白垩再绘画。墓主人头戴介帻，手持便面坐于方榻上，身旁有红色榜题"段清"，应为墓主人名字。其对面一男仆戴桶形帽，赤足，着短衣，手持烤肉串递给墓主人，男仆身旁有榜题"幼絜"，应为男仆名字。

（撰文：郭永利 摄影：张宝玺）

Tomb Occupant Having Dinner

2nd Year of Ganlu Era, Wei Kingdom (257 CE)
Height 17.5 cm; Width 36.5 cm
Unearthed from Tomb M1 at Xincheng of
Jiayuguan in Gansu, in 1972. Preserved in
Jiayuguan Museum of the Great Wall.

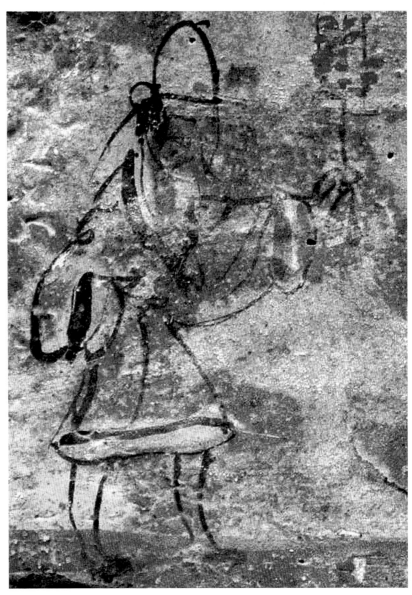

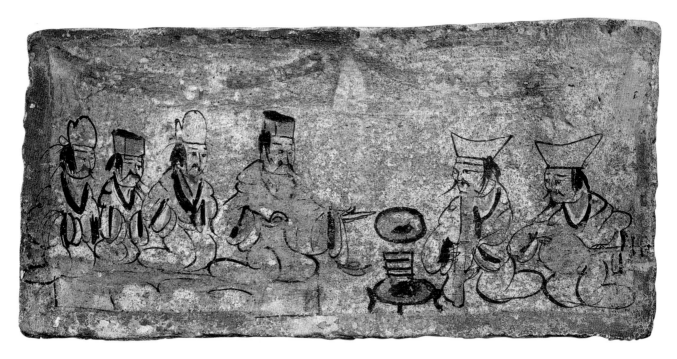

10. 宴乐图（一）

三国·魏甘露二年（257年）

高17.5、宽36.5厘米

1972年甘肃省嘉峪关市新城1号墓出土。现存于嘉峪关长城博物馆。

墓向340°。位于墓葬前室西壁。先于砖面上涂白垩再绘画。画面中上部绘帷帐的垂幔，下部左侧四位男子并坐于一张大榻之上，着帽及交领袍服，正在观赏画面右侧二位男伎乐的演奏，中间有一组酒具。为宴乐场景。

（撰文：郭永利 摄影：张宝玺）

Feasting with Music Accompanying (1)

2nd Year of Ganlu Era, Wei Kingdom (257 CE)

Height 17.5 cm; Width 36.5 cm

Unearthed from Tomb M1 at Xincheng of Jiayuguan in Gansu, in 1972. Preserved in Jiayuguan Museum of the Great Wall.

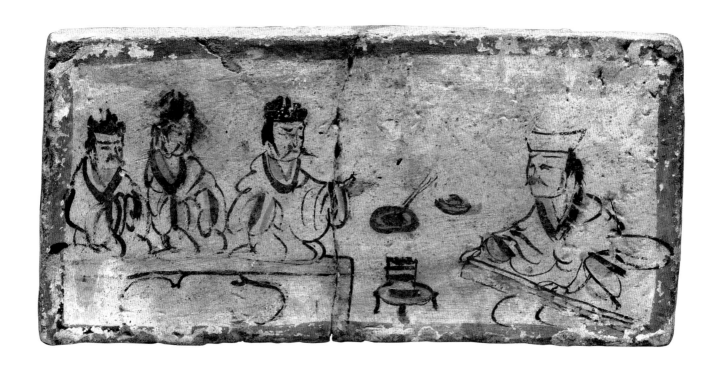

11.宴乐图（二）

三国·魏甘露二年（257年）

高17.5、宽36.5厘米

1972年甘肃省嘉峪关市新城1号墓出土。
现存于嘉峪关长城博物馆。

墓向340°。位于墓葬前室南壁。先于砖
面上涂白垩再绘画。画面中绘三男子均头
戴介帻，并坐于一张大榻之上，其对面有
乐伎正在弹卧箜篌，中间置酒具和食具。
为宴乐场景。

（撰文：郭永利　摄影：张宝玺）

Listening Music (2)

2nd Year of Ganlu Era, Wei Kingdom (257
CE)

Height 17.5 cm; Width 36.5 cm

Unearthed from Tomb M1 at Xincheng of
Jiayuguan in Gansu, in 1972. Preserved in
Jiayuguan Museum of the Great Wall.

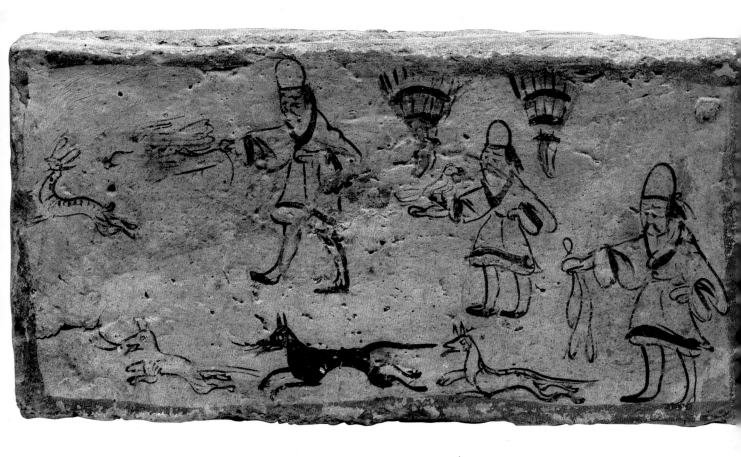

12. 狩猎图

三国·魏甘露二年（257年）

高17.5、宽36.5厘米

1972年甘肃省嘉峪关市新城1号墓出土。现存于嘉峪关长城博物馆。

墓向340°。此图位于墓葬前室西壁。先于砖面上涂白垩再绘画。画面中三男子头戴桶形帽，赤足短衣，手中有鹰和绳索，一只鹰已经放脱，三只犬疾速向前追赶奔逃的兔子。

<div align="right">（撰文：郭永利 摄影：张宝玺）</div>

Hunting Scene

2nd Year of Ganlu Era, Wei Kingdom (257 CE)

Height 17.5 cm; Width 36.5 cm

Unearthed from Tomb M1 at Xincheng of Jiayuguan in Gansu, in 1972. Preserved in Jiayuguan Museum of the Great Wall.

13.坞图

三国·魏甘露二年（257年）

高17.5、宽36.5厘米

1972年甘肃省嘉峪关市新城1号墓出土。现存于嘉峪关长城博物馆。

墓向340°。位于墓葬前室西壁。先于砖面上涂白垩再绘画。画面分栏。上栏绘牛、羊，下栏绘树木及马、牛等。画面左侧为高大的坞，有楼阁及开着的坞门，在坞门旁有朱书题名"坞"。画面描绘了曹魏时期河西地区畜牧业的兴旺景象。

（撰文：郭永利 摄影：张宝玺）

Wu-Castle

2nd Year of Ganlu Era, Wei Kingdom (257 CE)

Height 17.5 cm; Width 36.5 cm

Unearthed from Tomb M1 at Xincheng of Jiayuguan in Gansu, in 1972. Preserved in Jiayuguan Museum of the Great Wall.

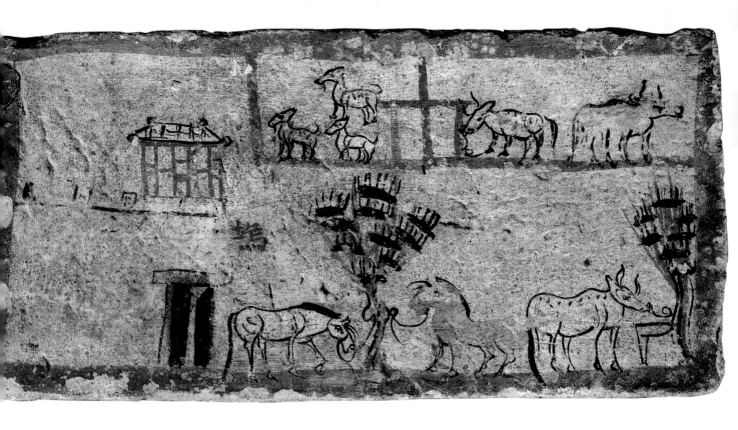

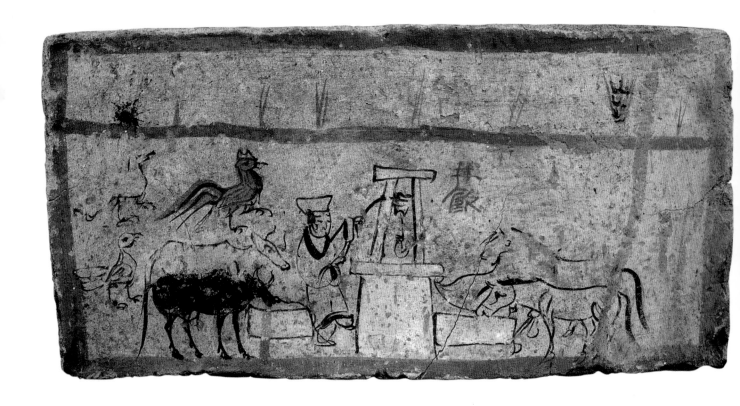

14.井饮图

三国·魏甘露二年（257年）

高17.5、宽36.5厘米

1972年甘肃省嘉峪关市新城1号墓出土。现存于嘉峪关长城博物馆。

墓向340°。位于墓葬前室北壁。先于砖面上涂白垩再绘画。画面分栏。上栏绘一排树木；下栏有井，一男仆正在汲水，井旁有饮水的牛、马及鸡群，在井的右上方有朱书榜题"井饮"。

<div style="text-align:right">（撰文：郭永利　摄影：张宝玺）</div>

Well Watering Livestock

2nd Year of Ganlu Era, Wei Kingdom (257 CE)

Height 17.5 cm; Width 36.5 cm

Unearthed from Tomb M1 at Xincheng of Jiayuguan in Gansu, in 1972. Preserved in Jiayuguan Museum of the Great Wall.

15.穹庐图

魏晋（220～316年）

高约17、宽约35厘米

1993年甘肃省酒泉市果园乡西沟村5号墓出土。原址保存。

墓向180°。位于前室西壁的上部第一层。画面中一女子披发，居于穹庐内，探头向外张望。穹庐两侧有繁茂的树木和飞鸟。表现了少数民族的生活画面。

<div align="right">（撰文：郭永利 摄影：肃州区博物馆）</div>

Dome-shaped Tent

Three-Kingdoms to Jin (220-316 CE)

Height ca. 17 cm; Width ca. 35 cm

Unearthed from Tomb M5 at Xigoucun of Guoyuanxiang in Jiuquan, Gansu, in 1993. Preserved on the original site.

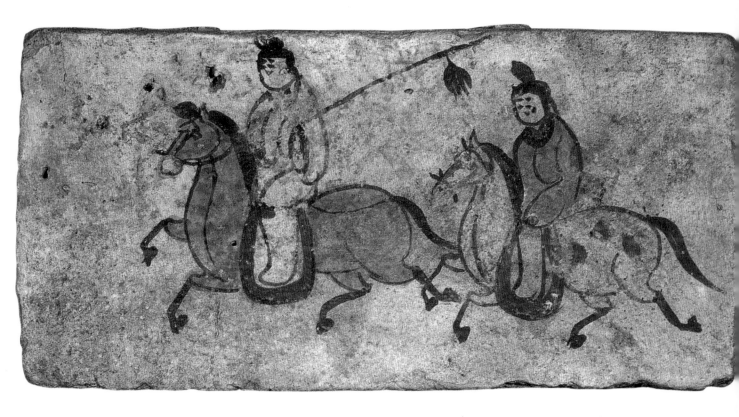

16. 出行图（一）

魏晋（220～316年）

高约17、宽约35厘米

1993年甘肃省酒泉市果园乡西沟村7号墓出土。现存于酒泉市肃州区博物馆。

墓向173°。位于前室西壁第四层，此层均为出行场景，由五幅图组成，此为其中之一。在砖面上涂白垩之后再绘画。绘一前一后两个骑吏骑马前行的场景。前面的骑吏着白衣裤，左肩斜扛长矛；后面的骑吏着灰色圆领衣，紧随其后。

（撰文：郭永利 摄影：肃州区博物馆）

Procession Scene (1)

Three-Kingdoms to Jin (220-316 CE)

Height ca. 17 cm; Width ca. 35 cm

Unearthed from Tomb M7 at Xigoucun of Guoyuanxiang in Jiuquan, Gansu, in 1993. Preserved in the Museum of Suzhou District in Jiuquan.

17.出行图（二）

魏晋（220～316年）

高约17、宽约35厘米

1993年甘肃省酒泉市果园乡西沟村7号墓出土。现存于酒泉市肃州区博物馆。

墓向173°。位于前室西壁第四层，此层均为出行场景，由五幅图组成，此为其中之一。在砖面上涂白垩之后再绘画。绘一前一后两个骑吏骑马前行的场景。前面的骑吏着白衣裤，一手持长矛，一手持缰策马疾行，其前方有墨书题名"兵胡大年"；后面的骑吏着灰色中衣，紧随其后，前方有墨书题名"兵孙旌"。

（撰文：郭永利 摄影：肃州区博物馆）

Procession Scene (2)

Three-Kingdoms to Jin (220-316 CE)

Height ca. 17 cm; Width ca. 35 cm

Unearthed from Tomb M7 at Xigoucun of Guoyuanxiang in Jiuquan, Gansu, in 1993. Preserved in the Museum of Suzhou District in Jiuquan.

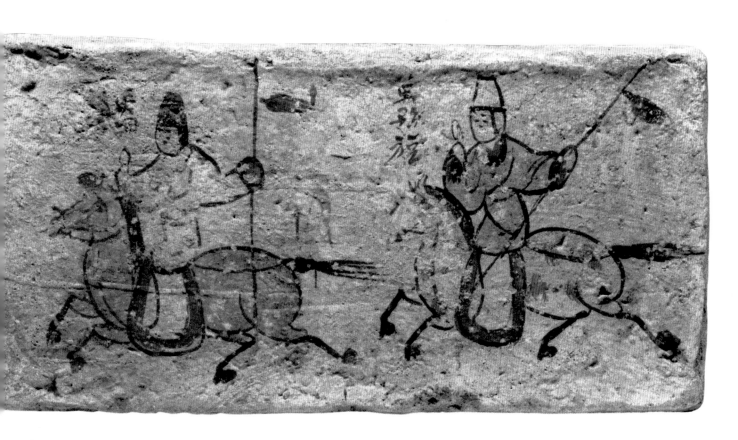

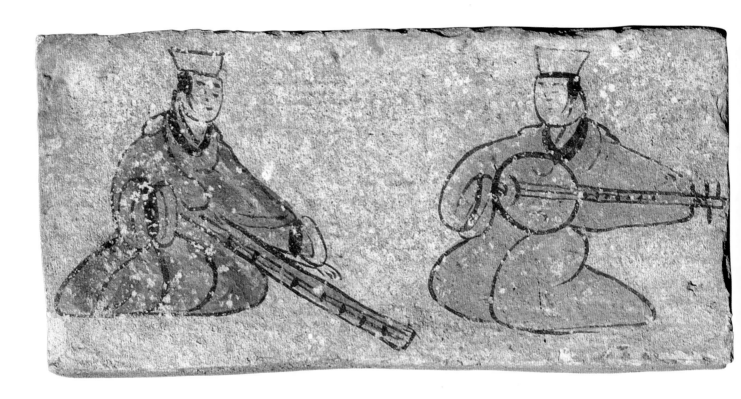

18.奏乐图

魏晋（220～316年）

高约17、宽约35厘米

1993年甘肃省酒泉市果园乡西沟村7号墓出土。现存于甘肃省文物考古研究所。

墓向173°。位于前室东壁第四层。此层为表现墓主人宴乐的内容，此图为其中之一。在砖面上涂白垩之后再绘画。画面中二男子相对而坐正在奏乐，左侧人物正在弹卧箜篌，右侧人物手持阮咸在弹奏。

（撰文：郭永利 摄影：肃州区博物馆）

Music Playing Scene

Three-Kingdoms to Jin (220-316 CE)

Height ca. 17 cm; Width ca. 35 cm

Unearthed from Tomb M7 at Xigoucun of Guoyuanxiang in Jiuquan, Gansu, in 1993. Preserved in Gansu Provincial Institute of Archaeology and Cultural Relics.

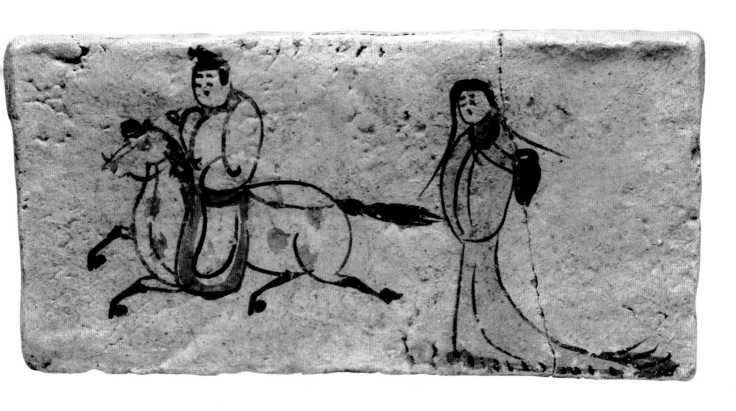

19.骑吏与羌人女子

魏晋（220～316年）

高约17、宽约35厘米

1993年甘肃省酒泉市果园乡西沟村7号墓出
土。现存于酒泉市肃州区博物馆。

墓向173°。位于前室北壁第二层。一男子
骑马飞驰，身旁有一女子正在路边行走，
披长发，背着水罐，着及地长裙，从其披
发及长裙特点看，与汉族妇女服饰完全不
同，应为羌人。

（撰文：郭永利 摄影：肃州区博物馆）

Mounted Petty Official and Woman in Qiang Dress

Three-Kingdoms to Jin (220-316 CE)

Height ca. 17 cm; Width ca. 35 cm

Unearthed from Tomb M7 at Xigoucun of Guoyuanxiang in Jiuquan, Gansu, in 1993. Preserved in Museum of Suzhou District in Jiuquan.

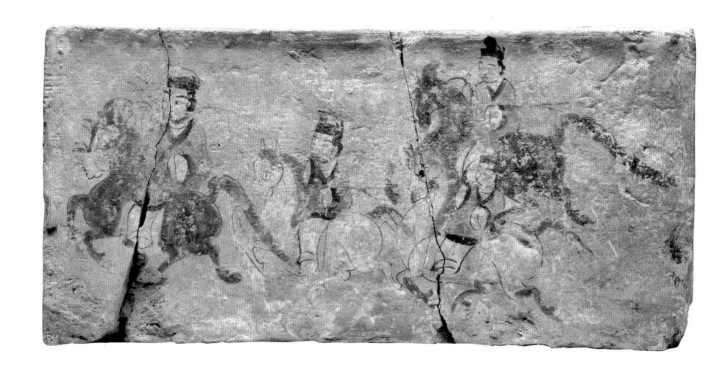

20. 出行图

魏晋（220～316年）

高19、宽39厘米

1993年甘肃省酒泉市果园乡高闸沟村魏晋墓出土。现存于酒泉市肃州区博物馆。墓向东。此墓出行图共由6幅画面组成，此图为其中之一。在砖面上涂白垩之后再绘画。画面中绘有四人骑马前行，前二人着进贤冠，后二人着介帻，显示出出行人物身份的不同。

（撰文：郭永利　摄影：肃州区博物馆）

Procession Scene

Three-Kingdoms to Jin (220-316 CE)

Height 19 cm; Width 39 cm

Unearthed from tomb of Three-Kingdoms to the Jin Dynasty at Gaozhagoucun of Guoyuanxiang in Jiuquan, Gansu, in 1993. Preserved in Museum of Suzhou District in Jiuquan.

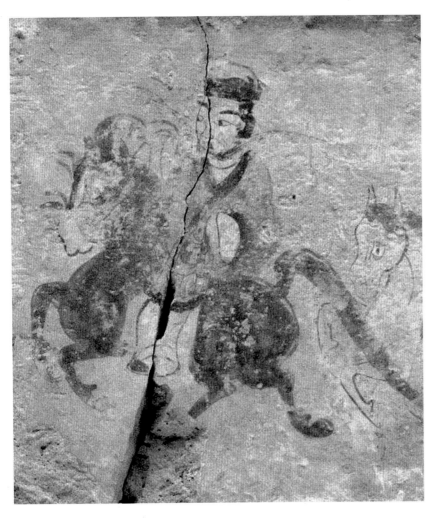

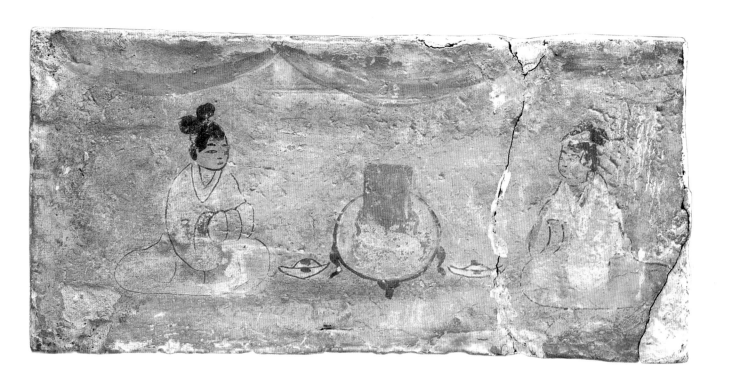

21.宴饮图

魏晋（220～316年）

高19、宽39厘米

1993年甘肃省酒泉市果园乡高闸沟村魏晋墓出土。现存于酒泉市肃州区博物馆。

墓向东。画面表现女墓主宴饮情形。女墓主坐于帷帐内，均梳高髻，着交领襦服相对而坐，中间置一组由承镟、樽、耳杯组成的酒具。

（撰文：郭永利 摄影：肃州区博物馆）

Feasting

Three-Kingdoms to Jin (220-316 CE)

Height 19 cm; Width 39 cm

Unearthed from tomb of Three-Kingdoms to the Jin Dynasty at Gaozhagoucun of Guoyuanxiang in Jiuquan, Gansu, in 1993. Preserved in Museum of Suzhou District in Jiuquan.

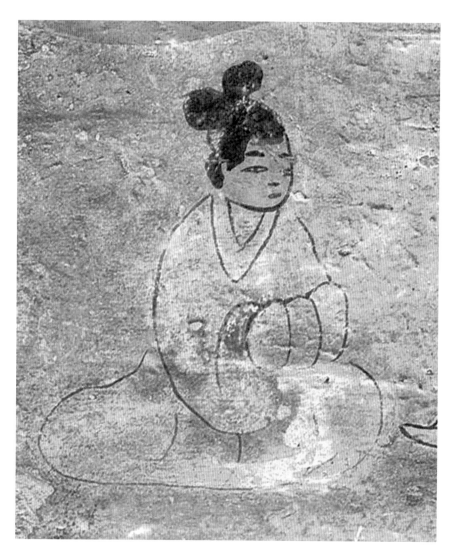

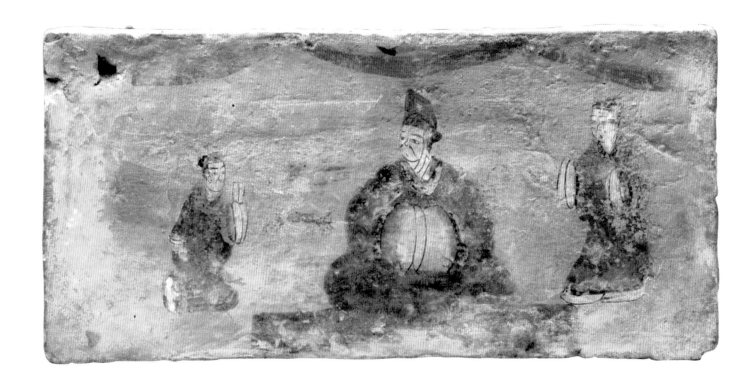

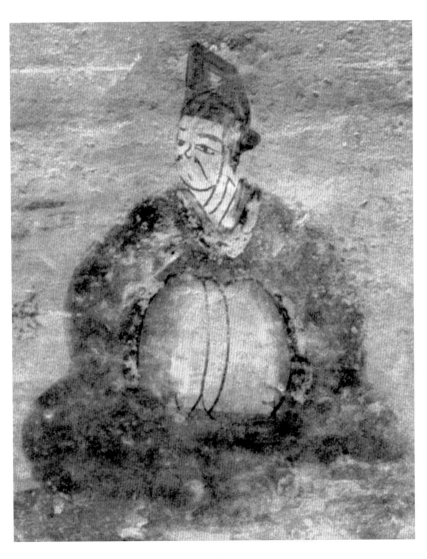

22.人物图（一）

魏晋（220～316年）

高19、宽39厘米

1993年甘肃省酒泉市果园乡高闸沟村魏晋墓出土。现存于酒泉市肃州区博物馆。

墓向东。画面顶部绘出帷帐，帷帐下中央绘墓主人坐于大榻上，头戴二梁进贤冠，身着交领皂袍服，双手拱起，正面而坐，侧头倾听，颇具威仪。墓主左侧立仆人，右侧跪着双手持笏的奏事者，均面向墓主人。

（撰文：郭永利 摄影：肃州区博物馆）

Figures (Portrait of Tomb Dccupant with Attendants) (1)

Three-Kingdoms to Jin (220-316 CE)

Height 19 cm; Width 39 cm

Unearthed from tomb of Three-Kingdoms to the Jin Dynasty at Gaozhagoucun of Guoyuanxiang in Jiuquan, Gansu, in 1993. Preserved in Museum of Suzhou District in Jiuquan.

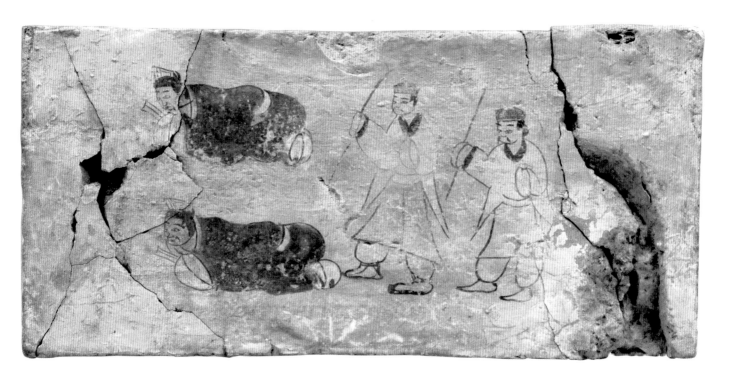

23. 人物图（二）

魏晋（220～316年）

高19、宽39厘米

1993年甘肃省酒泉市果园乡高闸沟村魏晋墓出土。现存于酒泉市肃州区博物馆。

墓向东。画面顶部绘出帷帐，帷帐下画面左侧绘两位着进贤冠的人物匍匐在地，手持笏。其身后站立着剪襟衣的男子，头戴赤帻，右手举棍状物。

（撰文：郭永利　摄影：肃州区博物馆）

Figures (Petty Officials and Attendants) (2)

Three-Kingdoms to Jin (220-316 CE)

Height 19 cm; Width 39 cm

Unearthed from tomb of Three-Kingdoms to the Jin Dynasty at Gaozhagoucun of Guoyuanxiang in Jiuquan, Gansu, in 1993. Preserved in Museum of Suzhou District in Jiuquan.

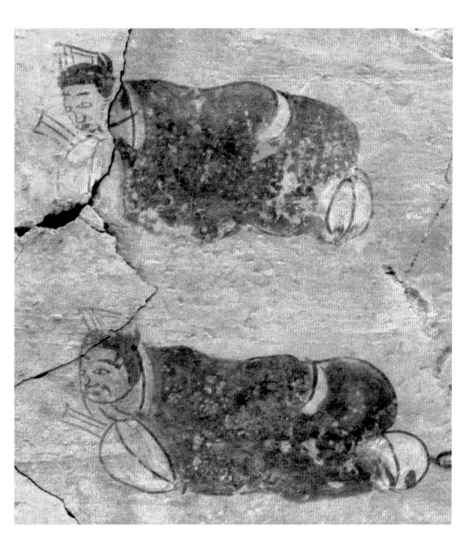

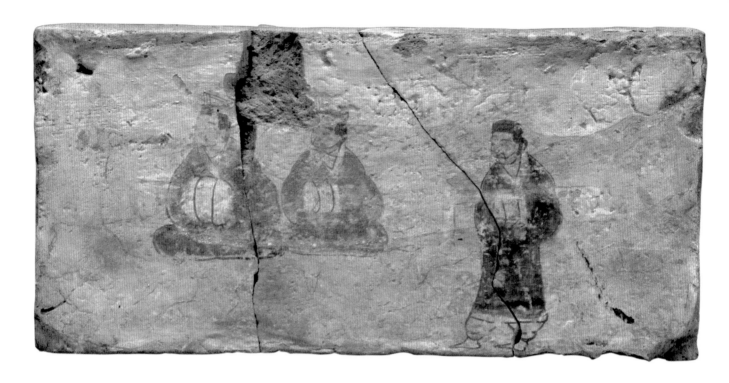

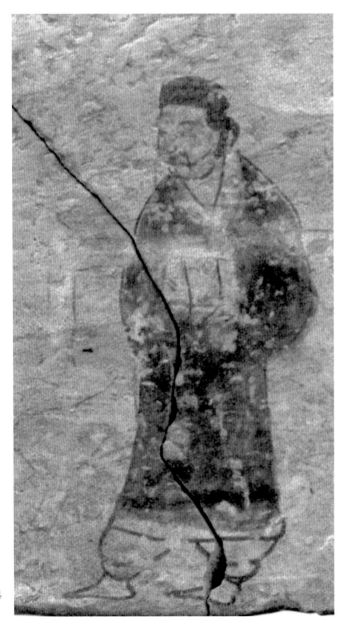

24. 人物图（三）

魏晋（220～316年）

高19、宽39厘米

1993年甘肃省酒泉市果园乡高闸沟村魏晋墓出土。现存于酒泉市肃州区博物馆。

墓向东。画面顶部绘出帷帐，帷帐下绘两位席地而坐的男子，头戴进贤冠，头向右侧。画面右半部分绘一男子怀抱长物而立。

（撰文：郭永利 摄影：肃州区博物馆）

Figures (Petty Officials and Attendants) (3)

Three-Kingdoms to Jin (220-316 CE)

Height 19 cm; Width 39 cm

Unearthed from tomb of Three-Kingdoms to the Jin Dynasty at Gaozhagoucun of Guoyuanxiang in Jiuquan, Gansu, in 1993. Preserved in Museum of Suzhou District in Jiuquan.

25.农耕图

魏晋（220～316年）

高19、宽39厘米

1993年甘肃省酒泉市果园乡高闸沟村魏晋墓出土。现存于酒泉市肃州区博物馆。

墓向东。画面中一农夫在赶牛耙地。

（撰文：郭永利　摄影：肃州区博物馆）

Harrowing Field

Three-Kingdoms to Jin (220-316 CE)

Height 19 cm; Width 39 cm

Unearthed from tomb of Three-Kingdoms to the Jin Dynasty at Gaozhagoucun of Guoyuanxiang in Jiuquan, Gansu, in 1993. Preserved in Museum of Suzhou District in Jiuquan.

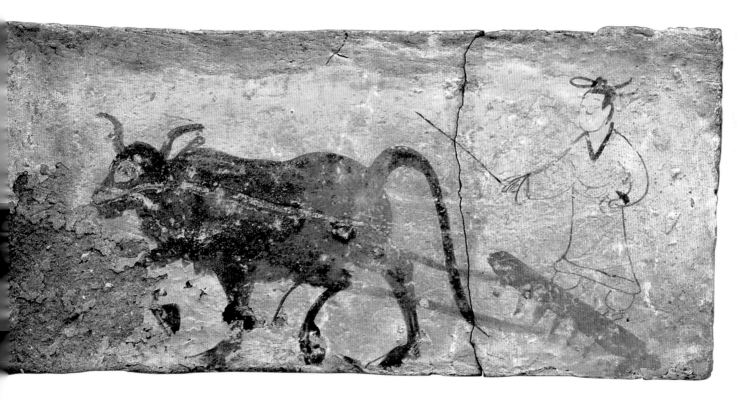

26. 放牧图

魏晋（220～316年）

高19、宽39厘米

1993年甘肃省酒泉市果园乡高闸沟村魏晋墓出土。现存于酒泉市肃州区博物馆。

墓向东。画面右侧绘一放牧者身披大衣，下着裤，足着长靴，赶着一群羊。放牧者服饰与汉族不同，应是居于河西地区的少数民族。

（撰文：郭永利　摄影：肃州区博物馆）

Herding

Three-Kingdoms to Jin (220-316 CE)

Height 19 cm; Width 39 cm

Unearthed from tomb of Three-Kingdoms to the Jin Dynasty at Gaozhagoucun of Guoyuanxiang in Jiuquan, Gansu, in 1993. Preserved in Museum of Suzhou District in Jiuquan.

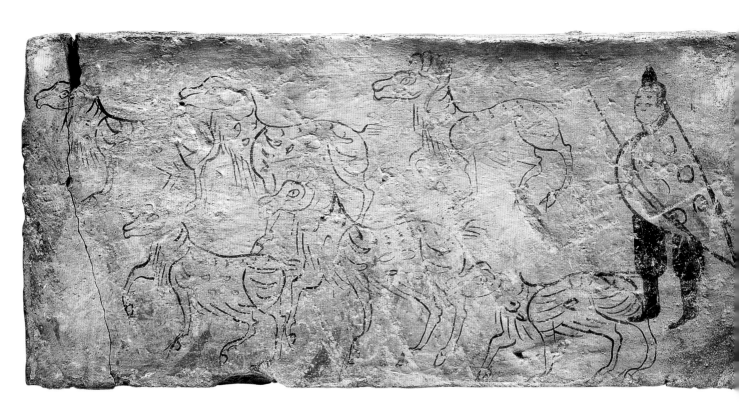

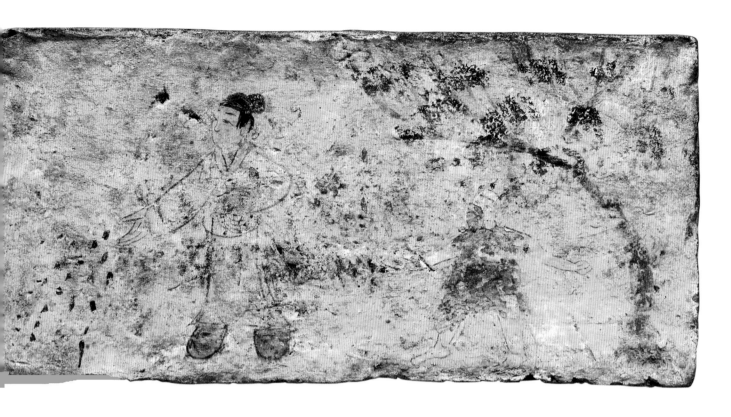

27.播种图

魏晋（220~316年）

高19、宽39厘米

1993年甘肃省酒泉市果园乡高闸沟村魏晋墓
出土。现存于酒泉市肃州区博物馆。

墓向东。画面绘母子二人在田地里撒种。
母亲着交领短衣，下着裤，手持钵在撒种
子；孩子短衣赤足，双臂伸展，紧随其
后，身后有一棵繁茂的大树。

（撰文：郭永利　摄影：肃州区博物馆）

Sowing

Three-Kingdoms to Jin (220-316 CE)

Height 19 cm; Width 39 cm

Unearthed from tomb of Three-Kingdoms
to the Jin Dynasty at Gaozhagoucun of
Guoyuanxiang in Jiuquan, Gansu, in 1993.
Preserved in Museum of Suzhou District in
Jiuquan.

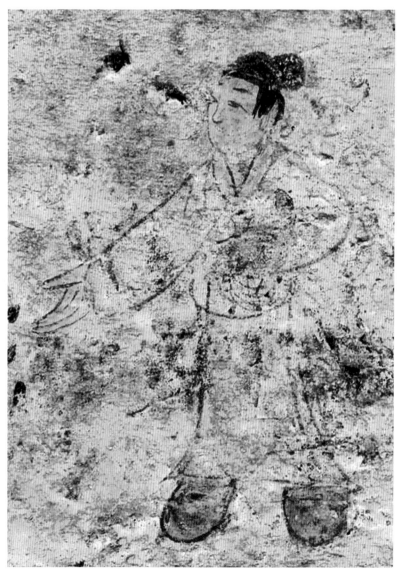

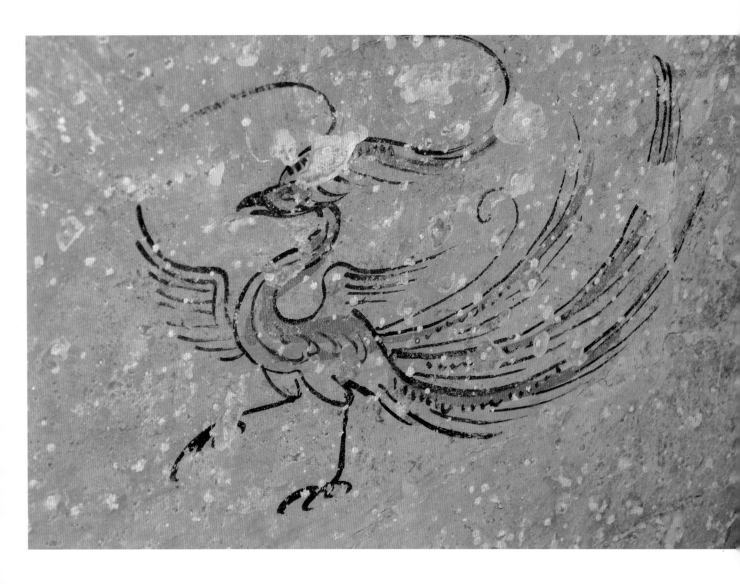

28. 朱雀图

魏晋（220～316年）

2007年甘肃省高台县罗城乡河西村地埂坡墓地1号墓出土。原址保存。

墓向71°。位于墓葬后室顶部南坡。此墓为双室土洞墓，墓壁经修整平滑坚硬后进行绘画。画面中朱雀居于南坡，代表南方。朱雀振翼站立，昂首，细足，一足抬起，大尾后扬。以墨线绘出轮廓后，再以红彩平涂，画面鲜丽活泼。

（撰文：郭永利　摄影：吴荭）

Scarlet Bird

Three-Kingdoms to Jin (220-316 CE)

Unearthed from Tomb M1 of Digengpo Cemetery at Hexicun of Luochengxiang in Gaotai, Gansu, in 2007. Preserved on the original site.

29.乐舞图

魏晋（220～316年）

2007年甘肃省高台县罗城乡河西村地埂坡墓地4号墓出土。原址保存。

墓向西。位于墓葬前室东壁、墓门上部。此墓为双室土洞墓，墓壁经修整平滑坚硬后进行绘画。以白垩为底，以土红色起稿，再以墨线绘出轮廓后平涂色彩。画面分左右两部分。左部分绘一前一后二男子，前者为髡发，着黑色短衣，下着裤，赤足，身背圆鼓；后者髡发，头顶有红色装饰，着红色短衣，下着裤，赤足，手持鼓槌击鼓。右部分绘二男子相对而舞，均为髡发，衣饰与击鼓者相同。此为宴乐内容。图中人物的衣饰特点与汉族不同，是居于河西的少数民族。

（撰文：郭永利　摄影：吴荭）

Music and Dancing Performance

Three Kingdoms to Jin (220-316 CE)

Unearthed from Tomb M4 of Digengpo Cemetery at Hexicun of Luochengxiang in Gaotai, Gansu, in 2007. Preserved on the original site.

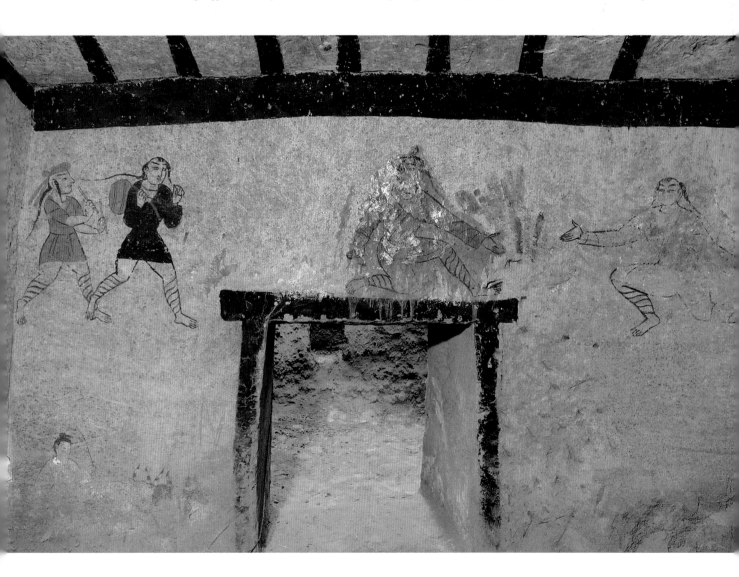

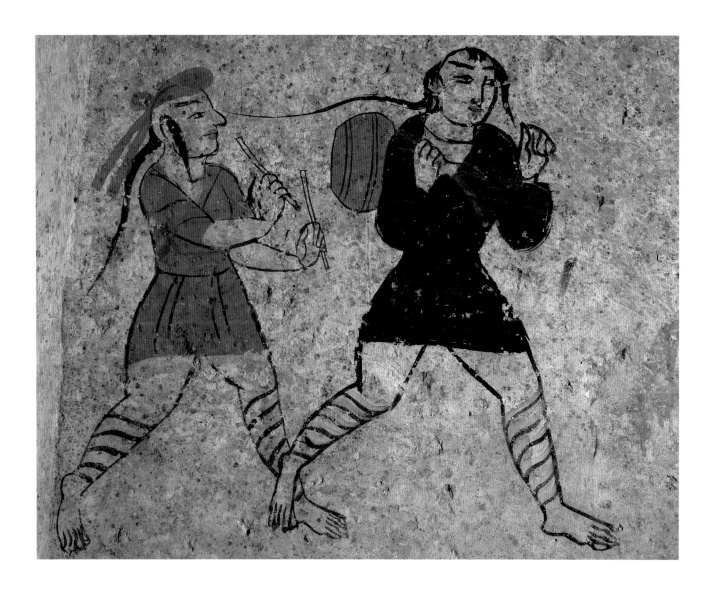

30. 乐舞图（局部一）

魏晋（220～316年）

2007年甘肃省高台县罗城乡河西村地埂坡墓地4号墓出土。原址保存。

墓向西。位于墓葬前室东壁。此墓为双室土洞墓，墓壁经修整平滑坚硬后进行绘画。以白垩为底，以土红色起稿，再以墨线绘出轮廓后平涂色彩。此为乐舞图局部图像中表演击鼓的二人。

（撰文：郭永利 摄影：吴荭）

Music and Dancing Performance (Detail 1)

Three-Kingdoms to Jin (220-316 CE)

Unearthed from Tomb M4 of Digengpo Cemetery at Hexicun of Luochengxiang in Gaotai, Gansu, in 2007. Preserved on the original site.

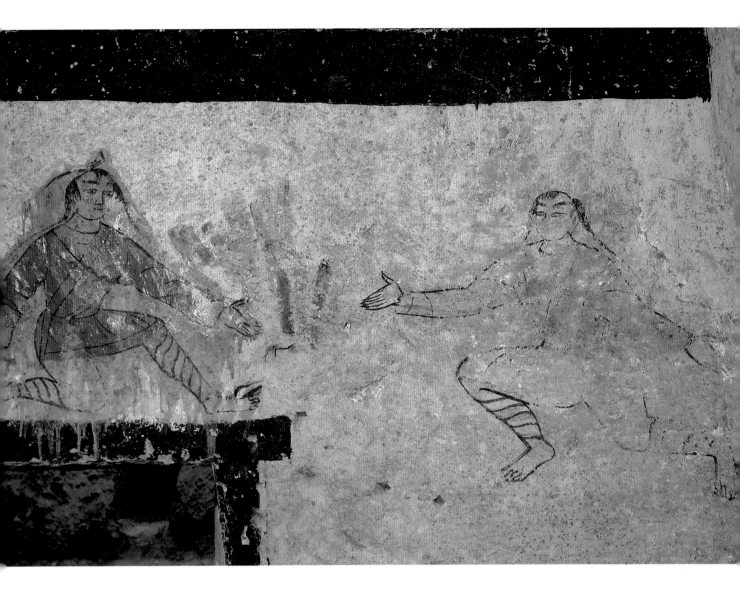

31. 乐舞图（局部二）

魏晋（220～316年）

2007年甘肃省高台县罗城乡河西村地埂坡墓地4号墓出土。原址保存。

墓向西。位于墓葬前室东壁。此墓为双室土洞墓，墓壁经修整平滑坚硬后进行绘画。以白垩为底，以土红色起稿，再以墨线绘出轮廓后平涂色彩。此为乐舞图局部图像中的两位舞者。

（撰文：郭永利 摄影：吴荭）

Music and Dancing Performance (Detail 2)

Three-Kingdoms to Jin (220-316 CE)

Unearthed from Tomb M4 of Digengpo Cemetery at Hexicun of Luochengxiang in Gaotai, Gansu, in 2007. Preserved on the original site.

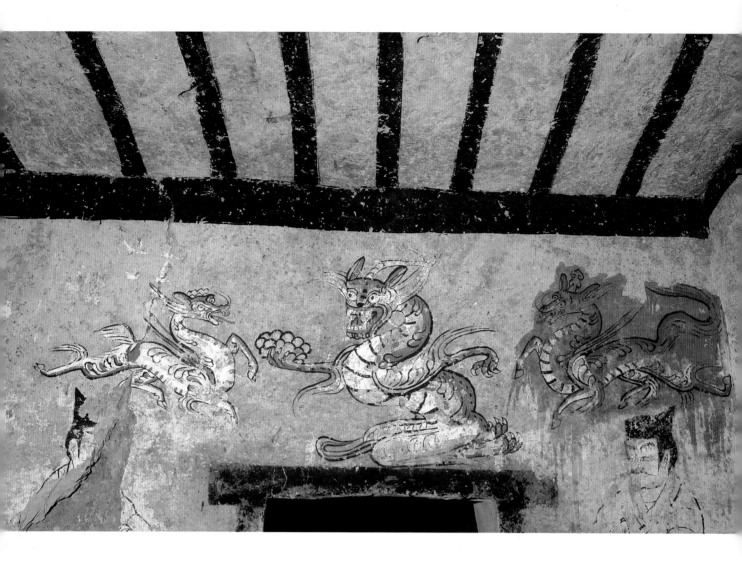

32.神兽图

魏晋（220～316年）

2007年甘肃省高台县罗城乡河西村地埂坡墓地4号墓出土。原址保存。

墓向西。位于墓葬前室西壁通向后室的甬道口上部。此墓为双室土洞墓，墓壁经修整平滑坚硬后进行绘画。以白垩为底，以土红色线条起稿，再以墨线绘出轮廓后平涂色彩。绘三只神兽。中间为受福，半立姿，头顶有一角，前足捧物，肩有双翼。右侧神兽，头顶有一角，蹄足，肩有双翼，长尾。左侧为麒麟，头顶有一角，蹄足，短尾，肩有双翼。

（撰文：郭永利　摄影：吴荭）

Mythical Animals

Three-Kingdoms to Jin (220-316 CE)

Unearthed from Tomb M4 of Digengpo Cemetery at Hexicun of Luochengxiang in Gaotai, Gansu, in 2007. Preserved on the original site.

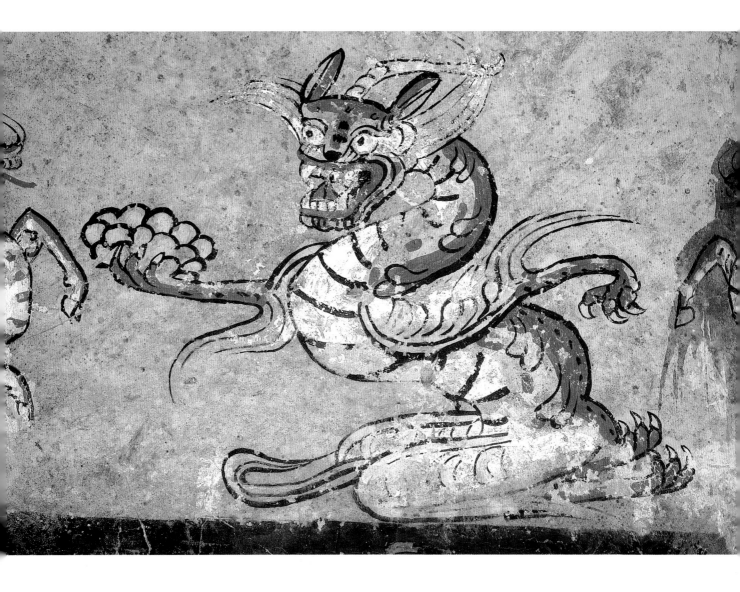

33.神兽图（局部一）

魏晋（220～316年）

2007年甘肃省高台县罗城乡河西村地埂坡墓地4号墓出土。原址保存。

墓向西向。位于墓葬前室西壁通向后室的甬道口上部。此墓为双室土洞墓，墓壁经修整平滑坚硬后进行绘画。以白垩为底，以土红色线条起稿，再以墨线绘出轮廓后平涂色彩。此为神兽图中的受福图。

（撰文：郭永利 摄影：吴荭）

Mythical Animals (Detail 1)

Three-Kingdoms to Jin (220-316 CE)

Unearthed from Tomb M4 of Digengpo Cemetery at Hexicun of Luochengxiang in Gaotai, Gansu, in 2007. Preserved on the original site.

34. 神兽图（局部二）

魏晋（220～316年）

2007年甘肃省高台县罗城乡河西村地埂坡墓地4号墓出土。原址保存。

墓向西。位于墓葬前室西壁通向后室的甬道口上部。此墓为双室土洞墓，墓壁经修整平滑坚硬后进行绘画。以白垩为底，以土红色线条起稿，再以墨线绘出轮廓后平涂色彩。此为神兽图中的麒麟图。

（撰文：郭永利 摄影：吴荭）

Mythical Animals (Detail 2)

Three-Kingdoms to Jin (220-316 CE)

Unearthed from Tomb M4 of Digengpo Cemetery at Hexicun of Luochengxiang in Gaotai, Gansu, in 2007. Preserved on the original site.

35. 宴饮图

魏晋（220～316年）

2007年甘肃省高台县罗城乡河西村地埂坡墓地4号墓出土。原址保存。

墓向西。位于墓葬前室北壁。此墓为双室土洞墓，墓壁经修整平滑坚硬后进行绘画。以白垩为底，以土红色线条起稿，再以墨线绘出轮廓后平涂色彩。画面可以分为左右两部分。左部分绘二男子相对而坐，似在博弈，二人均头戴尖顶帽，着圆领衣，直鼻大眼，胡须浓重，应为居于河西的少数民族。右部分二男子相对而坐，头戴双歧帽，上着交领袍服，中间置酒具，是宴饮场景，从其衣饰看，是汉族。

（撰文：郭永利 摄影：吴荭）

Feasting

Three-Kingdoms to Jin (220-316 CE)

Unearthed from Tomb M4 of Digengpo Cemetery at Hexicun of Luochengxiang in Gaotai, Gansu, in 2007. Preserved on the original site.

36.宴饮图（局部一）

魏晋（220～316年）

2007年甘肃省高台县罗城乡河西村地埂坡墓地4号墓出土。原址保存。

墓向西。位于墓葬前室北壁。此墓为双室土洞墓，墓壁经修整平滑坚硬后进行绘画。以白垩为底，以土红色线条起稿，再以墨线绘出轮廓后平涂色彩。此为宴饮图中的两位少数民族男子，似在博弈。

（撰文：郭永利 摄影：吴荘）

Feasting (Detail 1)

Three-Kingdoms to Jin (220-316 CE)

Unearthed from Tomb M4 of Digengpo Cemetery at Hexicun of Luochengxiang in Gaotai, Gansu, in 2007. Preserved on the original site.

37.宴饮图（局部二）

魏晋（220～316年）

2007年甘肃省高台县罗城乡河西村地埂坡墓地4号墓出土。原址保存。

墓向西。位于墓葬前室北壁。此墓为双室土洞墓，墓壁经修整平滑坚硬后进行绘画。以白垩为底，以土红色线条起稿，再以墨线绘出轮廓后平涂色彩。此为宴饮图中的两位汉族男子，在饮酒。

<div style="text-align: right">（撰文：郭永利 摄影：吴荭）</div>

Feasting (Detail 2)

Three-Kingdoms to Jin (220-316 CE)

Unearthed from Tomb M4 of Digengpo Cemetery at Hexicun of Luochengxiang in Gaotai, Gansu, in 2007. Preserved on the original site.

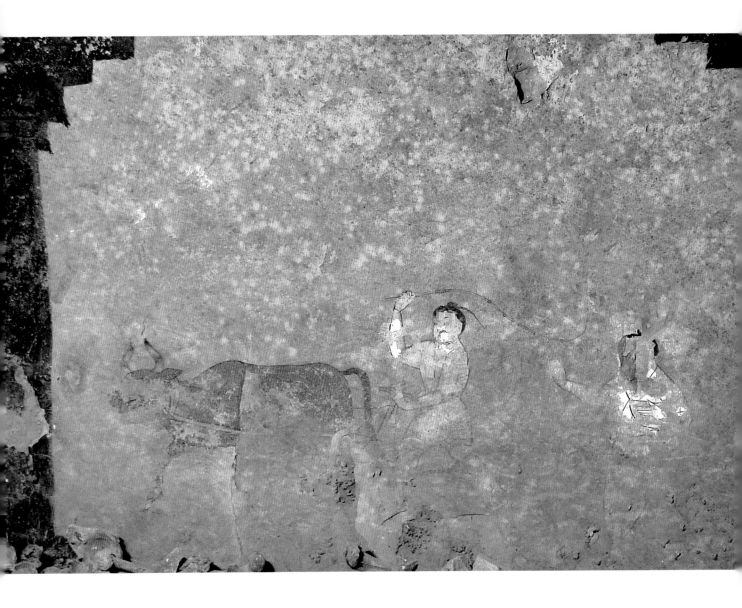

38.牛耕图

魏晋（220～316年）

2007年甘肃省高台县罗城乡河西村地埂坡墓地4号墓出土。原址保存。

墓向西。位于墓葬前室南壁。此墓为双室土洞墓，墓壁经修整平滑坚硬后进行绘画。以白垩为底，以土红色线条起稿，再以墨线绘出轮廓后平涂色彩。画面绘牛耕内容。一男子束发赤足，扶犁扬鞭，在耕地，后面跟随一男子在捧钵撒种。

<div align="right">（撰文：郭永利　摄影：吴荭）</div>

Plowing with Ox

Three-Kingdoms to Jin (220-316 CE)

Unearthed from Tomb M4 of Digengpo Cemetery at Hexicun of Luochengxiang in Gaotai, Gansu, in 2007. Preserved on the original site.

39.伏羲图

魏晋（220～316年）

高19.5、宽39厘米

1994年甘肃省高台县骆驼城壁画墓出土。现存于高台县博物馆。

墓向北。位于墓葬前室。在砖面上涂一层白垩，再于其上绘画。画面中的伏羲人首蛇身，兽足，头有三尖冠，着交领红衣，右手持日轮，日轮内有飞乌，左手持矩，身边绘云气。

（撰文：郭永利 摄影：高台县博物馆）

Fuxi

Three-Kingdoms to Jin (220-316 CE)

Height 19.5 cm; Width 39 cm

Unearthed from mural tomb at Luotuocheng in Gaotai, Gansu, in 1994. Preserved in Gaotai Museum.

40.女娲图

魏晋（220～316年）

高19.5、宽39厘米

1994年甘肃省高台县骆驼城壁画墓出土。现存于高台县博物馆。

墓向北。位于墓葬前室。在砖面上涂一层白垩，再于其上绘画。画面中的女娲人首蛇身，兽足，头梳高髻，着交领红衣，右手持月轮，月轮内有蟾蜍，左手持规，身边绘云气。

（撰文：郭永利　摄影：高台县博物馆）

Nüwa

Three-Kingdoms to Jin (220-316 CE)

Height 19.5 cm; Width 39 cm

Unearthed from mural tomb at Luotuocheng in Gaotai, Gansu, in 1994. Preserved in Gaotai Museum.

41. 东王公图

魏晋（220～316年）

高19.5、宽39厘米

1994年甘肃省高台县骆驼城壁画墓出土。现存于高台县博物馆。

墓向北。位于墓葬前室。在砖面上涂一层白垩，在再其上绘画。画面中的东王公身着交领红色袍服，席地拱手而坐，侧面。头有三尖冠，肩有双翼。身后有一棵树，前绘一朵云气。

（撰文：郭永利 摄影：高台县博物馆）

Dongwanggong (King Father of the East)

Three-Kingdoms to Jin (220-316 CE)

Height 19.5 cm; Width 39 cm

Unearthed from mural tomb at Luotuocheng in Gaotai, Gansu, in 1994. Preserved in Gaotai Museum.

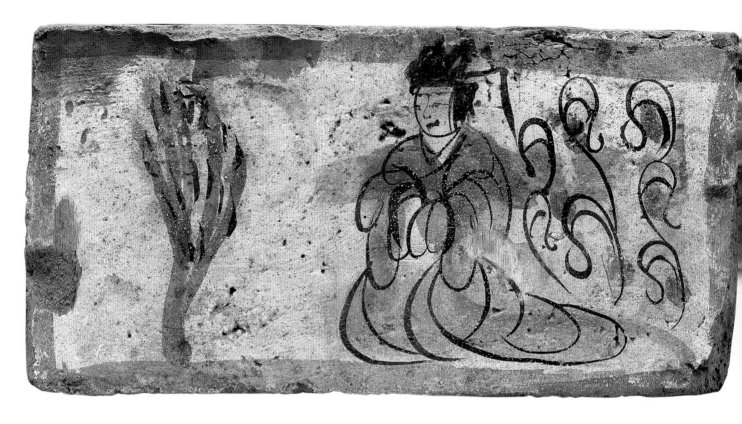

42. 西王母图

魏晋（220～316年）

高19.5、宽39厘米

1994年甘肃省高台县骆驼城壁画墓出土。现存于高台县博物馆。

墓向北。此图位于墓葬前室。在砖面上涂一层白垩，再于其上绘画。画面中的西王母头梳高髻，身着交领红色袍服，席地拱手而坐，面前绘一棵树，身后绘大朵云气。

<div align="right">（撰文：郭永利　摄影：高台县博物馆）</div>

Xiwangmu (Queen Mother of the West)

Three-Kingdoms to Jin (220-316 CE)

Height 19.5 cm; Width 39 cm

Unearthed from mural tomb at Luotuocheng in Gaotai, Gansu, in 1994. Preserved in Gaotai Museum.

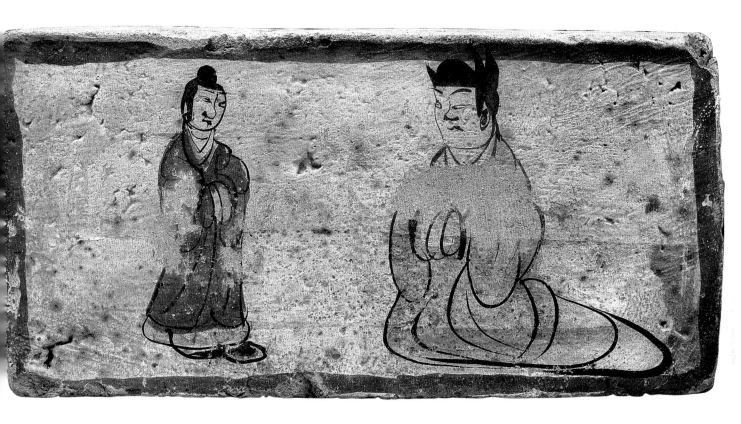

43. 人物图

魏晋（220～316年）

高19.5、宽39厘米

1994年甘肃省高台县骆驼城壁画墓出土。现存于高台县博物馆。

墓向北。位于墓葬前室。在砖面上涂一层白垩，再于其上绘画。画面中的人物一坐一立，坐着的为墓主人，头戴介帻，侧身席地拱手而坐，身形高大。立着的为仆人，身形较小，面向墓主人似在倾听。

<div align="right">（撰文：郭永利 摄影：高台县博物馆）</div>

Figures

Three-Kingdoms to Jin (220-316 CE)

Height 19.5 cm; Width 39 cm

Unearthed from mural tomb at Luotuocheng in Gaotai, Gansu, in 1994. Preserved in Gaotai Museum.

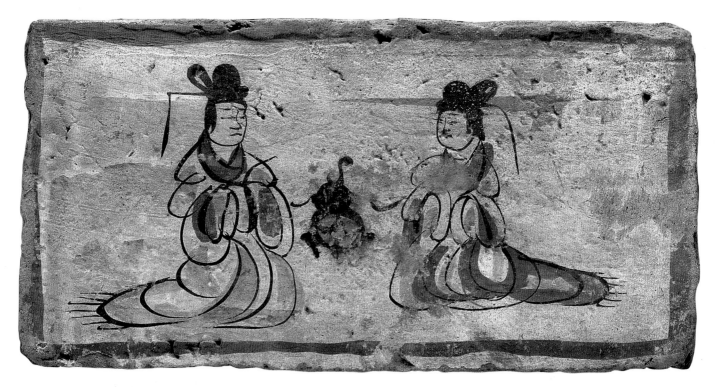

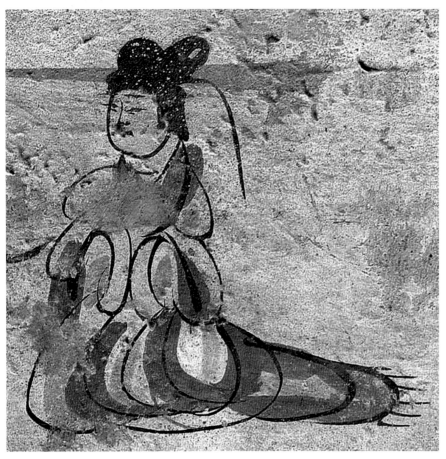

44. 宴饮图

魏晋（220～316年）

高19.5、宽39厘米

1994年甘肃省高台县骆驼城壁画墓出土。现存于高台县博物馆。

墓向北。位于墓葬前室。在砖面上涂一层白垩，再于其上绘画。画面中二女子头梳高髻，着间色裙，拱手相对，席地而坐，中间置一组酒具，为家居宴饮场景。

（撰文：郭永利 摄影：高台县博物馆）

Women Drinking

Three-Kingdoms to Jin (220-316 CE)
Height 19.5 cm; Width 39 cm
Unearthed from mural tomb at Luotuocheng in Gaotai, Gansu, in 1994. Preserved in Gaotai Museum.

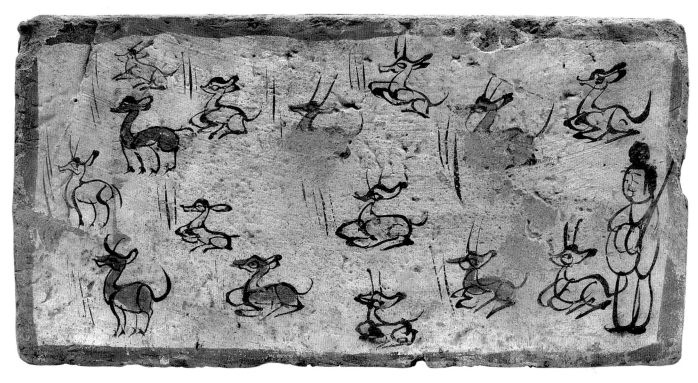

45.牧鹿图

魏晋（220～316年）

高19.5、宽39厘米

1994年甘肃省高台县骆驼城壁画墓出土。现存于高台县博物馆。

墓向北。位于墓葬前室。在砖面上涂一层白垩，再于其上绘画。画面中一群鹿或卧或立，在草丛中悠闲地吃草。右下角立着牧鹿人，手中持棍，束发。

（撰文：郭永利 摄影：高台县博物馆）

Herding Deer

Three-Kingdoms to Jin (220-316 CE)

Height 19.5 cm; Width 39 cm

Unearthed from mural tomb at Luotuocheng in Gaotai, Gansu, in 1994.
Preserved in Gaotai Museum.

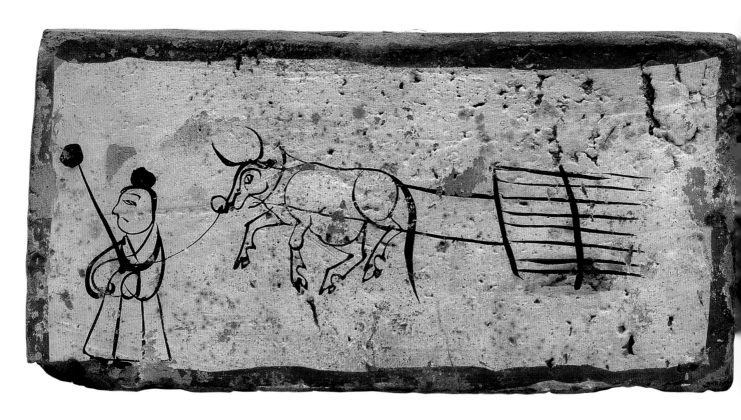

46.耢地图

魏晋（220~316年）

高19.5、宽39厘米

1994年甘肃省高台县骆驼城壁画墓出土。现存于高台县博物馆。

墓向北。位于墓葬前室。在砖面上涂一层白垩，再于其上绘画。画面中一男子束发，着长衣，高鼻深目，手持长杆站立，身后一牛拉着空耢耢地，为"空曳耢"。

（撰文：郭永利 摄影：高台县博物馆）

Leveling Land with Ox

Three-Kingdoms to Jin (220-316 CE)

Height 19.5 cm; Width 39 cm

Unearthed from mural tomb at Luotuocheng in Gaotai, Gansu, in 1994. Preserved in Gaotai Museum.

47.牵马图

魏晋（220～316年）

高19.5、宽39厘米

1994年甘肃省高台县骆驼城壁画墓出土。现存于高台县博物馆。

墓向北。位于墓葬前室。在砖面上涂一层白垩，再于其上绘画。一男子束发短衣，手牵马站立。马形体高大，人物身形较小。在右上角处还有一匹黑马。

（撰文：郭永利 摄影：高台县博物馆）

Horses and Groom

Three-Kingdoms to Jin (220-316 CE)

Height 19.5 cm; Width 39 cm

Unearthed from mural tomb at Luotuocheng in Gaotai, Gansu, in 1994. Preserved in Gaotai Museum.

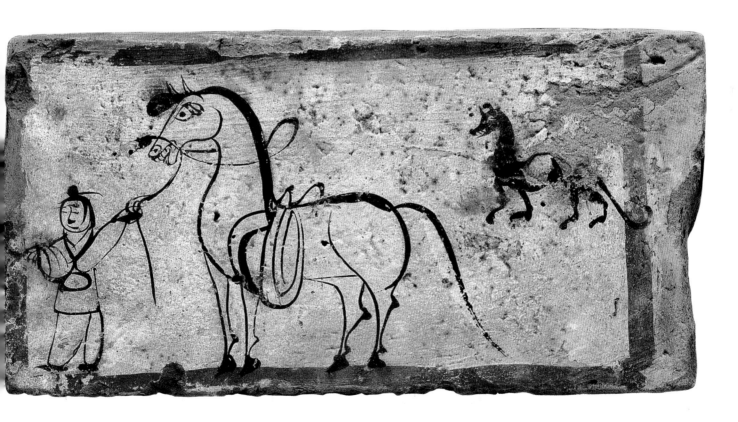

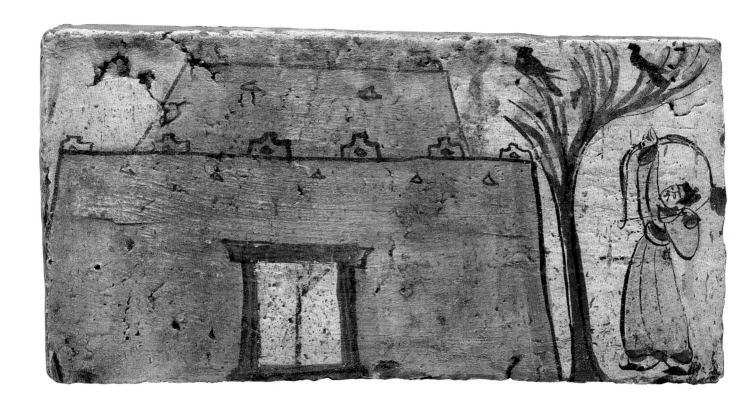

▲48.树下射鸟图

魏晋（220～316年）

高16、宽38厘米

2000年甘肃省高台县骆驼城苦水口1号墓出土。现存于高台县博物馆。

墓向东。位于墓葬前室。在砖面上涂一层白垩，再于其上绘画。画面中绘一座高大的坞，门对开，有高大的望楼。坞外有一棵大树，树上立着两只鸟，一男子于树下张弓射鸟。

（撰文：郭永利 摄影：高台县博物馆）

Shooting Perching Birds in Front of a Castle

Three-Kingdoms to Jin (220-316 CE)

Height 16 cm; Width 38 cm

Unearthed from Tomb M1 at Kushuikou of Luotuocheng in Gaotai, Gansu, in 2000. Preserved in Gaotai Museum.

49.树下射鸟图（局部）▶

魏晋（220～316年）

2000年甘肃省高台县骆驼城苦水口1号墓出土。现存于高台县博物馆。

墓向东。位于墓葬前室。此图为前图的局部。

（撰文：郭永利 摄影：高台县博物馆）

Shooting Perching Birds in Front of a Castle (Detail)

Three-Kingdoms to Jin (220-316 CE)

Unearthed from Tomb M1 at Kushuikou of Luotuocheng in Gaotai, Gansu, in 2000. Preserved in Gaotai Museum.

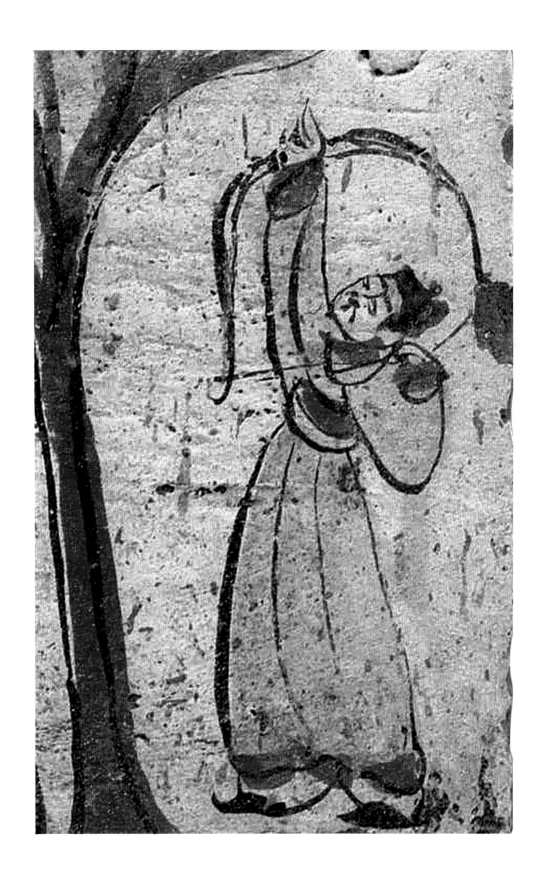

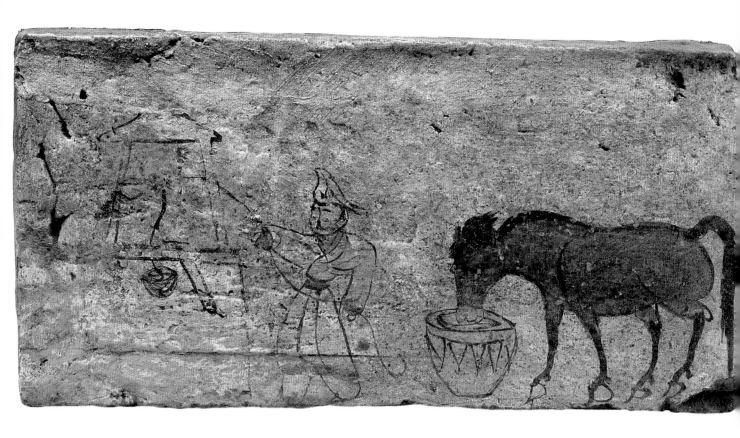

▲50.饮马图

魏晋（220～316年）

高16、宽38厘米

2000年甘肃省高台县骆驼城苦水口1号墓出土。现存于高台县博物馆。

墓向东。位于墓葬前室。在砖面上涂一层白垩，再于其上绘画。左半部分一戴尖顶帽的男子正在井边汲水，身后一匹马低头饮水。

（撰文：郭永利 摄影：高台县博物馆）

Watering Horse

Three-Kingdoms to Jin (220-316 CE)

Height 16 cm; Width 38 cm

Unearthed from Tomb M1 at Kushuikou of Luotuocheng in Gaotai, Gansu, in 2000. Preserved in Gaotai Museum.

51.采桑图 ▶

魏晋（220～316年）

高16、宽38厘米

2000年甘肃省高台县骆驼城苦水口1号墓出土。现存于高台县博物馆。

墓向东。位于墓葬前室。在砖面上涂一层白垩，再于其上绘画。画面中央绘一棵大树，两边各站着一位妇女，身着宽袖斜领衫，下系长裙，二人提着蓝筐，一人用手折枝，一人手持笼钩，正在采桑。

（撰文：郭永利 摄影：高台县博物馆）

Gathering Mulberry Leaves

Three-Kingdoms to Jin (220-316 CE)

Height 16 cm; Width 38 cm

Unearthed from Tomb M1 at Kushuikou of Luotuocheng in Gaotai, Gansu, in 2000. Preserved in Gaotai Museum.

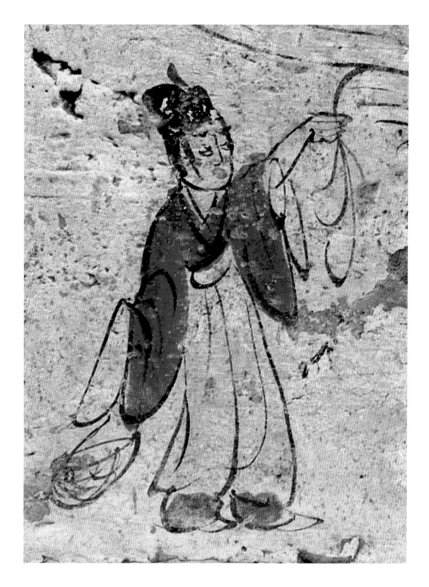

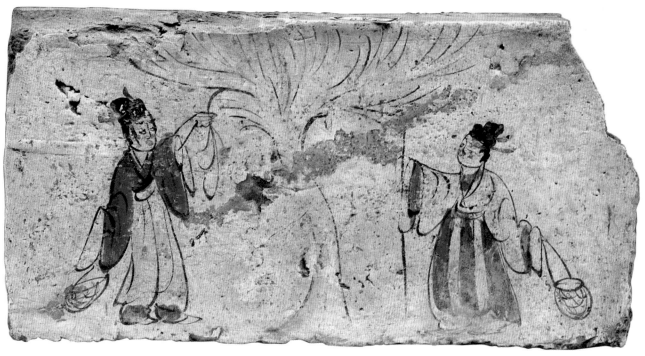

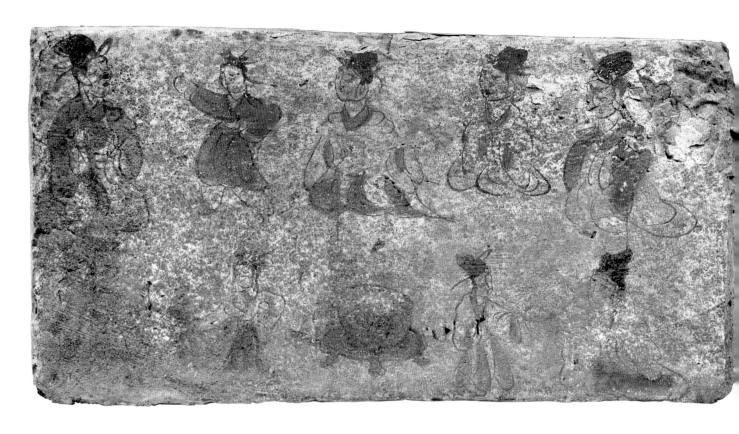

52.宴饮图

魏晋（220～316年）

高16、宽38厘米

2000年甘肃省高台县骆驼城苦水口1号墓出土。现存于高台县博物馆。

墓向东。位于墓葬前室。在砖面上涂一层白垩，再于其上绘画。画面中几位女子环列而坐，中间置酒具，乐伎在跳舞、弹阮咸，仆人立于下方，正在为主人取酒。

<div align="right">（撰文：郭永利 摄影：高台县博物馆）</div>

Feasting

Three-Kingdoms to Jin (220-316 CE)

Height 16 cm; Width 38 cm

Unearthed from Tomb M1 at Kushuikou of Luotuocheng in Gaotai, Gansu, in 2000. Preserved in Gaotai Museum.

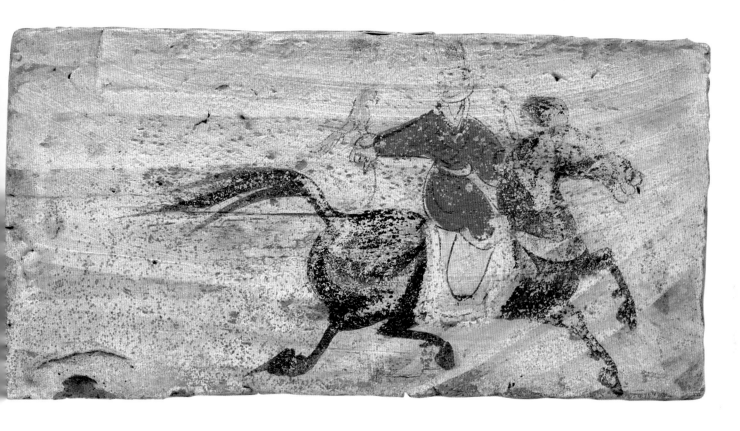

53.驾鹰图

魏晋（220～316年）

高16、宽38厘米

2000年甘肃省高台县骆驼城苦水口1号墓出土。现存于高台县博物馆。

墓向东。位于墓葬前室。在砖面上涂一层白垩，再于其上绘画。一男子头戴帽，身着红色短衣，骑马疾行，臂上驾鹰。是墓主人狩猎出行图中的场景之一。

<div align="right">（撰文：郭永利 摄影：高台县博物馆）</div>

Hunting with Falcon

Three-Kingdoms to Jin (220-316 CE)

Height 16 cm; Width 38 cm

Unearthed from Tomb M1 at Kushuikou of Luotuocheng in Gaotai, Gansu, in 2000. Preserved in Gaotai Museum.

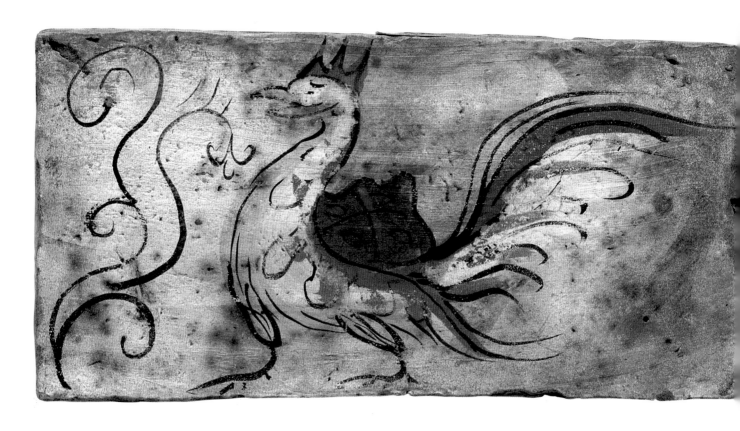

54.凤图

魏晋（220～316年）

高16、宽38厘米

2000年甘肃省高台县骆驼城苦水口1号墓出土。现存于高台县博物馆。

墓向东。位于墓葬中室的上部。在砖面上涂一层白垩，再于其上绘画。一只凤立于中央，前面绘云朵。此种凤鸟图像呈龟背状，具有河西地区的特点，也是识别凤鸟与其他祥瑞鸟的区别性标志。

（撰文：郭永利 摄影：高台县博物馆）

Phoenix

Three-Kingdoms to Jin (220-316 CE)

Height 16 cm; Width 38 cm

Unearthed from Tomb M1 at Kushuikou of Luotuocheng in Gaotai, Gansu, in 2000. Preserved in Gaotai Museum.

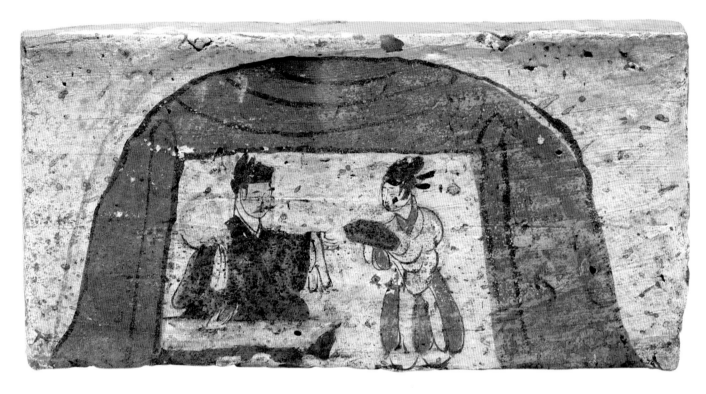

55.进食图

魏晋（220～316年）

高16、宽38厘米

2000年甘肃省高台县骆驼城苦水口1号墓出土。现存于高台县博物馆。

墓向东。位于墓葬中室。在砖面上涂一层白垩，再于其上绘画。画面中的墓主人居于穹庐内，头戴介帻，手持便面，坐于榻上。婢女在一边侍奉，作捧盒状。

（撰文：郭永利 摄影：高台县博物馆）

Serving Food

Three-Kingdoms to Jin (220-316 CE)

Height 16 cm; Width 38 cm

Unearthed from Tomb M1 at Kushuikou of Luotuocheng in Gaotai, Gansu, in 2000. Preserved in Gaotai Museum.

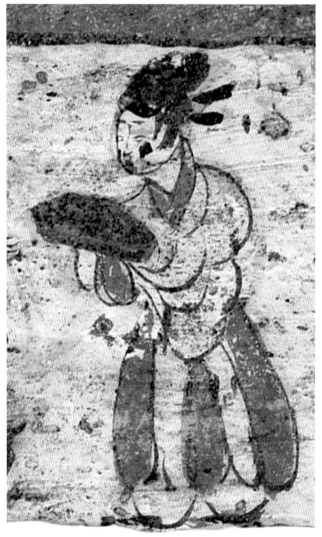

56. 人物图

魏晋（220～316年）

高16、宽38厘米

1999年甘肃省高台县许三湾墓群3号墓出土。现存于高台县博物馆。

墓向东。在砖面上涂一层白垩，再于其上绘画。画面上方绘帷帐，其下有两位妇女席地同向而坐，身边置耳杯，为宴饮的场景。此图以宽线条绘出轮廓，尤其是帷帐的画法别具一格，与河西地区常见的魏晋壁画以细线条为主的造型不同，反映出当时河西地区墓室壁画的多样风格。

（撰文：郭永利 摄影：高台县博物馆）

Women in Banquet

Three-Kingdoms to Jin (220-316 CE)

Height 16 cm; Width 38 cm

Unearthed from Tomb M3 at Cemetery of Xusanwan in Gaotai, Gansu, in 1999. Preserved in Gaotai Museum.

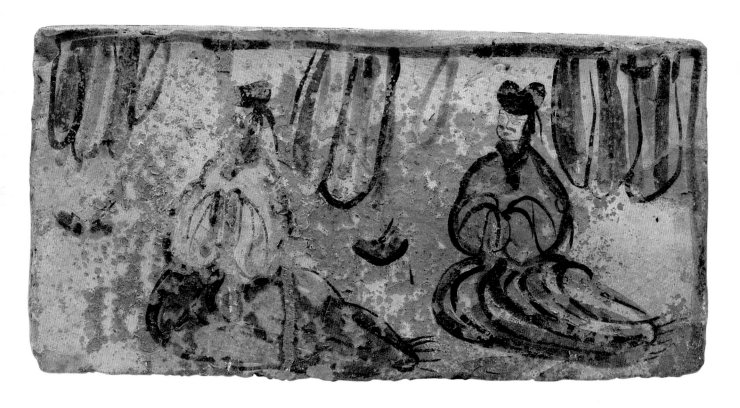

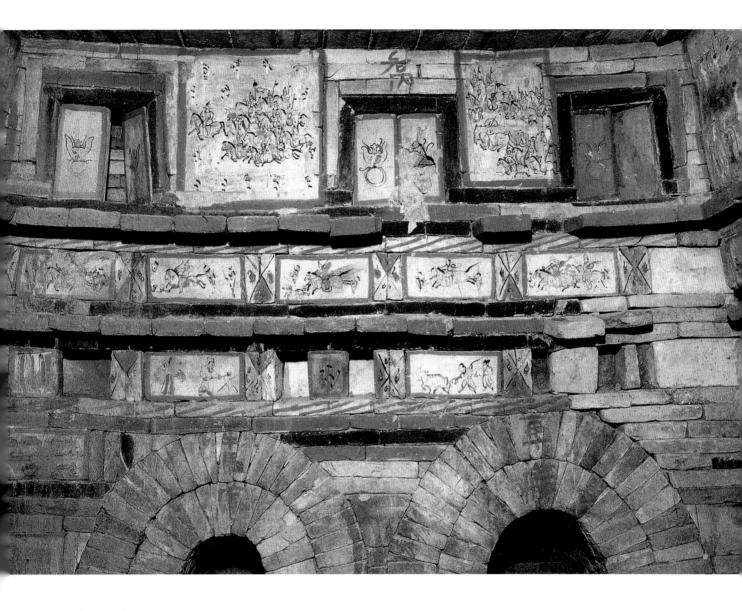

57.出行图

魏晋（220～316年）

高250、宽300厘米

1972年甘肃省嘉峪关市新城3号墓出土。原址保存。

墓向351°。位于墓葬前室东壁上层。在墓壁涂白垩，然后于其上绘画。此墓出行图没有完全采用一砖一画的形式，而是部分运用通幅壁画的形式，显示了早期壁画的特点。此图人物众多，规模宏大，是河西地区这一时期墓葬出行图中最大的。

（撰文：郭永利 摄影：张宝玺）

Procession Scene

Three-Kingdoms to Jin (220-316 CE)

Height 250 cm; Width 300 cm

Unearthed from Tomb M3 at Xincheng in Jiayuguan, Gansu, in 1972. Preserved on the original site.

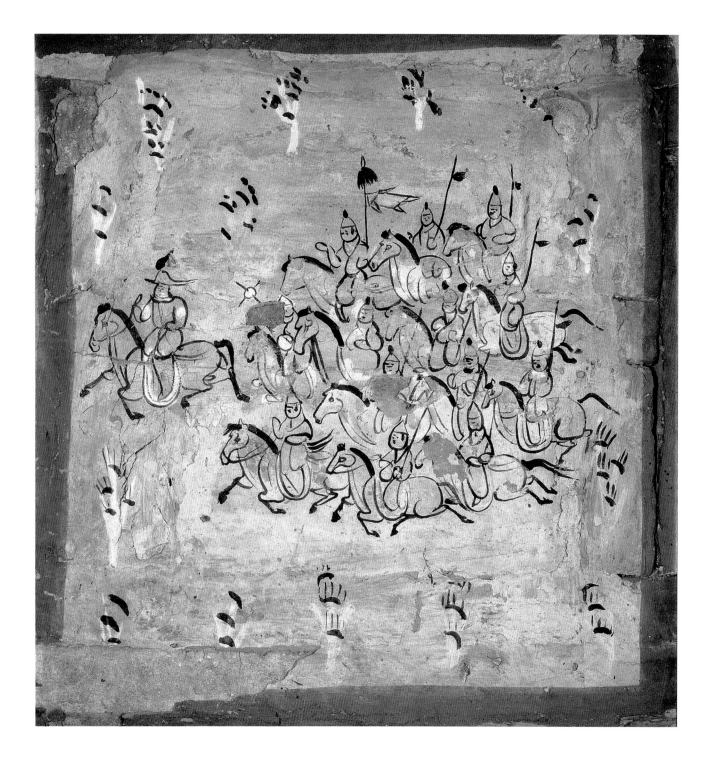

58. 出行图（局部）

魏晋（220～316年）

高58、宽54厘米

1972年甘肃省嘉峪关市新城3号墓出土。原址保存。

墓向351°。位于墓葬前室东壁上层。在墓壁涂白垩，再于其上绘画。这幅出行图采用整壁的通幅壁画形式。出行队伍中段居前的一人似为墓主，后面跟随的从骑者中有持幢、幡和鼓的，其他人物手中持长矛。

（撰文：郭永利 摄影：张宝玺）

Procession Scene (Detail)

Three-Kingdoms to Jin (220-316 CE)

Unearthed from Tomb M3 at Xincheng in Jiayuguan, Gansu, in 1972. Preserved on the original site.

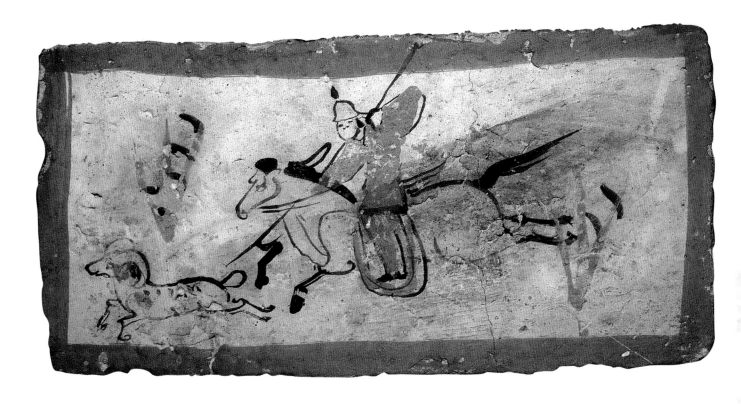

59. 狩猎图

魏晋（220～316年）

高17.5、宽36.5厘米

1972年甘肃省嘉峪关市新城3号墓出土。现存于嘉峪关长城博物馆。

墓向351°。位于前室东壁上部。在砖面上涂白垩，再于其上绘画。画面中一男子着戎装，骑马飞奔，手持长矟刺向猎物。

（撰文：郭永利　摄影：张宝玺）

Hunting Scene

Three-Kingdoms to Jin (220-316 CE)

Height 17.5 cm; Width 36.5 cm

Unearthed from Tomb M3 at Xincheng in Jiayuguan, Gansu, in 1972. Preserved in Jiayuguan Museum of the Great Wall.

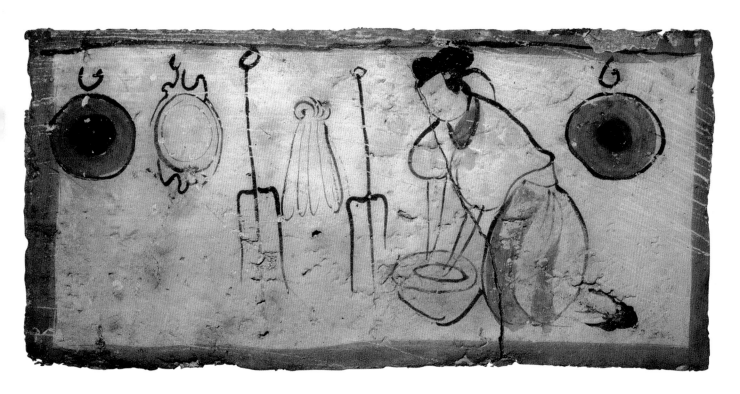

60. 庖厨图

魏晋（220～316年）

高17.5、宽36.5厘米

1972年甘肃省嘉峪关市新城3号墓出土。现存于嘉峪关长城博物馆。

墓向351°。位于前室南壁。在砖面上涂白垩，然后于其上绘画。画面中一女子跪于地上，双手在盆内和面。画面上方，是一排悬着的厨具，有盘、叉等物。

（撰文：郭永利 摄影：张宝玺）

Cooking

Three-Kingdoms to Jin (220-316 CE)

Height 17.5 cm; Width 36.5 cm

Unearthed from Tomb M3 at Xincheng in Jiayuguan, Gansu, in 1972. Preserved in Jiayuguan Museum of the Great Wall.

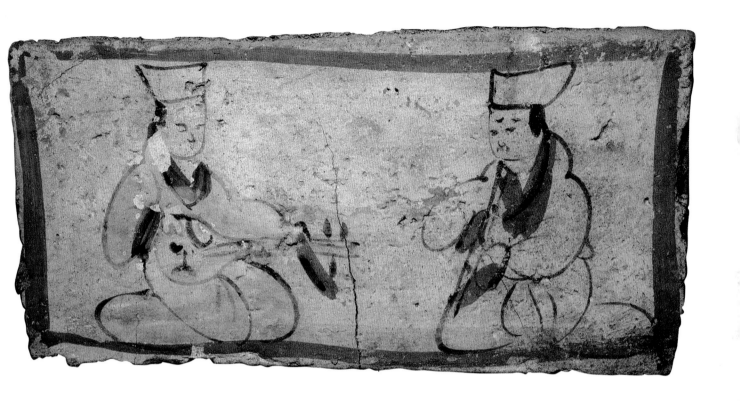

61. 奏乐图

魏晋（220~316年）

高17.5、宽36.5厘米

1972年甘肃省嘉峪关市新城3号墓出土。现存于嘉峪关长城博物馆。

墓向351°。位于前室西壁下部。在砖面上涂白垩，再于其上绘画。画面中二男子戴高帽，相对而坐，一人弹阮咸，一人吹长笛，为宴饮奏乐的内容。

（撰文：郭永利　摄影：张宝玺）

Music Performance

Three-Kingdoms to Jin (220-316 CE)

Height 17.5 cm; Width 36.5 cm

Unearthed from Tomb M3 at Xincheng in Jiayuguan, Gansu, in 1972. Preserved in Jiayuguan Museum of the Great Wall.

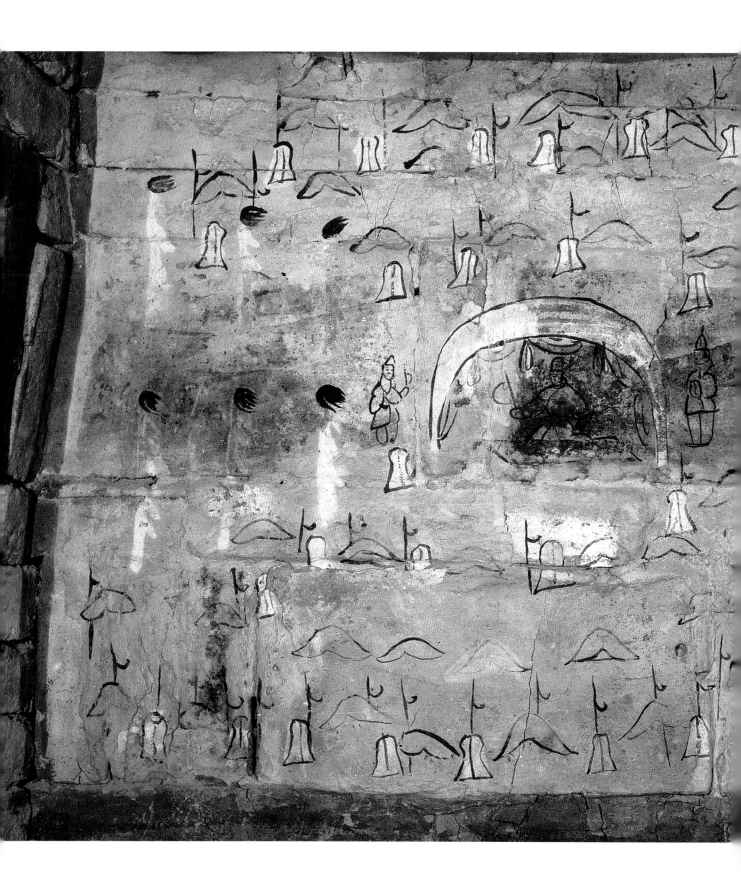

62.屯营图（一）

魏晋（220～316年）

高60、宽90厘米

1972年甘肃省嘉峪关市新城3号墓出土。原址保存。墓向351°。位于前室南壁上层东侧。在墓壁涂白垩，再于其上绘画。画面采用整壁的通幅壁画形式。画面中央为大帐，墓主人手持便面，端坐于帐内的大榻上，帐门外立二侍卒。大帐外是布列森然的小帐。

（撰文：郭永利 摄影：张宝玺）

Military Colony (1)

Three-Kingdoms to Jin (220-316 CE)

Height 60 cm; Width 90 cm

Unearthed from Tomb M3 at Xincheng in Jiayuguan, Gansu, in 1972. Preserved on the original site.

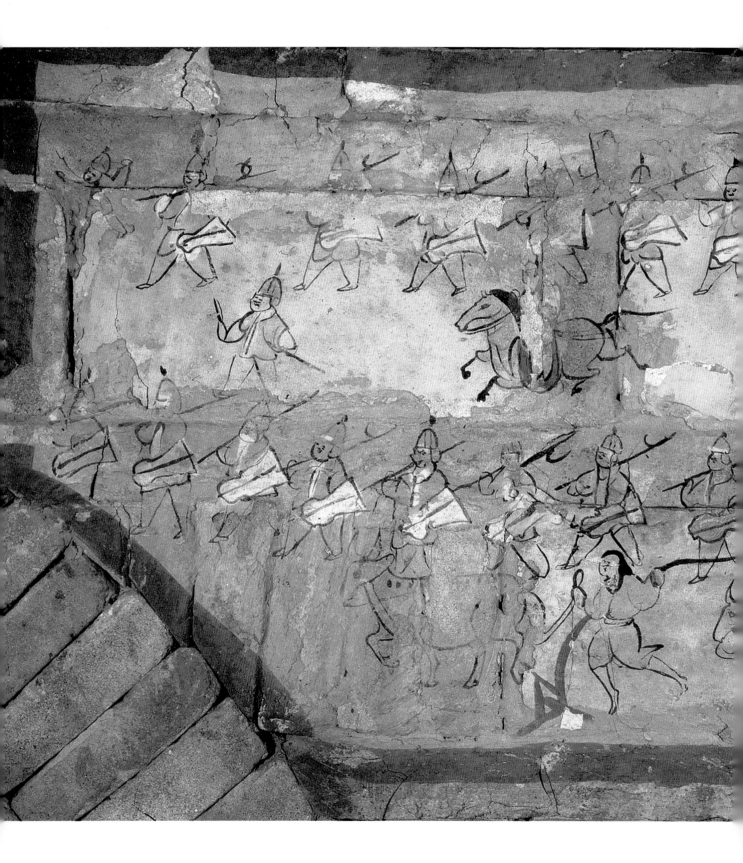

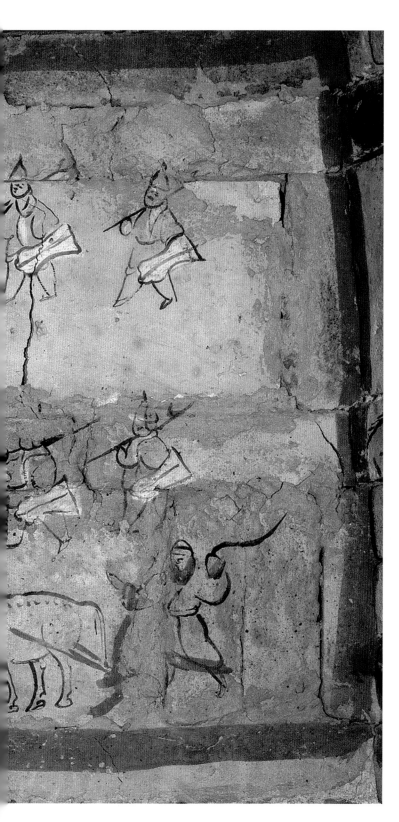

63. 屯营图（二）

魏晋（220～316年）

高60、宽90厘米

1972年甘肃省嘉峪关市新城3号墓出土。原址保存。墓向351°。位于前室南壁上层西侧。在墓壁涂白垩，再于其上绘画。作者运用整壁的通幅壁画形式，表现亦兵亦农的屯营场景。兵卒持盾荷戟列队回营，下方绘牛耕图，描绘了河西地区当时军屯的景象，具有重要的历史价值与艺术价值。

（撰文：郭永利 摄影：张宝玺）

Military Colony (2)

Three-Kingdoms to Jin (220-316 CE)

Height 60 cm; Width 90 cm

Unearthed from Tomb M3 at Xincheng in Jiayuguan, Gansu, in 1999. Preserved on the original site.

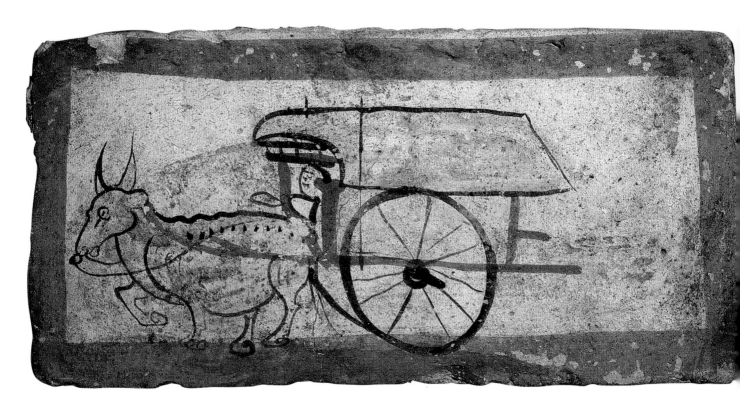

64. 牛车图

魏晋（220～316年）

高17.5、宽36.5厘米

1972年甘肃省嘉峪关市新城3号墓出土。现存于嘉峪关长城博物馆。

墓向351°。位于中室东壁上部。在砖面上涂白垩，然后于其上绘画。画面绘一辆犊车，有驭夫驾车。

<div align="right">（撰文：郭永利　摄影：张宝玺）</div>

Ox Cart

Three-Kingdoms to Jin (220-316 CE)

Height 17.5 cm; Width 36.5 cm

Unearthed from Tomb M3 at Xincheng in Jiayuguan, Gansu, in 1972. Preserved in Jiayuguan Museum of the Great Wall.

65. 狩猎图

魏晋（220～316年）

高17.5、宽36.5厘米

1973年甘肃省嘉峪关市新城5号墓出土。现存于甘肃省博物馆。

墓向353°。位于前室北壁。在砖面上涂白垩，再于其上绘画。猎手头戴尖顶帽，纵马回身，手中拉满弓射向奔逃的兔子。

（撰文、摄影：郭永利）

Hunting Scene

Three-Kingdoms to Jin (220-316 CE)

Height 17.5 cm; Width 36.5 cm

Unearthed from Tomb M5 at Xincheng in Jiayuguan, Gansu, in 1973. Preserved in Gansu Museum.

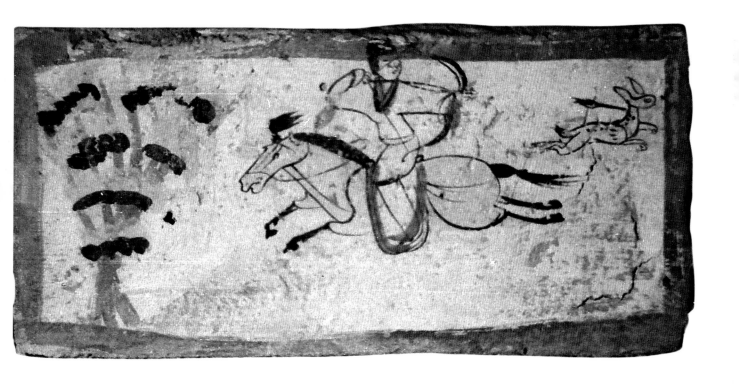

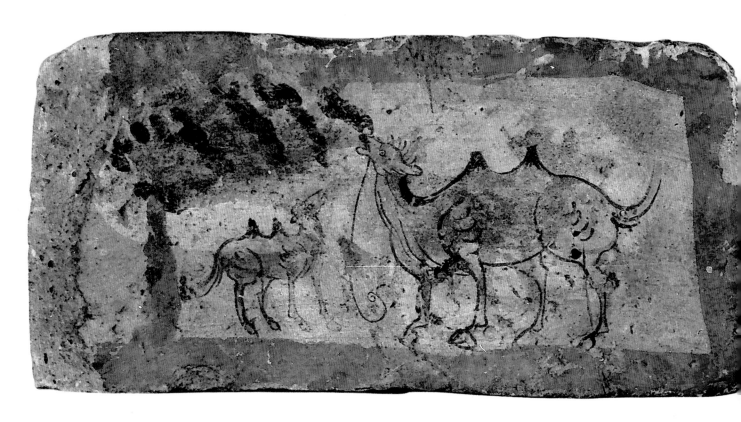

66.骆驼图

魏晋（220～316年）

高17.5、宽36.5厘米

1973年甘肃省嘉峪关市新城5号墓出土。现存于甘肃省博物馆。

墓向353°。位于前室西壁。在砖面上涂白垩后绘画。画面中绘一棵大树，树下一大一小两只骆驼在悠然地吃着树叶，极有生活情趣。

（撰文：郭永利 摄影：张宝玺）

Camels

Three-Kingdoms to Jin (220-316 CE)

Height 17.5 cm; Width 36.5 cm

Unearthed from Tomb M5 at Xincheng in Jiayuguan, Gansu, in 1973. Preserved in Gansu Museum.

67.便面、麈尾图

魏晋（220～316年）

高17.5、宽36.5厘米

1973年甘肃省嘉峪关市新城5号墓出土。现存于甘肃省博物馆。

墓向353°。位于后室后壁。在砖面上涂白垩，再于其上绘画。画面中便面和麈尾均悬于壁上，是男墓主人私用之物。此类图像表明墓葬后室为墓主夫妇的内寝之地。

（撰文、摄影·郭永利）

Silk Fan and Whisk

Three-Kingdoms to Jin (220-316 CE)

Height 17.5 cm; Width 36.5 cm

Unearthed from Tomb M5 at Xincheng in Jiayuguan, Gansu, in 1973. Preserved in Gansu Museum.

68. 采桑图

魏晋（220～316年）

高17.5、宽36.5厘米

1973年甘肃省嘉峪关市新城6号墓出土。原址保存。

墓向341°。位于前室南壁。在砖面上涂白垩，再于其上绘画。画面中央有一棵大树，树下站一女子，短发赤足，提笼筐采桑，画面左侧一儿童立于树下。人物的发饰显示人物为居于河西地区的少数民族。

（撰文：郭永利 摄影：张宝玺）

Gathering Mulberry Leaves

Three-Kingdoms to Jin (220-316 CE)

Height 17.5 cm; Width 36.5 cm

Unearthed from Tomb M6 at Xincheng in Jiayuguan, Gansu, in 1973. Preserved on the original site.

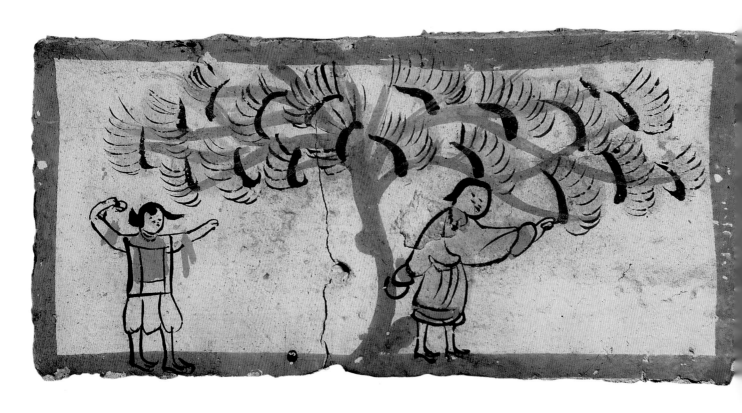

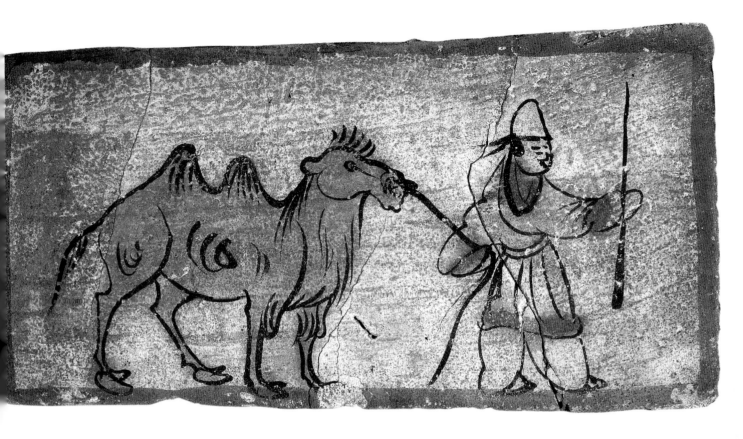

69.牵驼图

魏晋（220～316年）

高17.5、宽36.5厘米

1973年甘肃省嘉峪关市新城6号墓出土。原址保存。

墓向341°。位于前室北壁上层。在砖面上涂白垩，再于其上绘画。一男子头戴桶形帽，着短衣，左手持棒，右手牵驼。

（撰文：郭永利　摄影：张宝玺）

Camel and Groom

Three-Kingdoms to Jin (220-316 CE)

Height 17.5 cm; Width 36.5 cm

Unearthed from Tomb M6 at Xincheng in Jiayuguan, Gansu, in 1973. Preserved on the original site.

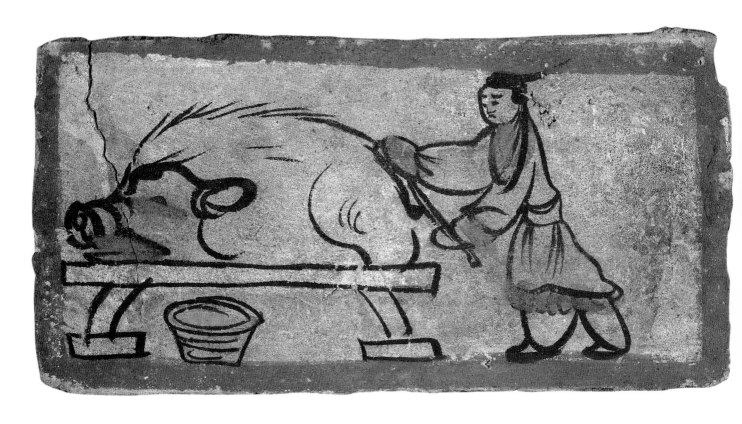

70. 宰猪图

魏晋（220~316年）

高17.5、宽36.5厘米

1973年甘肃省嘉峪关市新城6号墓出土。原址保存。

墓向341°。位于前室东壁。在砖面上涂白垩，再于其上绘画。猪体形硕大，极为肥壮，置于长几待宰，几旁置盆，后有一持刀屠夫。

（撰文：郭永利　摄影：张宝玺）

Butchering a Pig

Three-Kingdoms to Jin (220-316 CE)

Height 17.5 cm; Width 36.5 cm

Unearthed from Tomb M6 at Xincheng in Jiayuguan, Gansu, in 1973. Preserved on the original site.

71.宰羊图

魏晋（220～316年）

高17.5、宽36.5厘米

1973年甘肃省嘉峪关市新城6号墓出土。原址保存。

墓向341°。位于前室东壁。在砖面上涂白垩，再于其上绘画。画面中羊被倒悬于架上，一男子立于架旁。

（撰文：郭永利 摄影：张宝玺）

Butchering a Goat

Three-Kingdoms to Jin (220-316 CE)

Height 17.5 cm; Width 36.5 cm

Unearthed from Tomb M6 at Xincheng in Jiayuguan, Gansu, in 1973. Preserved on the original site.

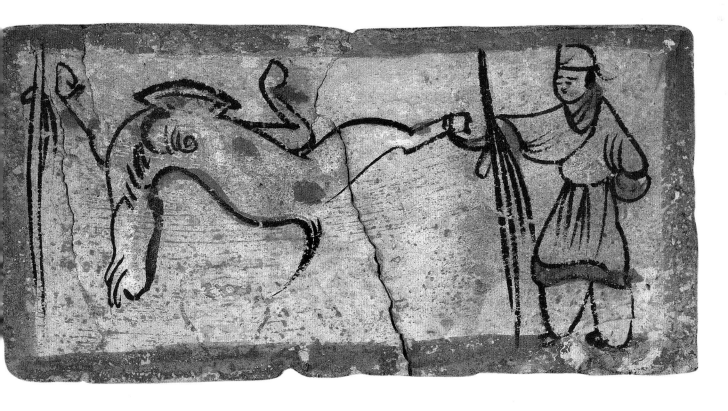

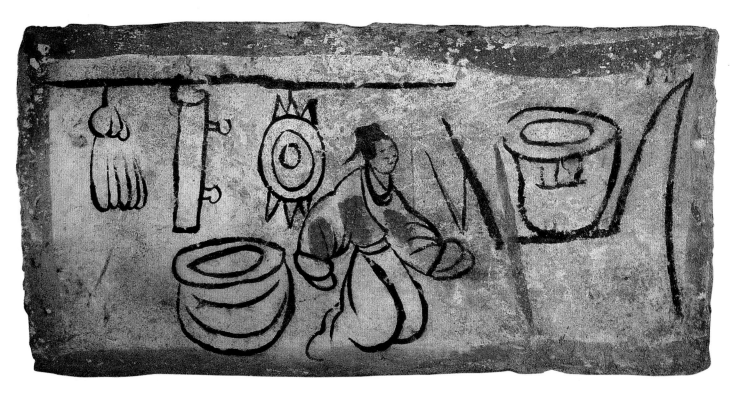

72. 庖厨图

魏晋（220～316年）

高17.5、宽36.5厘米

1973年甘肃省嘉峪关市新城6号墓出土。原址保存。

墓向341°。位于前室东壁。在砖面上涂白垩，再于其上绘画。画面中一位女子在灶前烧火做饭，身后置一大盆，左上方为悬着的厨具，有盘、长几等物。

<div align="right">（撰文：郭永利　摄影：张宝玺）</div>

Cooking Scene

Three-Kingdoms to Jin (220-316 CE)

Height 17.5 cm; Width 36.5 cm

Unearthed from Tomb M6 at Xincheng in Jiayuauan, Gansu, in 1973. Preserved on the original site.

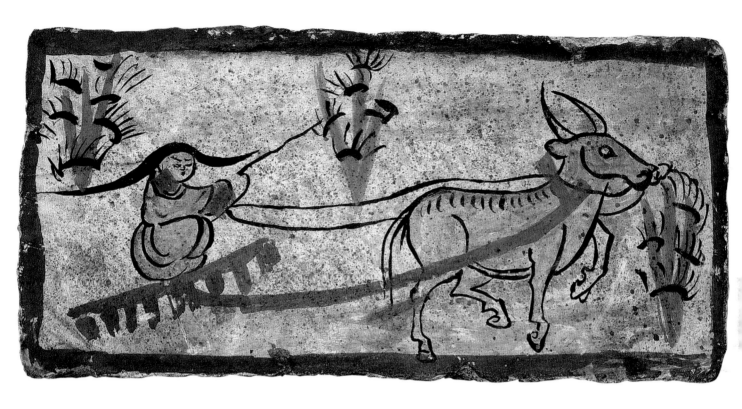

73. 耙地图

魏晋（220～316年）

高17.5、宽36.5厘米

1973年甘肃省嘉峪关市新城6号墓出土。原址保存。

墓向341°。位于前室西壁。在砖面上涂白垩，再于其上绘画。画面中一男子披发，蹲于耙上，双手牵着缰绳，驾一牛在耙地。周围绘有三棵粗壮的树。人物披发，与汉族发式不同，是居于河西地区的羌人形象。

<div align="right">（撰文：郭永利　摄影：张宝玺）</div>

Harrowing Field

Three-Kingdoms to Jin (220-316 CE)

Height 17.5 cm; Width 36.5 cm

Unearthed from Tomb M6 at Xincheng in Jiayuguan, Gansu, in 1973. Preserved on the original site.

74. 男墓主宴饮图

魏晋（220~316年）

高150、宽220厘米

1973年甘肃省嘉峪关市新城6号墓出土。原址保存。

墓向341°。位于中室西壁，与女墓主宴饮图相对。在砖面上涂白垩后绘画。画面中男墓主居中，正在接仆人递过来的烤肉串，宾客手持便面或手持耳杯正在欢饮，下方有乐伎正在演奏。周围是捧案进食的众仆以及正在切肉的庖厨等内容。最上方绘出行图，下方绘丝帛。

（撰文、摄影：郭永利）

Serving Feast for the Male Tomb Occupant and Guests

Three-Kingdoms to Jin (220-316 CE)

Height 150 cm; Width 220 cm

Unearthed from Tomb M6 at Xincheng in Jiayuguan, Gansu, in 1973. Preserved on the original site.

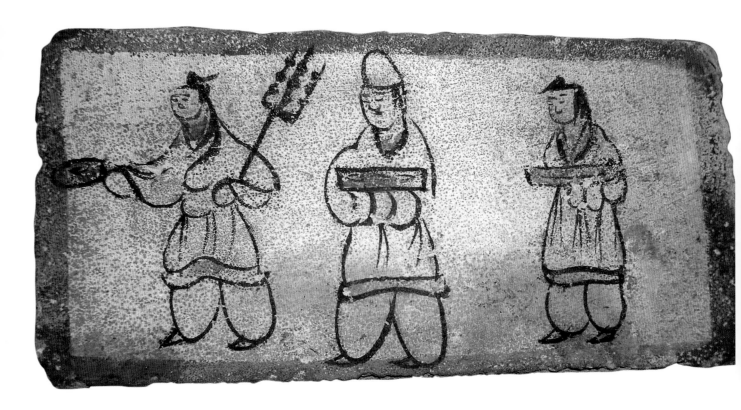

75.进食图

魏晋（220～316年）

高17.5、宽36.5厘米

1973年甘肃省嘉峪关市新城6号墓出土。原址保存。

墓向341°。位于中室西壁。在砖面上涂白垩，再于其上绘画。三仆人成一列，头束发或戴桶形帽，前面一位手持烤肉串，后面两位手捧食案走向墓主。

（撰文、摄影：郭永利）

Serving Food

Three-Kingdoms to Jin (220-316 CE)

Height 17.5 cm; Width 36.5 cm

Unearthed from Tomb M6 at Xincheng in Jiayuguan, Gansu, in 1973. Preserved on the original site.

76.乐伎图

魏晋（220～316年）

高17.5、宽36.5厘米

1973年甘肃省嘉峪关市新城6号墓出土。原址保存。

墓向341°。位于中室西壁。在砖面上涂白垩，再于其上绘画。画面中二男子头戴帽，席地而坐，一位弹阮咸，一位吹长笛，中间置酒具。为宴饮图像的一部分。

<div align="right">（撰文、摄影：郭永利）</div>

Music Performance

Three-Kingdoms to Jin (220-316 CE)

Height 17.5 cm; Width 36.5 cm

Unearthed from Tomb M6 at Xincheng in Jiayuguan, Gansu, in 1973. Preserved on the original site.

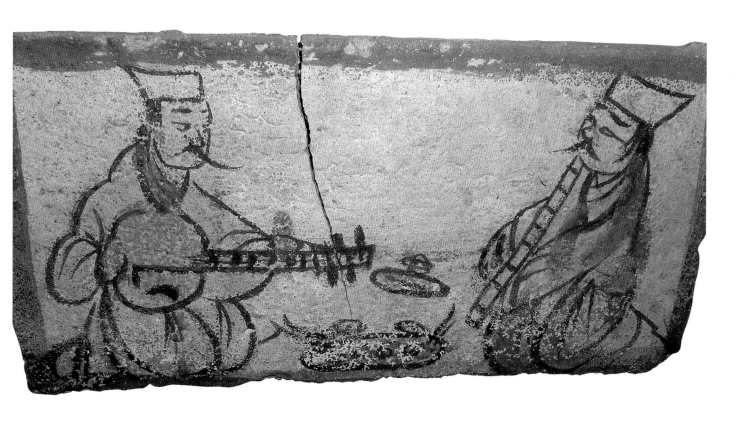

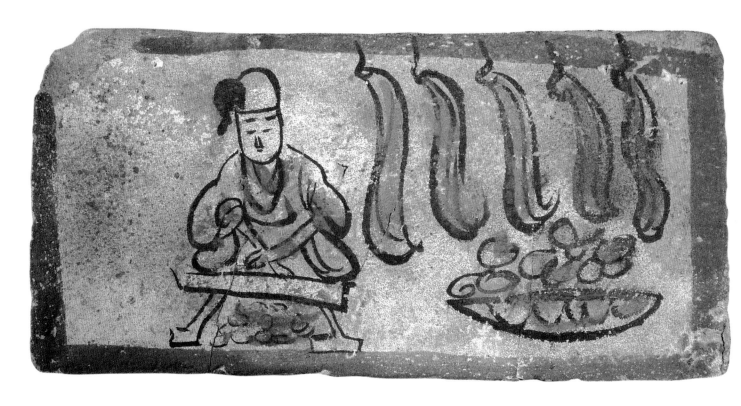

77. 切肉图（一）

魏晋（220～316年）

高17.5、宽36.5厘米

1973年甘肃省嘉峪关市新城6号墓出土。原址保存。

墓向341°。位于中室西壁。在砖面上涂白垩，再于其上绘画。画面中一男子头戴桶形帽，长俎置于前，正在切肉，切下的肉块装入身旁的盆中，盆里肉块堆积如山，画面右上方悬挂多块牲肉。这是宴饮图的局部内容。

<div align="right">（撰文、摄影：郭永利）</div>

Slicing Meat (1)

Three-Kingdoms to Jin (220-316 CE)

Height 17.5 cm; Width 36.5 cm

Unearthed from Tomb M6 at Xincheng in Jiayuguan, Gansu, in 1973. Preserved on the original site.

78. 切肉图（二）

魏晋（220～316年）

高17.5、宽36.5厘米

1973年甘肃省嘉峪关市新城6号墓出土。原址保存。

墓向341°。位于中室北壁。在砖面上涂白垩，再于其上绘画。一男子正在俎上切肉，肉块纷纷落下，画面右侧一位女婢正在帮忙，左侧放着整齐的长几和盆。

（撰文：郭永利 摄影：张宝玺）

Slicing Meat (2)

Three-Kingdoms to Jin (220-316 CE)

Height 17.5 cm; Width 36.5 cm

Unearthed from Tomb M6 at Xincheng in Jiayuguan, Gansu, in 1973. Preserved on the original site.

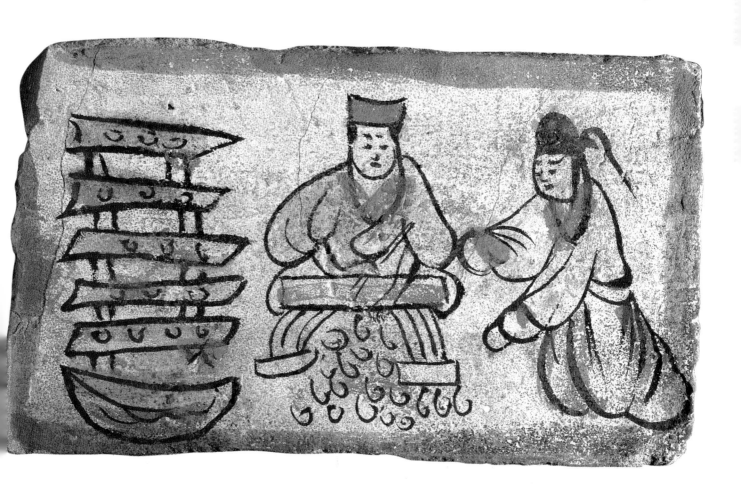

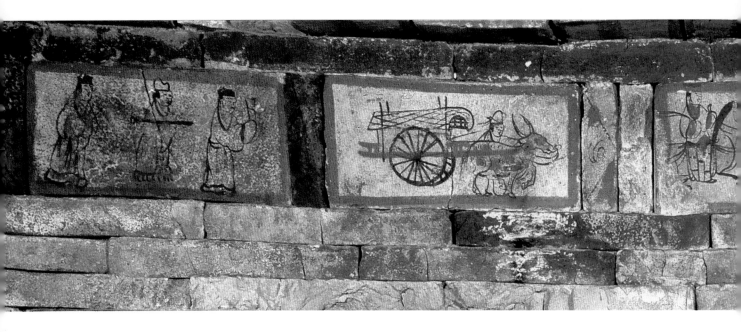

79. 出行图（一）

魏晋（220～316年）

高17.5、宽220厘米

1973年甘肃省嘉峪关市新城6号墓出土。原址保存。

墓向341°。位于中室西壁。在砖面上涂白垩后绘画。此为出行图的主要内容，共5幅，均位于中室西壁上层。另外在该墓北壁和南壁还各绘一幅图表示出行队伍的头尾。因此整个出行图由7幅图像组成，均为小幅砖画，一块砖上画一部分，再组合成完整的出行图。有导骑、从骑、牛车、捧剑持笏的官吏等。

<div style="text-align: right;">（撰文、摄影：郭永利）</div>

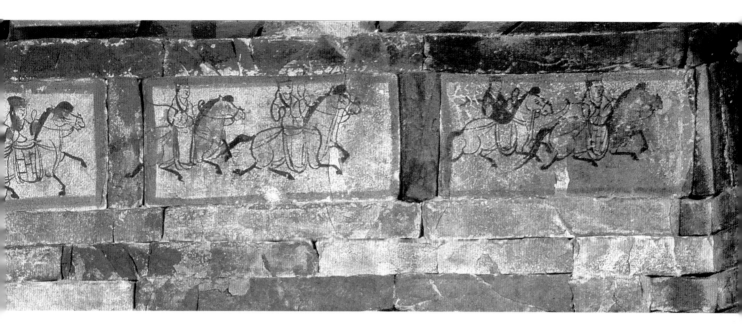

Procession Scene (1)

Three-Kingdoms to Jin (220-316 CE)

Height 17.5 cm; Width 220 cm

Unearthed from Tomb M6 at Xincheng in Jiayuguan, Gansu, in 1973. Preserved on the original site.

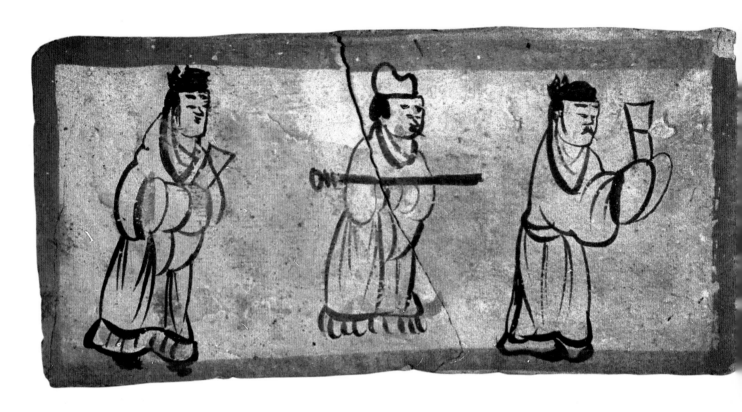

80. 出行图（一）（局部一）

魏晋（220～316年）

高17.5、宽36.5厘米

1973年甘肃省嘉峪关市新城6号墓出土。原址保存。

墓向341°。位于中室西壁。在砖面上涂白垩，再于其上绘画。画面中三位人物，前后两位头戴介帻，身着袍服，手持笏躬身前行，中间一位戴帢者捧剑。

（撰文：郭永利 摄影：张宝玺）

Procession Scene (1) (Detail 1)

Three-Kingdoms to Jin (220-316 CE)

Height 17.5 cm; Width 36.5 cm

Unearthed from Tomb M6 at Xincheng in Jiayuguan, Gansu, in 1973. Preserved on the original site.

81. 出行图（一）（局部二）

魏晋（220～316年）

高17.5、宽36.5厘米

1973年甘肃省嘉峪关市新城6号墓出土。原址保存。

墓向341°。位于中室西壁。在砖面上涂白垩，再于其上绘画。犊车一辆，一戴桶形帽的男子在驾车，车内虽不见人物，但从其位置来看，应为墓主人之车。

<div align="right">（撰文：郭永利　摄影：张宝玺）</div>

Procession scene (1) (Detail 2)

Three-Kingdoms to Jin (220-316 CE)

Height 17.5 cm; Width 36.5 cm

Unearthed from Tomb M6 at Xincheng in Jiayuguan, Gansu, in 1973. Preserved on the original site.

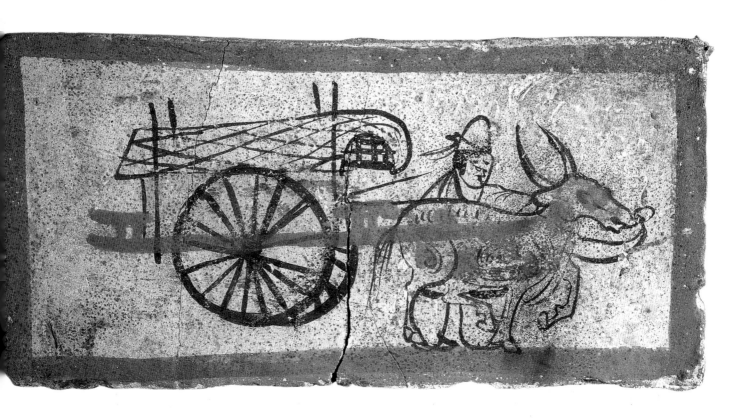

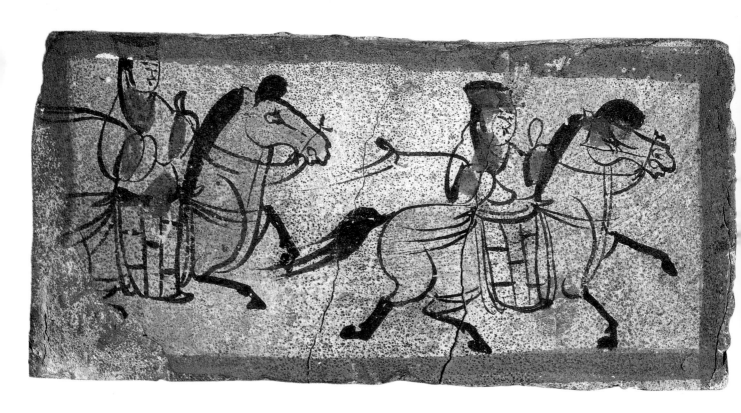

82.出行图（一）（局部三）

魏晋（220～316年）

高17.5、宽36.5厘米

1973年甘肃省嘉峪关市新城6号墓出土。原址保存。

墓葬方向341°。位于中室西壁。在砖面上涂白垩，再于其上绘画。二骑吏一前一后骑马，均头戴赤帻。

<div align="right">（撰文：郭永利 摄影：张宝玺）</div>

Procession Scene (1) (Detail 3)

Three-Kingdoms to Jin (220-316 CE)

Height 17.5 cm; Width 36.5 cm

Unearthed from Tomb M6 at Xincheng in Jiayuguan, Gansu, in 1973. Preserved on the original site.

83.出行图（一）（局部四）

魏晋（220~316年）

高17.5、宽36.5厘米

1973年甘肃省嘉峪关市新城6号墓出土。原址保存。

墓向341°。位于中室西壁。在砖面上涂白垩，再于其上绘画。二骑吏一前一后骑马，前面的一位头戴赤帻，手持鞭，另一人头戴黑帻随行于后。

<div align="right">（撰文：郭永利　摄影：张宝玺）</div>

Procession Scene (1) (Detail 4)

Three-Kingdoms to Jin (220-316 CE)

Height 17.5 cm; Width 36.5 cm

Unearthed from Tomb M6 at Xincheng in Jiayuguan, Gansu, in 1973. Preserved on the original site.

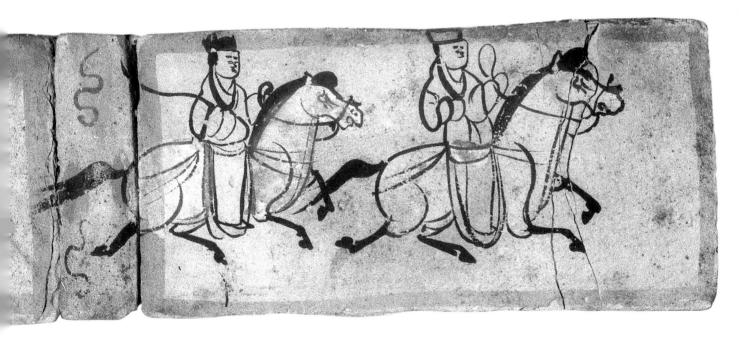

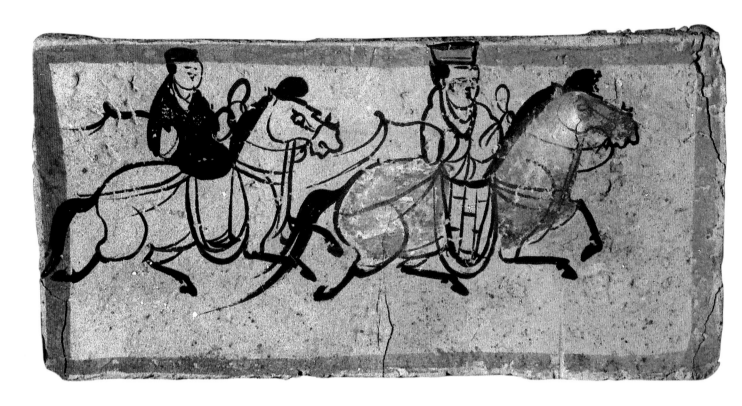

84. 出行图（一）（局部五）

魏晋（220～316年）

高17.5、宽36.5厘米

1973年甘肃省嘉峪关市新城6号墓出土。原址保存。

墓向341°。位于中室西壁。在砖面上涂白垩，再于其上绘画。二骑吏一前一后骑马，前面的一位头戴赤帻，手持鞭，另一人头戴黑帻随行于后。

（撰文：郭永利 摄影：张宝玺）

Procession Scene (1) (Detail 5)

Three-Kingdoms to Jin (220-316 CE)

Height 17.5 cm; Width 36.5 cm

Unearthed from Tomb M6 at Xincheng in Jiayuguan, Gansu, in 1973. Preserved on the original site.

85.出行图（二）

魏晋（220～316年）

高17.5、宽36.5厘米

1973年甘肃省嘉峪关市新城6号墓出土。原址保存。

墓向341°。位于中室北壁。在砖面上涂白垩，再于其上绘画。二位持笏的官吏走在出行队伍的最前面，头戴黑介帻，身着长袍躬身前行。此为出行图的首部。

（撰文：郭永利　摄影：张宝玺）

Procession Scene (2)

Three-Kingdoms to Jin (220-316 CE)

Height 17.5 cm; Width 36.5 cm

Unearthed from Tomb M6 at Xincheng in Jiayuguan, Gansu, in 1973. Preserved on the original site.

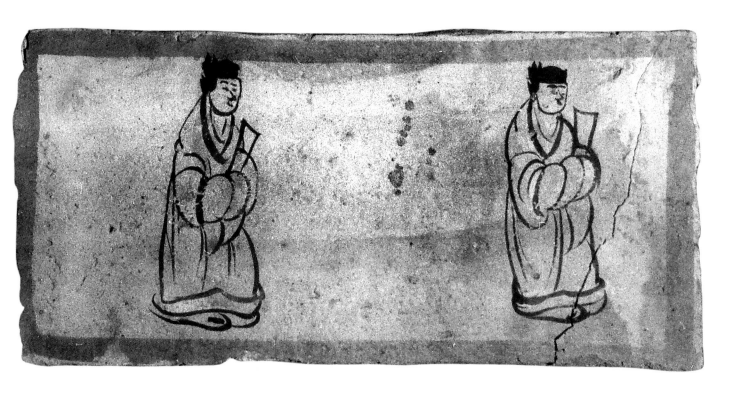

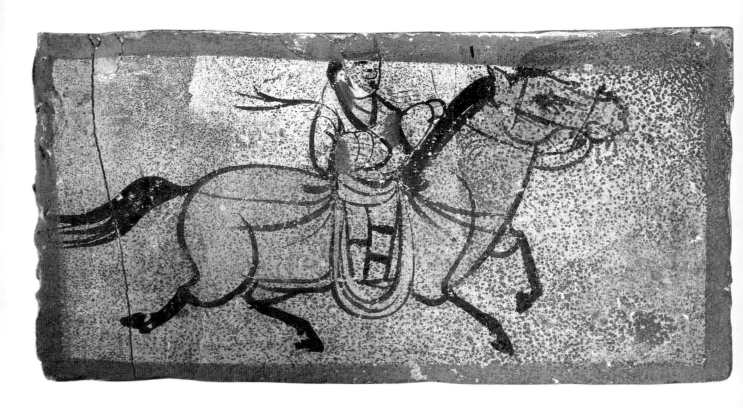

▲ 86. 出行图（三）

魏晋（220～316年）

高17.5、宽36.5厘米

1973年甘肃省嘉峪关市新城6号墓出土。原址保存。

墓向341°。位于中室南壁。在砖面上涂白垩，再于其上绘画。一骑吏头戴赤帻，马上持鞭。此图为出行队伍的尾部。

（撰文：郭永利 摄影：张宝玺）

Procession Scene (3)

Three-Kingdoms to Jin (220-316 CE)

Height 17.5 cm; Width 36.5 cm

Unearthed from Tomb M6 at Xincheng in Jiayuguan, Gansu, in 1973. Preserved on the original site.

87. 丝帛箱奁图 ▶

魏晋（220～316年）

高约125、宽约130厘米

1973年甘肃省嘉峪关市新城6号墓出土。原址保存。

墓向341°。位于墓葬后室。在砖面上涂白垩后绘画。分层绘画，绘有箱、圆形丝帛和方形丝帛图像，圆圈形图像也是丝帛。这是河西地区魏晋墓室壁画的绘法之一，象征墓主人拥有可观的财富。

（撰文：郭永利 摄影：张宝玺）

Silk Rolls and Costume Cases

Three-Kingdoms to Jin (220-316 CE)

Height 125 cm; Width 130 cm

Unearthed from Tomb M6 at Xincheng in Jiayuguan, Gansu, in 1973. Preserved on the original site.

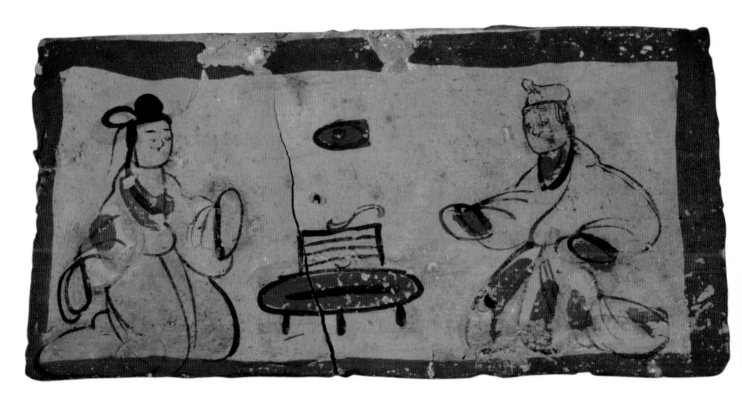

88.宴饮图

魏晋（220～316年）

高17.5、宽36.5厘米

1973年甘肃省嘉峪关市新城7号墓出土。原址保存。

墓向336°。位于前室北壁。在砖面上涂白垩后绘画。画面中男女墓主相对而坐，女墓主高髻，着交领衫，下着裙；男墓主着袍服。二人中间置一组酒具，上方有一只耳杯。为宴饮场景。

<div align="right">（撰文、摄影：郭永利）</div>

Drinking Scene

Three-Kingdoms to Jin (220-316 CE)

Height 17.5 cm; Width 36.5 cm

Unearthed from Tomb M7 at Xincheng in Jiayuguan, Gansu, in 1973. Preserved on the original site.

89. 狩猎图

魏晋（220～316年）

高17.5、宽36.5厘米

1973年甘肃省嘉峪关市新城7号墓出土。原址保存。

墓向336°。位于前室东壁。画面中猎手骑马拉弓，在追射前方奔逃的黄羊。

（撰文：郭永利 摄影：张宝玺）

Hunting Scene

Three-Kingdoms to Jin (220-316 CE)

Height 17.5 cm; Width 36.5 cm

Unearthed from Tomb M7 at Xincheng in Jiayuauan, Gansu, in 1973. Preserved on the original site.

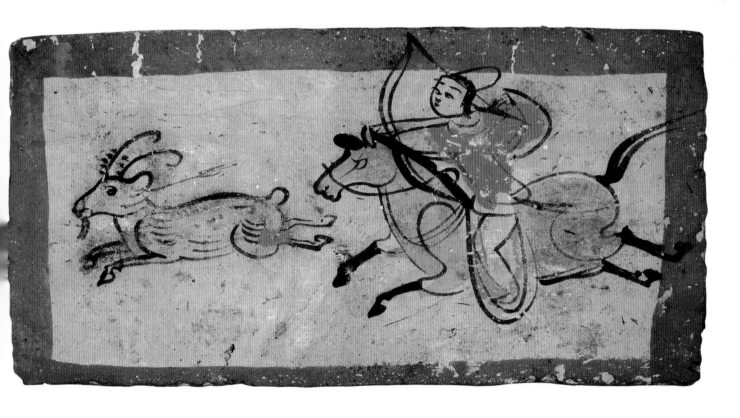

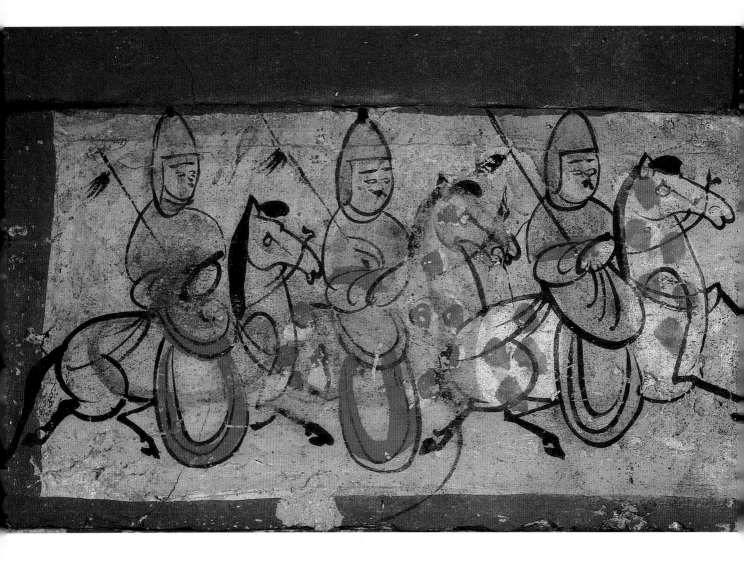

90.出行图

魏晋（220～316年）

高17.5、宽36.5厘米

1973年甘肃省嘉峪关市新城7号墓出土。原址保存。

墓向336°。位于前室西壁。在砖面上涂白垩，再于其上绘画。此墓完整的出行图共由7幅图组成，此为其中之一。画面中三人一列，均着兜鍪，骑马持鞭前行，显示墓主人的威仪。

（撰文、摄影：郭永利）

Procession Scene

Three-Kingdoms to Jin (220-316 CE)

Height 17.5 cm; Width 36.5 cm

Unearthed from Tomb M7 at Xincheng in Jiayuguan, Gansu, in 1973. Preserved on the original site.

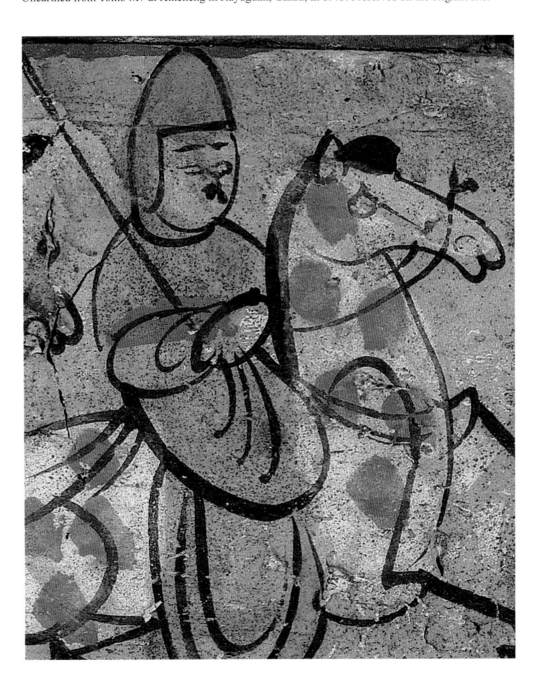

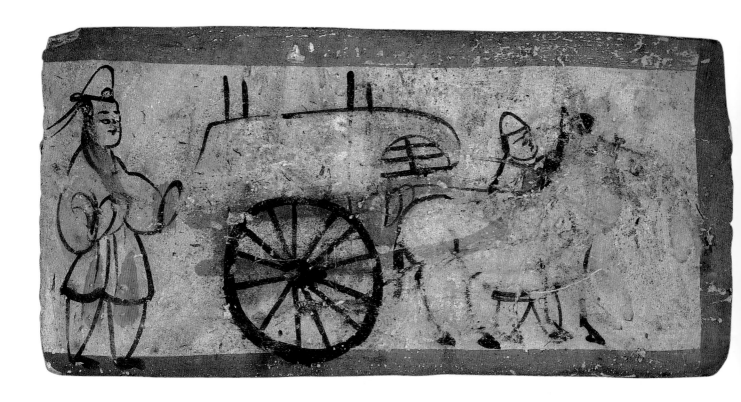

91.牛车图

魏晋（220～316年）

高17.5、宽36.5厘米

1973年甘肃省嘉峪关市新城7号墓出土。原址保存。

墓向336°。位于前室西壁。在砖面上涂白垩，再于其上绘画。画面中绘犊车一辆。前有驾车的驭夫，后有随行的男仆。车中虽不见人物图像，却是牛车队伍中最尊贵的一辆，应是墓主人乘用的牛车。

（撰文、摄影：郭永利）

Ox Cart and Driver and Attendant

Three-Kingdoms to Jin (220-316 CE)

Height 17.5 cm; Width 36.5 cm

Unearthed from Tomb M7 at Xincheng in Jiayuguan, Gansu, in 1973.
Preserved on the original site.

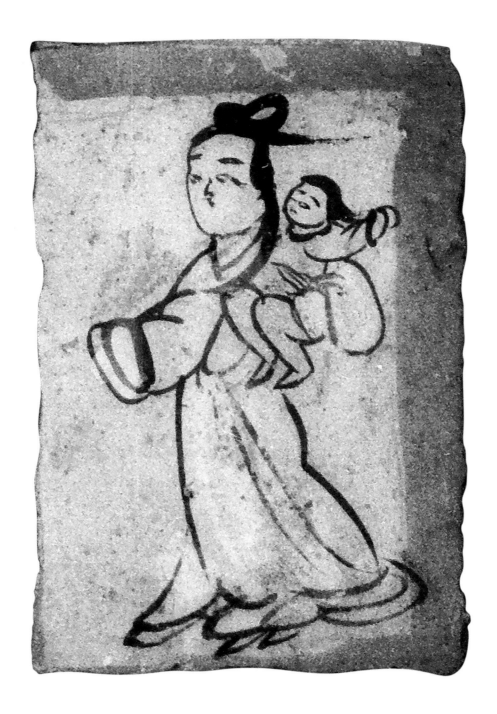

92. 母子图

魏晋（220～316年）

高17.5、宽17.5厘米

1973年甘肃省嘉峪关市新城7号墓出土。原址保存。
墓向336°。位于前室东壁。画面中一位母亲抱着幼
小的孩子。

（撰文：郭永利 摄影：张宝玺）

Mother Holding Child

Three-Kingdoms to Jin (220-316 CE)

Height 17.5 cm; Width 17.5 cm

Unearthed from Tomb M7 at Xincheng in
Jiayuguan, Gansu, in 1973. Preserved on the
original site.

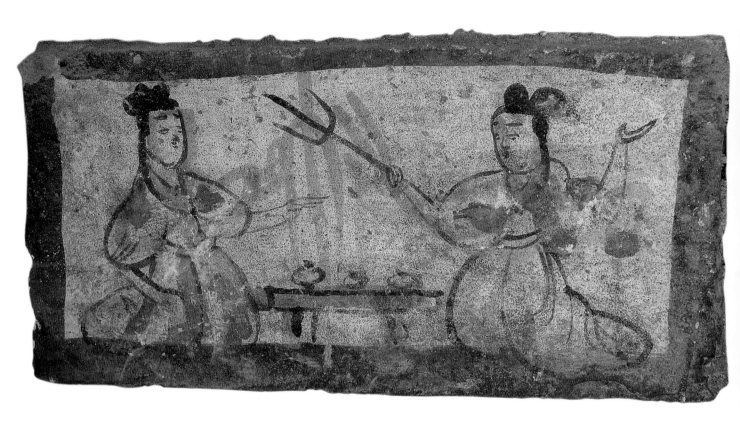

93.庖厨图

魏晋（220～316年）

高17.5、宽36.5厘米

1973年甘肃省嘉峪关市新城7号墓出土。原址保存。

墓向336°。位于中室北壁。在砖面上涂白垩，再于其上绘画。画面中二女婢相对而坐，中间置小长几，上陈耳杯，一女手持叉。二人在准备进食用具。

<div align="right">（撰文：郭永利　摄影：郭永利）</div>

Cooking Scene

Three-Kingdoms to Jin (220-316 CE)

Height 17.5 cm; Width 36.5 cm

Unearthed from Tomb M7 at Xincheng in Jiayuguan, Gansu, in 1973. Preserved on the original site.

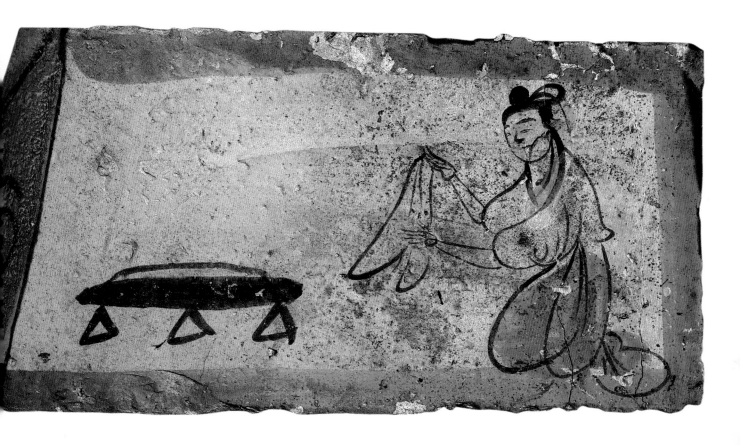

94.炊事图

魏晋（220～316年）

高17.5、宽36.5厘米

1973年甘肃省嘉峪关市新城7号墓出土。原址保存。

墓向336°。位于中室北壁。画面中一女婢正忙于炊事。面前置锅，下有三个支点，锅底火正旺，女婢手中之物似为用手抻出的薄饼。

（撰文：郭永利 摄影：张宝玺）

Cooking Scene

Three-Kingdoms to Jin (220-316 CE)

Height 17.5 cm; Width 36.5 cm

Unearthed from Tomb M7 at Xincheng in Jiayuguan, Gansu, in 1973. Preserved on the original site.

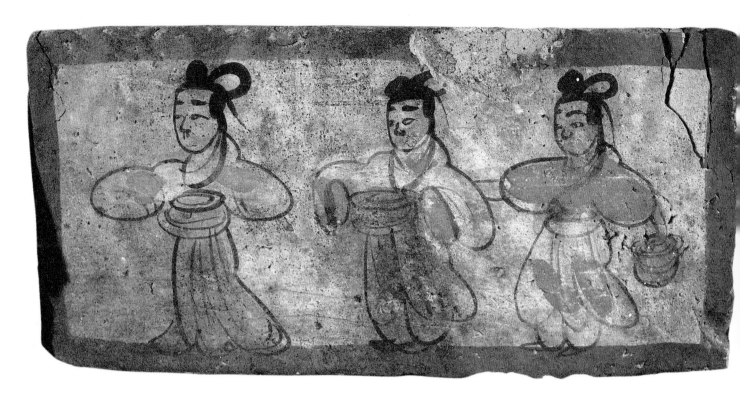

95.进食图

魏晋（220～316年）

高17.5、宽36.5厘米

1973年甘肃省嘉峪关市新城7号墓出土。原址保存。

墓向336°。位于中室北壁。画面中三女婢各捧罐、盆等器具前行。

（撰文、摄影：郭永利）

Serving Food

Three-Kingdoms to Jin (220-316 CE)

Height 17.5 cm; Width 36.5 cm

Unearthed from Tomb M7 at Xincheng in Jiayuguan, Gansu, in 1973. Preserved on the original site.

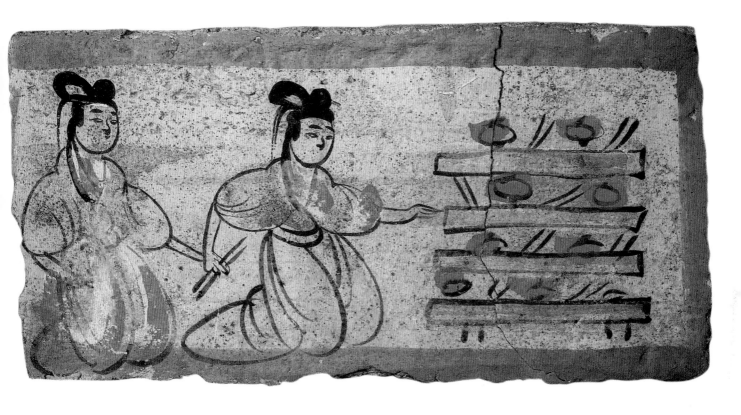

96. 备宴图

魏晋（220～316年）

高17.5、宽36.5厘米

1973年甘肃省嘉峪关市新城7号墓出土。原址保存。

墓向336°。位于中室东壁。二女婢席地而坐，二人合作，正在准备宴席的小几、餐具等。

<div align="right">（撰文：郭永利　摄影：张宝玺）</div>

Banquet Preparation Scene

Three-Kingdoms to Jin (220-316 CE)

Height 17.5 cm; Width 36.5 cm

Unearthed from Tomb M7 at Xincheng in Jiayuguan, Gansu, in 1973. Preserved on the original site.

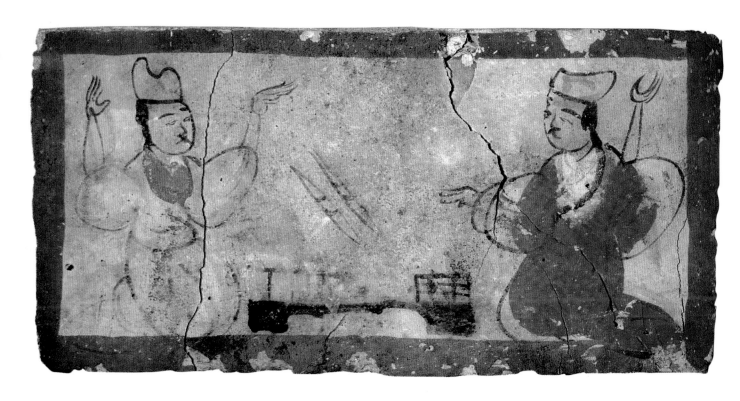

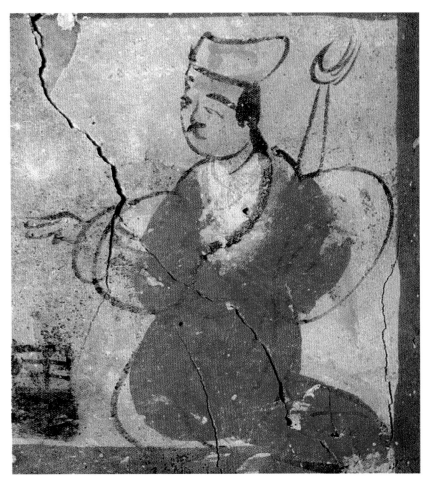

97.六博图

魏晋（220～316年）

高17.5、宽36.5厘米

1973年甘肃省嘉峪关市新城7号墓出土。原址保存。

墓向336°。位于中室东壁。画面中二男子相对而坐，举手投箸，中间放置博具。

（撰文：郭永利 摄影：张宝玺）

Playing Liubo Game

Three-Kingdoms to Jin (220-316 CE)

Height 17.5 cm; Width 36.5 cm

Unearthed from Tomb M7 at Xincheng in Jiayuguan, Gansu, in 1973. Preserved on the original site.

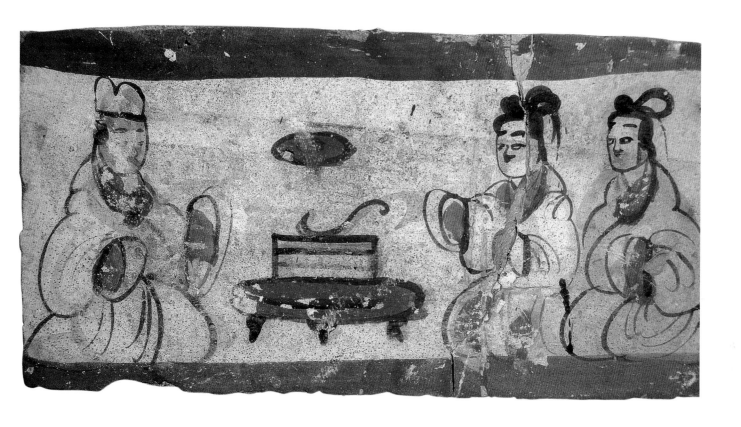

98.宴饮图

魏晋（220～316年）

高17.5、宽36.5厘米

1973年甘肃省嘉峪关市新城7号墓出土。
原址保存。

墓向336°。位于中室南壁。在砖面上涂
白垩，再于其上绘画。画面中一男子和
两位女子相对而坐。女子高髻，着交领
衫，下着裙；男子着袍服。三人中间为酒
具，上方有食具。是宴饮场景。

（撰文：郭永利 摄影：郭永利）

Drinking Scene

Three-Kingdoms to Jin (220-316 CE)

Height 17.5 cm; Width 36.5 cm

Unearthed from Tomb M7 at Xincheng in
Jiayuguan, Gansu, in 1973. Preserved on the
original site.

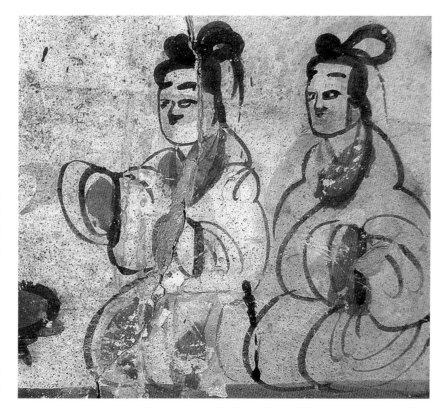

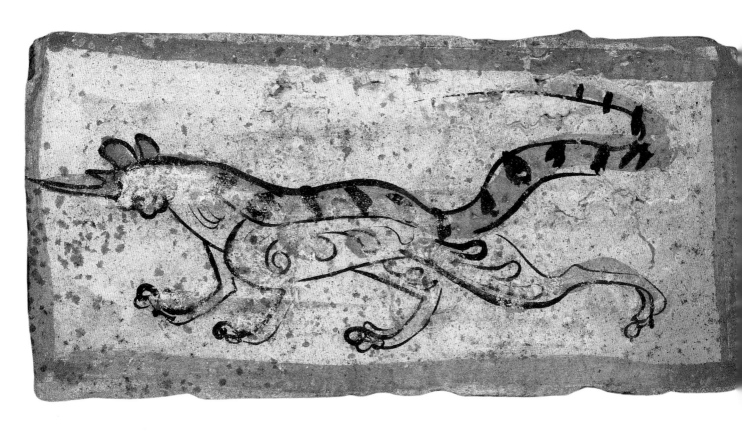

99. 镇墓兽（一）

魏晋（220～316年）

高17.5、宽36.5厘米

1979年甘肃省嘉峪关市新城12号墓出土。现存于嘉峪关长城博物馆。

墓向345°。位于前室北壁墓门处。在砖面上涂白垩，再于其上绘画。画面中独角兽长尾上卷，眼睛圆睁，头向下，背部有斑纹，立于墓门两侧，意在镇墓辟邪。

（撰文：郭永利　摄影：张宝玺）

Tomb Guardian Beast (1)

Three-Kingdoms to Jin (220-316 CE)

Height 17.5 cm; Width 36.5 cm

Unearthed from Tomb M12 at Xincheng in Jiayuguan, Gansu, in 1979. Preserved in Jiayuguan Museum of the Great Wall.

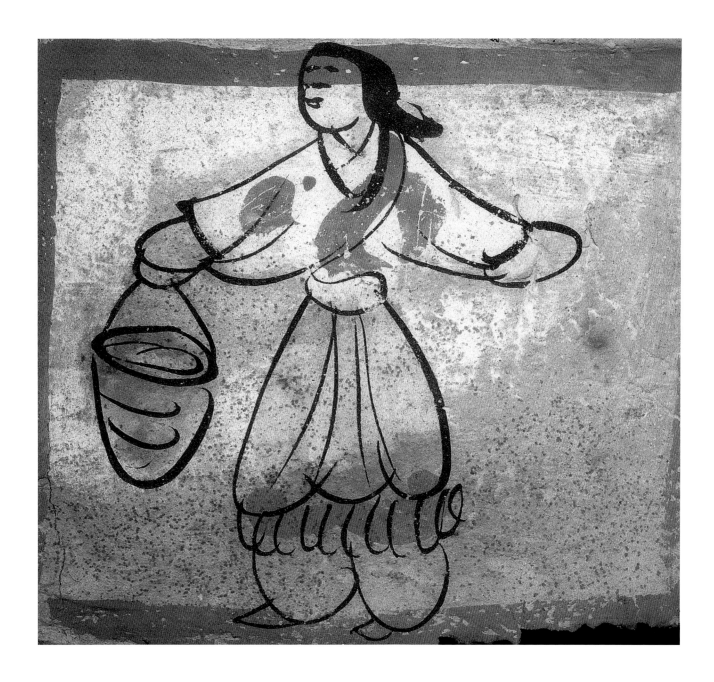

100.提篮女子图

魏晋（220～316年）

高17.5、宽17.5厘米

1979年甘肃省嘉峪关市新城12号墓出土。现存于嘉峪关长城博物馆。

墓向345°。位于墓葬前室北壁。在砖面上涂白垩，然后于其上绘画。画面中一女着交领短衣，下着裤，手提一篮，长发披肩。其发式与汉族妇女不同，应为河西地区的少数民族。

<div align="right">（撰文：郭永利 摄影：张宝玺）</div>

Woman Carrying a Basket

Three-Kingdoms to Jin (220-316 CE)

Height 17.5 cm; Width 17.5 cm

Unearthed from Tomb M12 at Xincheng in Jiayuguan, Gansu, in 1979. Preserved in Jiayuguan Museum of the Great Wall.

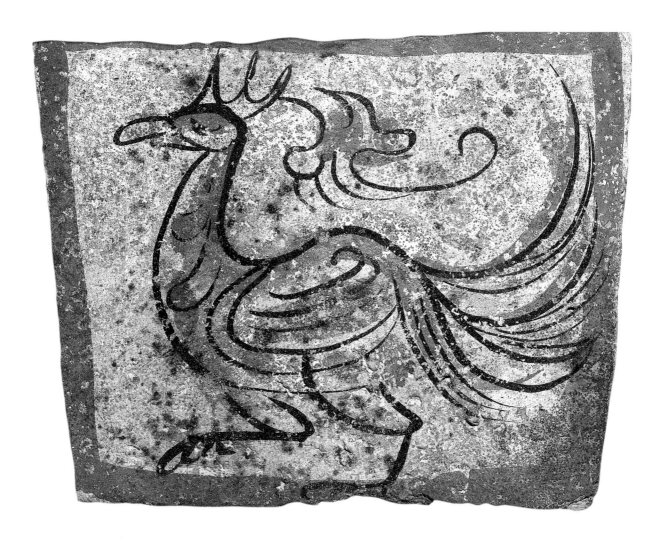

101.朱雀图

魏晋（220～316年）

高17.5、宽36.5厘米

1979年甘肃省嘉峪关市新城12号墓出土。现存于嘉峪关长城博物馆。

墓向345°。位于墓葬前室北壁的一侧。在砖面上涂白垩，再于其上绘画。朱雀昂首立姿，大尾卷扬，画面上方绘一朵云气。

（撰文：郭永利 摄影：张宝玺）

Scarlet Bird

Three-Kingdoms to Jin (220-316 CE)

Height 17.5 cm; Width 36.5 cm

Unearthed from Tomb M12 at Xincheng in Jiayuguan, Gansu, in 1979. Preserved in Jiayuguan Museum of the Great Wall.

102.椎牛图

魏晋（220～316年）

高17.5、宽36.5厘米

1979年甘肃省嘉峪关市新城12号墓出土。现存于嘉峪关长城博物馆。

墓向345°。位于前室东壁。画面中一男子上着短衣，下着裤，一手用力拉着牛，侧身跨步，一手持椎向牛击去，牛头昂起，似乎在努力抵抗。

（撰文：郭永利 摄影：张宝玺）

Slaughtering an Ox with a Hammer

Three-Kingdoms to Jin (220-316 CE)

Height 17.5 cm; Width 36.5 cm

Unearthed from Tomb M12 at Xincheng in Jiayuguan, Gansu, in 1979. Preserved in Jiayuguan Museum of the Great Wall.

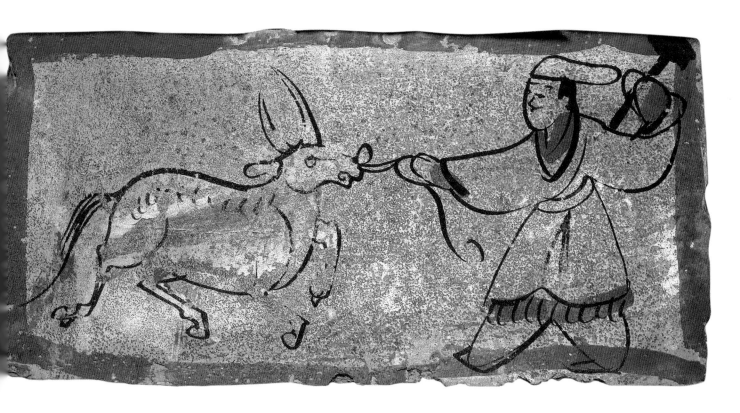

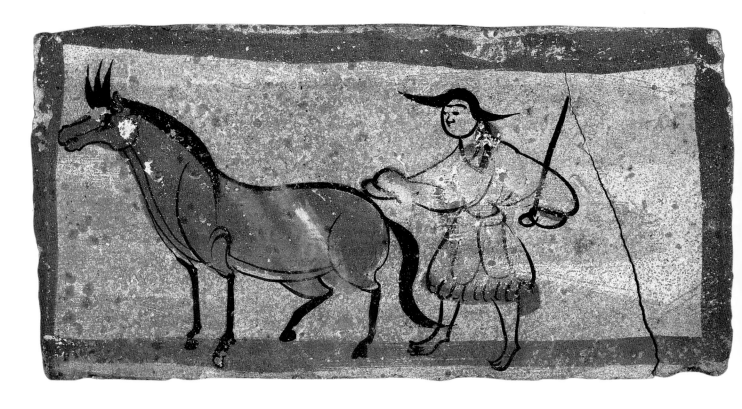

103.牧马图

魏晋（220～316年）

高17.5、宽36.5厘米

1979年甘肃省嘉峪关市新城12号墓出土。现存于嘉峪关长城博物馆。

墓向345°。位于前室东壁。在砖面上涂白垩，再于其上绘画。牧马人持鞭立于马后。人物着短衣，赤足，长发扬起，其发式与汉族不同，应为少数民族。

（撰文：郭永利 摄影：张宝玺）

Herding Horse

Three-Kingdoms to Jin (220-316 CE)

Height 17.5 cm; Width 36.5 cm

Unearthed from Tomb M12 at Xincheng in Jiayuguan, Gansu, in 1979. Preserved in Jiayuguan Museum of the Great Wall.

104. 鸡群图

魏晋（220～316年）

高17.5、宽36.5厘米

1979年甘肃省嘉峪关市新城12号墓出土。现存于嘉峪关长城博物馆。

墓向345°。位于前室东壁。在砖面上涂白垩，再于其上绘画。画面上绘满了13只鸡，表现了墓主人的富足。

<div style="text-align: right;">（撰文：郭永利　摄影：张宝玺）</div>

Chicken Shoal

Three-Kingdoms to Jin (220-316 CE)

Height 17.5 cm; Width 36.5 cm

Unearthed from Tomb M12 at Xincheng in Jiayuguan, Gansu, in 1979. Preserved in Jiayuguan Museum of the Great Wall.

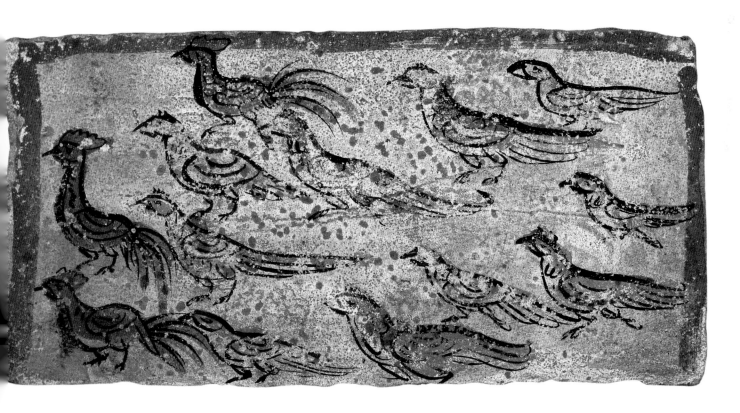

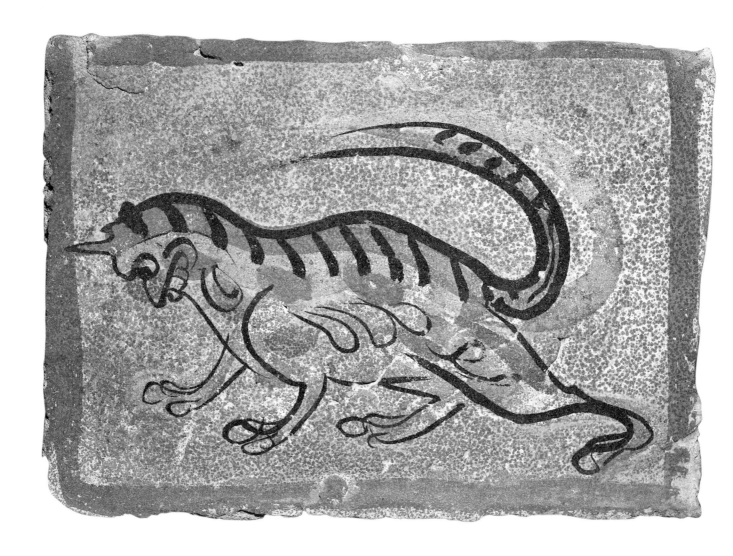

105.镇墓兽（二）

魏晋（220～316年）

高17.5、宽36.5厘米

1979年甘肃省嘉峪关市新城12号墓出土。现存于嘉峪关长城博物馆。

墓向345°。位于前室南壁。在砖面上涂白垩，再于其上绘画。画面中独角兽长尾上卷，眼睛圆睁，头向下，尖角向前，背部有斑纹，立于甬道口的一侧，意在镇墓辟邪。

（撰文：郭永利 摄影：张宝玺）

Tomb Guardian Beast (2)

Three-Kingdoms to Jin (220-316 CE)

Height 17.5 cm; Width 36.5 cm

Unearthed from Tomb M12 at Xincheng in Jiayuguan, Gansu, in 1979. Preserved in Jiayuguan Museum of the Great Wall.

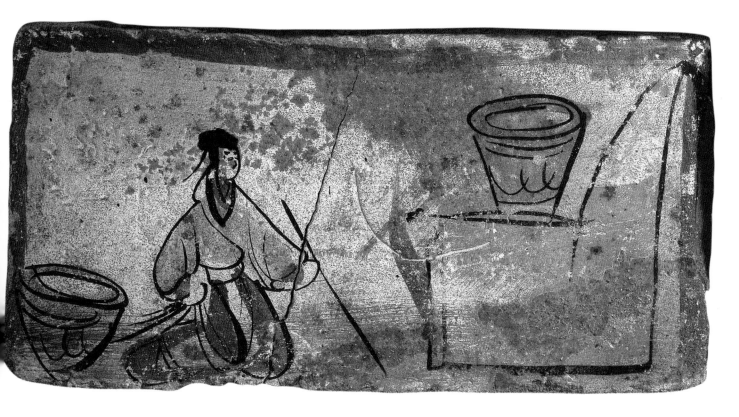

106.炊事图

魏晋（220～316年）

高17.5、宽36.5厘米

1979年甘肃省嘉峪关市新城12号墓出土。现存于嘉峪关长城博物馆。

墓向345°。位于前室南壁。在砖面上涂白垩，再于其上绘画。一女婢坐于地上，在烧火做饭，灶间火正旺，其身后置一大水盆。

<div align="right">（撰文：郭永利 摄影：张宝玺）</div>

Cooking Scene

Three-Kingdoms to Jin (220-316 CE)

Height 17.5 cm; Width 36.5 cm

Unearthed from Tomb M12 at Xincheng in Jiayuguan, Gansu, in 1979. Preserved in Jiayuguan Museum of the Great Wall.

107. 坞图

魏晋（220～316年）

高17.5、宽36.5厘米

1979年甘肃省嘉峪关市新城12号墓出土。现存于嘉峪关长城博物馆。

墓向345°。位于前室南壁。在砖面上涂白垩，再于其上绘画。画面中的坞为四方形，有对开的大门，坞内有高大的望楼，坞外有树木，坞的封闭性较强，有着较强的防守功能。这应是墓主人居所的真实写照。

（撰文：郭永利 摄影：张宝玺）

Wu-Castle

Three-Kingdoms to Jin (220-316 CE)

Height 17.5 cm; Width 36.5 cm

Unearthed from Tomb M12 at Xincheng in Jiayuguan, Gansu, in 1979. Preserved in Jiayuguan Museum of the Great Wall.

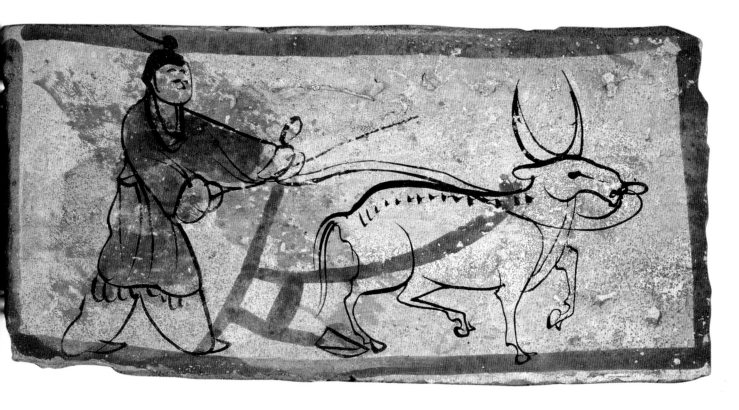

108.牛耕图

魏晋（220～316年）

高17.5、宽36.5厘米

1979年甘肃省嘉峪关市新城12号墓出土。现存于嘉峪关长城博物馆。

墓向345°。位于前室西壁。在砖面上涂白垩，再于其上绘画。画面中一男子束发，着短衣，下着裤，正在驾牛扶犁耕地。

（撰文：郭永利 摄影：张宝玺）

Plowing with an Ox

Three-Kingdoms to Jin (220-316 CE)

Height 17.5 cm; Width 36.5 cm

Unearthed from Tomb M12 at Xincheng in Jiayuguan, Gansu, in 1979. Preserved in Jiayuguan Museum of the Great Wall.

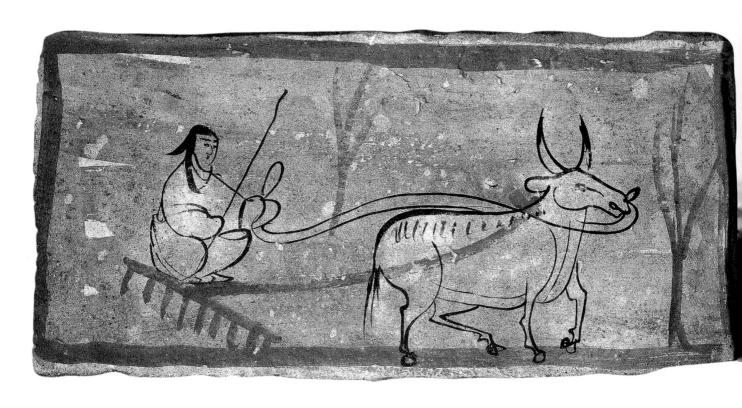

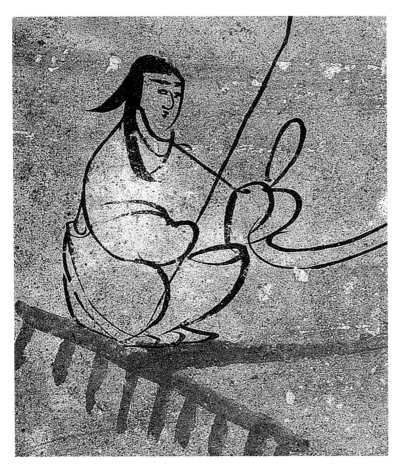

109. 耙地图

魏晋（220～316年）

高17.5、宽36.5厘米

1979年甘肃省嘉峪关市新城12号墓出土。现存于嘉峪关长城博物馆。

墓向345°。位于前室西壁。在砖面上涂白垩，再于其上绘画。画面中一男子蹲在耙上，驾牛耙地，地旁有树。男子长发，应为少数民族。

（撰文：郭永利 摄影：张宝玺）

Harrowing Field

Three-Kingdoms to Jin (220-316 CE)

Height 17.5 cm; Width 36.5 cm

Unearthed from Tomb M12 at Xincheng in Jiayuguan, Gansu, in 1979. Preserved in Jiayuguan Museum of the Great Wall.

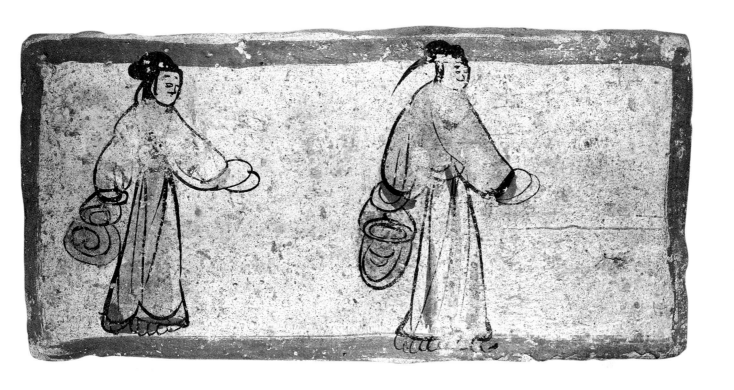

110. 提篮图

魏晋（220～316年）

高17.5、宽36.5厘米

1979年甘肃省嘉峪关市新城12号墓出土。现存于嘉峪关长城博物馆。

墓向345°。位于前室西壁。在砖面上涂白垩，再于其上绘画。画面中二女高髻，衣裙及地，一前一后前行，手中各持篮。应是去采桑的妇女。

（撰文：郭永利 摄影：张宝玺）

Women Carrying Baskets

Three-Kingdoms to Jin (220-316 CE)

Height 17.5 cm; Width 36.5 cm

Unearthed from Tomb M12 at Xincheng in Jiayuguan, Gansu, in 1979. Preserved in Jiayuguan Museum of the Great Wall.

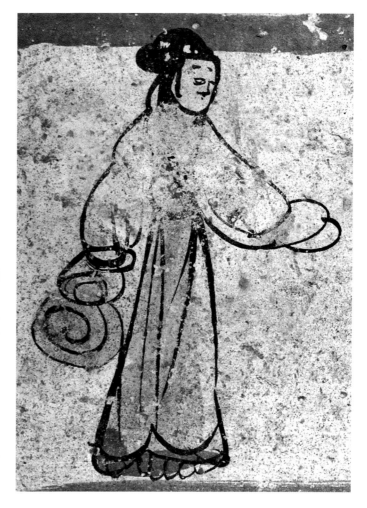

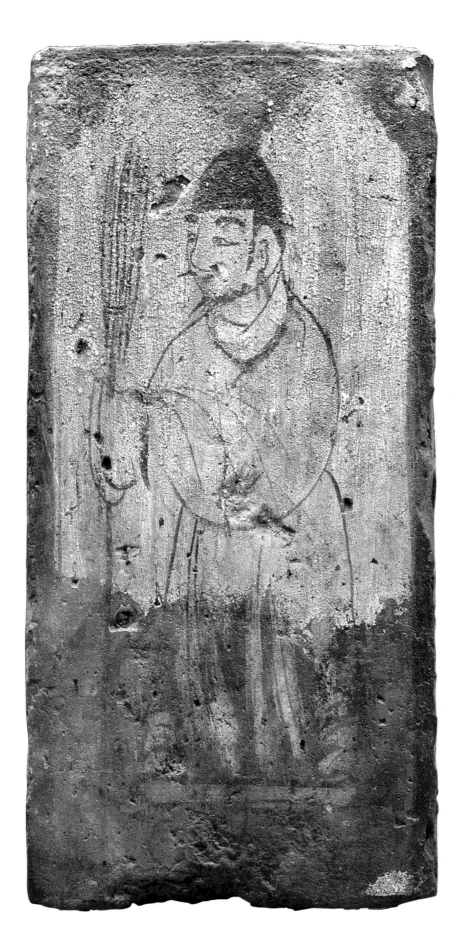

111.持帚男仆图

西晋（265～316年）

高31.5、宽16厘米

1987年甘肃省敦煌市佛爷庙湾墓群133号墓出土。现存于敦煌市博物馆。

墓向275°。位于墓葬照墙的顶部、天门双阙的阙身。在砖面上涂白垩后再绘画。画面中男子着长衫，头戴尖顶帽，手中持帚直立。其身后绘有仿木结构的斗拱和柱。

（撰文：郭永利 摄影：傅立诚）

Servant with Broom

Western Jin (265-316 CE)

Height 31.5 cm; Width 16 cm

Unearthed from Tomb M133 at cemetery of Foyemiaowan in Dunhuang, Gansu, in 1987. Preserved in Dunhuang Museum.

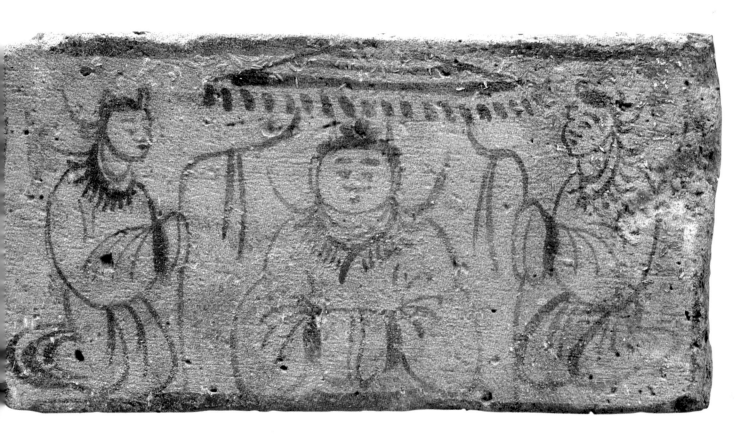

112.西王母图

西晋（265～316年）

高16、宽33厘米

1999年甘肃省敦煌市佛爷庙湾墓群出土。现存于敦煌市博物馆。

位于墓葬照墙。在砖面上直接以墨线绘画。西王母笼袖端坐，肩部有双翼，头顶有曲柄华盖。两旁有双立耳羽人侍者，双手执华盖柄。

（撰文：郭永利 摄影：傅立诚）

Xiwangmu (Queen Mother of the West)

Western Jin (265-316 CE)

Height 16 cm; Width 33 cm

Unearthed from tomb at cemetery of Foyemiaowan in Dunhuang, Gansu, in 1999. Preseved in Dunhuang Museum.

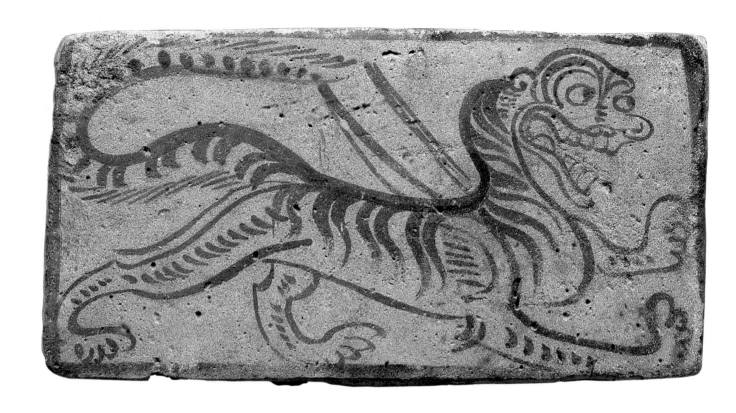

113. 白虎图

西晋（265～316年）

高约16、宽约31.5厘米

1999年甘肃省敦煌市佛爷庙湾墓群出土。现存于敦煌市博物馆。

在砖面上直接以墨线绘画。白虎张口露齿，肩有双翼，大尾上扬，作奔腾状，背部有条纹。画法精细。

（撰文：郭永利 摄影：傅立诚）

White Tiger

Western Jin (265-316 CE)

Height 16 cm; Width 31.5 cm

Unearthed from tomb at cemetery of Foyemiaowan in Dunhuang, Gansu, in 1999. Preseved in Dunhuang Museum.

114. 捧盾门吏图

西晋（265～316年）

高33、宽16厘米

2001年甘肃省敦煌市佛爷庙湾墓群出土。现存于敦煌市博物馆。

位于墓葬照墙。在砖面上涂白垩后再绘画。画面中人物头着武弁，直立，着短衣，下着裤，双眼圆睁，双手捧盾，盾上置一把剑。身后有红色线绘出的斗拱和柱。应为门亭长。

（撰文：郭永利 摄影：傅立诚）

Door Guard Serving Shield

Western Jin (265-316 CE)

Height 16 cm; Width 33 cm

Unearthed from tomb at cemetery of Foyemiaowan in Dunhuang, Gansu, in 2001. Preseved in Dunhuang Museum.

115.持帚门吏图

西晋（265～316年）

高33、宽16厘米

2001年甘肃省敦煌市佛爷庙湾墓群出土。现存于敦煌市博物馆。

位于墓葬照墙。在砖面上涂白垩后再绘画。头戴黑帻，着短衣，下着裤，手持帚侧立。

（撰文：郭永利 摄影：傅立诚）

Door Guard with Broom

Western Jin (265-316 CE)

Height 16 cm; Width 33 cm

Unearthed from tomb at cemetery of Foyemiaowan in Dunhuang, Gansu, in 2001. Preseved in Dunhuang Museum.

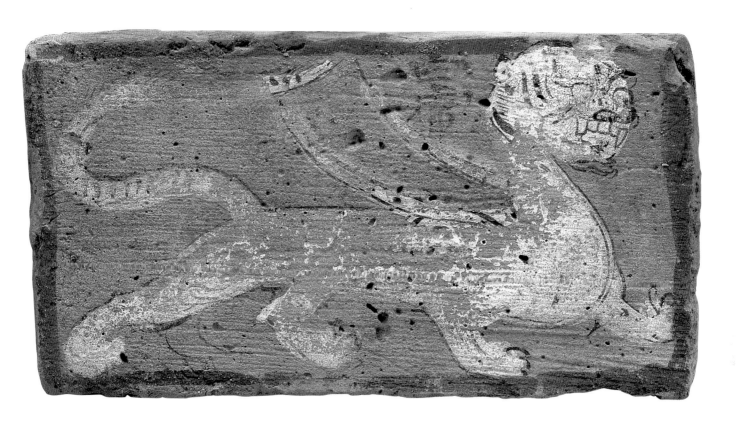

116.白虎图

西晋（265～316年）

高15、宽30厘米

1991年甘肃省敦煌市佛爷庙湾墓群1号墓出土。现存于敦煌市博物馆。

墓向280°。位于墓葬照墙。在砖面上用白垩涂出大形后，再于其上以墨线绘出轮廓等，物像轮廓外不施白垩。白虎昂首迈进，肩有双翼。上方有墨书"白虎"题名。

（撰文：郭永利 摄影：傅立诚）

White Tiger

Western Jin (265-316 CE)

Height 15 cm; Width 30 cm

Unearthed from tomb at M1 at cemetery of Foyemiaowan in Dunhuang, Gansu, in 1991. Preseved in Dunhuang Museum.

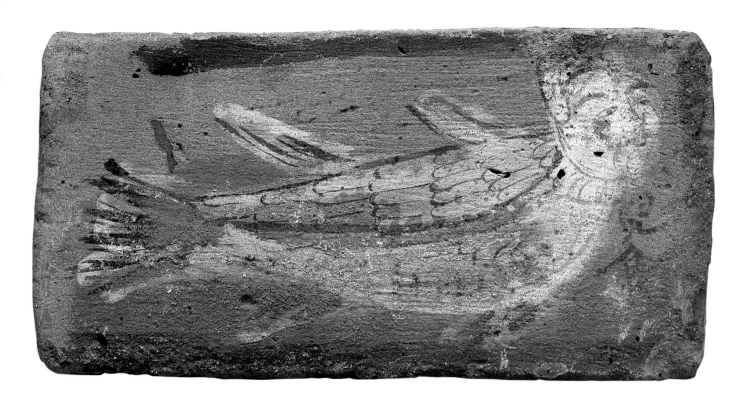

117. 鲵鱼图

西晋（265～316年）

高15、宽30厘米

1991年甘肃省敦煌市佛爷庙湾墓群1号墓出土。现存于敦煌市博物馆。

墓向280°。位于墓葬照墙。在砖面上用白垩涂出大形后，再于其上以墨线绘出轮廓等，物像轮廓外不施白垩。画面中的鲵鱼人首鱼身，双耳上立，俗称娃娃鱼。右下方题名"儿鱼"（即鲵鱼）。为祥瑞。

（撰文：郭永利 摄影：傅立诚）

Salamander Fish

Western Jin (265-316 CE)

Height 15 cm; Width 30 cm

Unearthed from tomb at M1 at cemetery of Foyemiaowan in Dunhuang, Gansu, in 1991. Preseved in Dunhuang Museum.

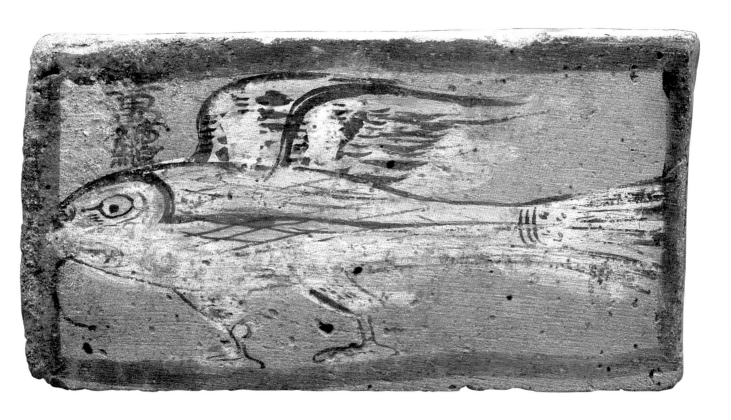

118.万鱣图

西晋（265～316年）

高15、宽30厘米

1991年甘肃省敦煌市佛爷庙湾墓群1号墓出土。现存于敦煌市博物馆。

墓向280°。位于墓葬照墙。在砖面上用白垩涂出大形后，再于其上以墨线绘出轮廓等，物像轮廓外不施白垩。画面中动物鱼身鸟翼，下有一双鸟足，应为飞鱼。左上方题名为"万鱣"，是动物祥瑞之一。

（撰文：郭永利 摄影：傅立诚）

Wanshan (Winged Sturgeon)

Western Jin (265-316 CE)

Height 15 cm; Width 30 cm

Unearthed from tomb at M1 at cemetery of Foyemiaowan in Dunhuang, Gansu, in 1991. Preseved in Dunhuang Museum.

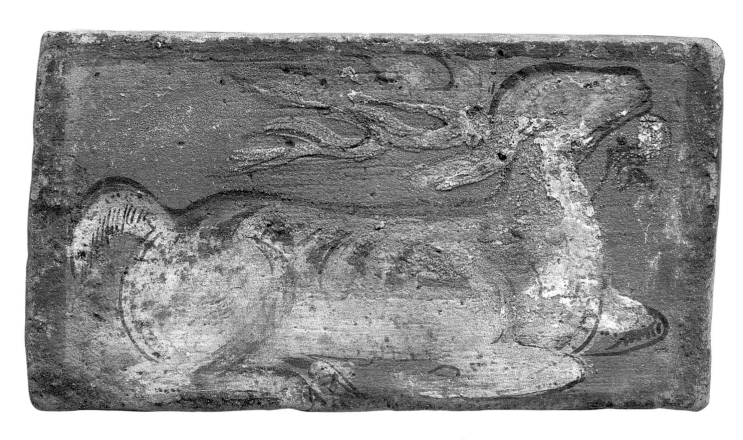

119.鹿图

西晋（265～316年）

高15、宽30厘米

1991年甘肃省敦煌市佛爷庙湾墓群1号墓出土。现存于敦煌市博物馆。

墓向280°。位于墓葬照墙。在砖面上用白垩涂出大形后，再于其上以墨线绘出轮廓等，物像轮廓外不施白垩。画面中鹿头高昂，大角后扬，呈卧姿。右侧有题名"鹿"。

（撰文：郭永利 摄影：傅立诚）

Deer

Western Jin (265-316 CE)

Height 15 cm; Width 30 cm

Unearthed from tomb at M1 at cemetery of Foyemiaowan in Dunhuang, Gansu, in 1991. Preseved in Dunhuang Museum.

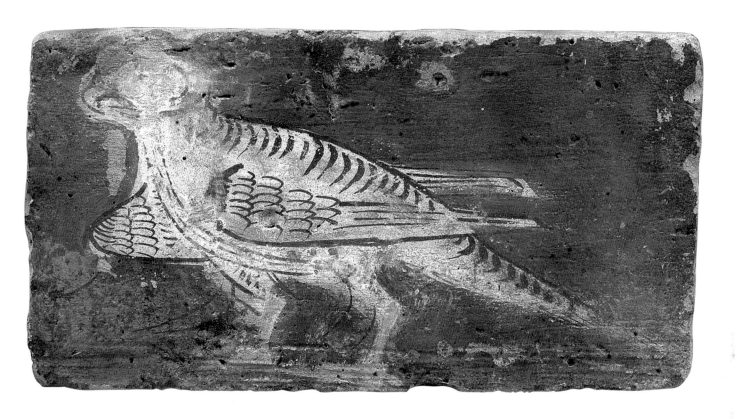

120.鹦鹉图

西晋（265～316年）

高17、宽26厘米

1985年甘肃省敦煌市佛爷庙湾墓群出土。现存于敦煌市博物馆。

墓葬方向不详。位置不详。在砖面上用白垩涂出大形后，再于其上以墨线绘出轮廓等，物像轮廓外不施白垩。画面中鹦鹉头昂起，钩喙，立姿，长尾向下，背、尾部有斑纹，双翼绘出细密的羽毛。画法精细。

（撰文：郭永利 摄影：傅立诚）

Parrot

Western Jin (265-316 CE)

Height 17 cm; Width 26 cm

Unearthed from tomb at cemetery of Foyemiaowan in Dunhuang, Gansu, in 1985. Preseved in Dunhuang Museum.

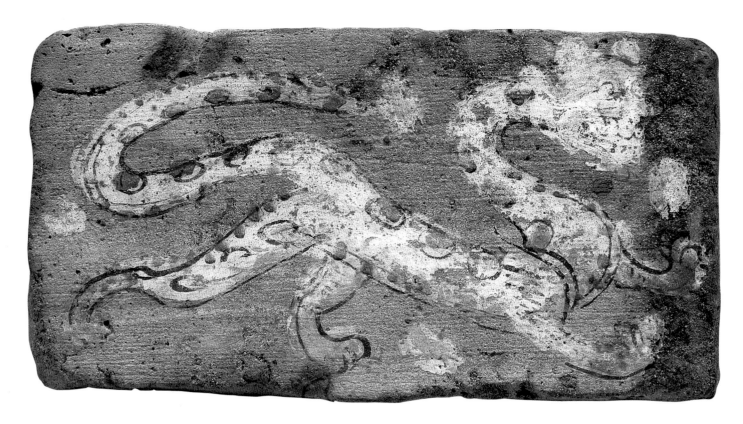

121. 神兽图

西晋（265～316年）

高16、宽31.5厘米

1995年甘肃省敦煌市佛爷庙湾墓群118号墓出土。现存于敦煌市博物馆。

墓向265°。位于墓葬照墙的中部。在砖面上用白垩涂出大形后，再于其上以墨线绘出轮廓等，物像轮廓外不施白垩。画面中的麃鼊头抬起，双眼圆睁，身体细长，尾上卷，颈、背、尾部有圆斑。为祥瑞之一。

（撰文：郭永利 摄影：傅立诚）

Mythical Animal

Western Jin (265-316 CE)

Height 16 cm; Width 31.5 cm

Unearthed from tomb M118 at cemetery of Foyemiaowan in Dunhuang, Gansu, in 1995. Preserved in Dunhuang Museum.

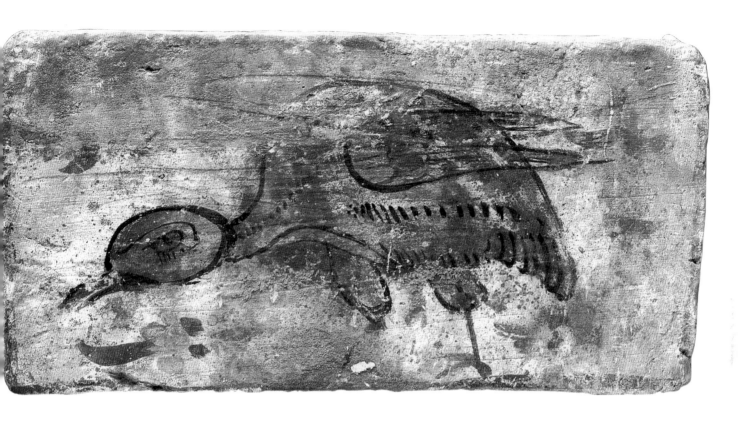

122.赤雀图

西晋（265～316年）

高约16、宽约31.5厘米

1997年甘肃省瓜州县踏实墓群2号墓出土。现存于瓜州县博物馆。

位于墓葬照墙。在砖面上涂白垩后绘画。赤雀圆睛长喙，淡墨色绘出身体，细长足，尾下垂，作低首觅食状。为祥瑞之一。

（撰文：郭永利 摄影：傅立诚）

Scarlet Bird

Western Jin (265-316 CE)

Height 16 cm; Width 31.5 cm

Unearthed from Tomb M2 at Tashi cemetery in Guazhou, Gansu, in 1997. Preserved in Guazhou Museum.

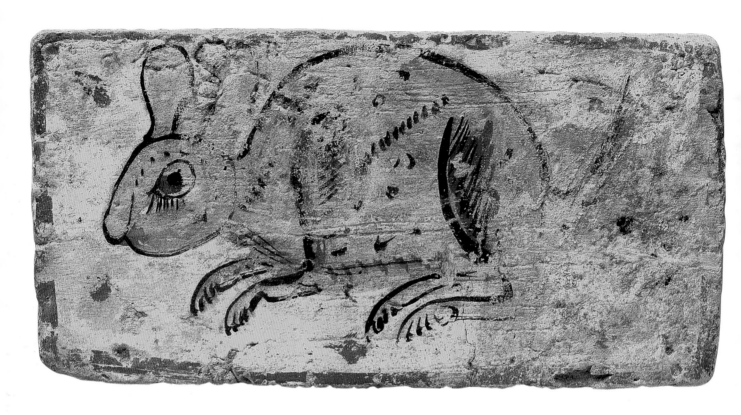

123.白兔图

西晋（265～316年）

高约16、宽约315厘米

1997年甘肃省瓜州县踏实墓群2号墓出土。现存于瓜州县博物馆。

位于墓葬照墙。在砖面上涂白垩后绘画。白兔四肢蜷曲，双耳直立。

（撰文：郭永利 摄影：傅立诚）

White Rabbit

Western Jin (265-316 CE)

Height 16 cm; Width 31.5 cm

Unearthed from Tomb M2 at Tashi cemetery in Guazhou, Gansu, in 1997. Preserved in Guazhou Museum.

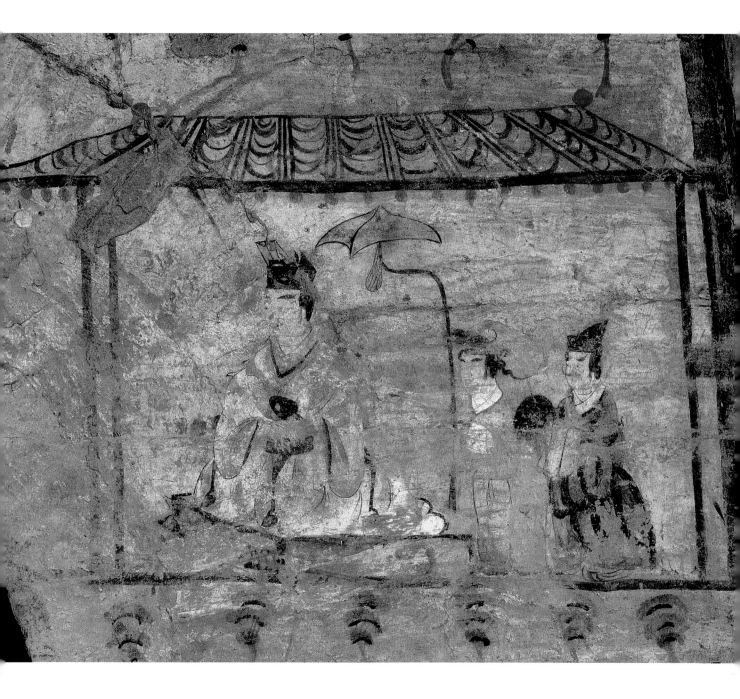

124.墓主图

十六国（304～439年）

高约80、宽约110厘米

1977年甘肃省酒泉市果园乡丁家闸5号墓出土。原址保存。

墓向92°。位于墓葬前室西壁中层的北端。壁画是在墓壁先抹一层草拌泥层后，再涂一层细黄土泥皮，再于其上绘画。墓主人头着三梁进贤冠，身着交领袍服，手持麈尾，凭几坐于榻上，头顶上有华盖，于亭内观赏乐舞。身后立有男女二侍者，男侍戴小冠捧盒而立，女侍梳高髻着短衣，手持曲柄华盖。人物神采鲜明，画风趋于精细。

<div align="right">（撰文、摄影：郭永利）</div>

Portrait of Tomb Occupant

Sixteen-States Period (304-439 CE)

Height ca. 80 cm; Width ca. 110 cm

Unearthed from Tomb M5 at Dingjiazha of Guoyuanxiang in Jiuquan, Gansu, in 1997. Preserved on the original site.

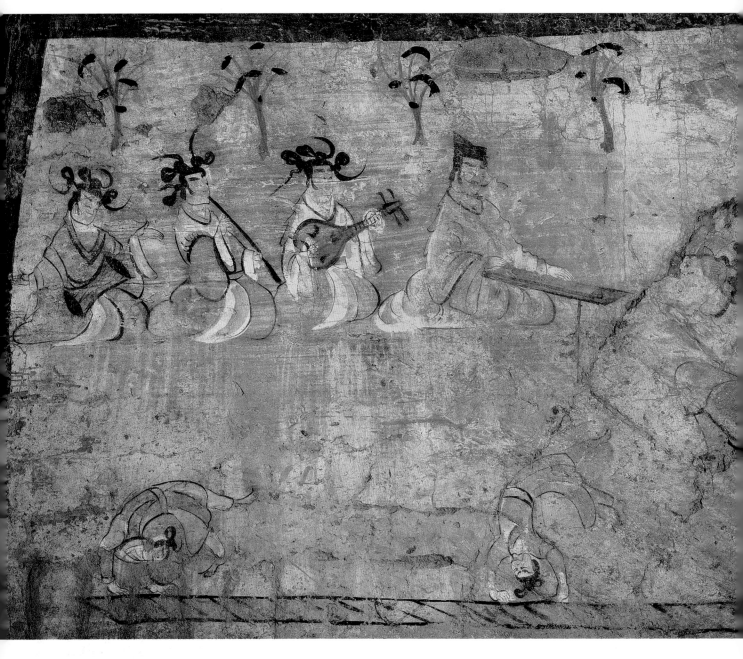

125. 乐舞图

十六国（304～439年）

高约100、宽约100厘米

1977年甘肃省酒泉市果园乡丁家闸5号墓出土。原址保存。

墓向92°。位于墓葬前室西壁中层的南端。壁画是在墓壁先抹一层草拌泥层后，再涂一层细黄土泥皮，再于其上绘画。四乐伎正在表演，前面男乐伎头着小冠，在弹卧箜篌，第二个女伎手持阮，其后女伎在吹长笛，最后的女伎在拍细腰鼓。下方有女伎在表演百戏。

<div style="text-align: right;">（撰文、摄影：郭永利）</div>

Music, Dancing and Acrobatics Performance

Sixteen-States Period (304-439 CE)

Height ca. 100 cm; Width ca. 100 cm

Unearthed from Tomb M5 at Dingjiazha of Guoyuanxiang in Jiuquan, Gansu, in 1997. Preserved on the original site.

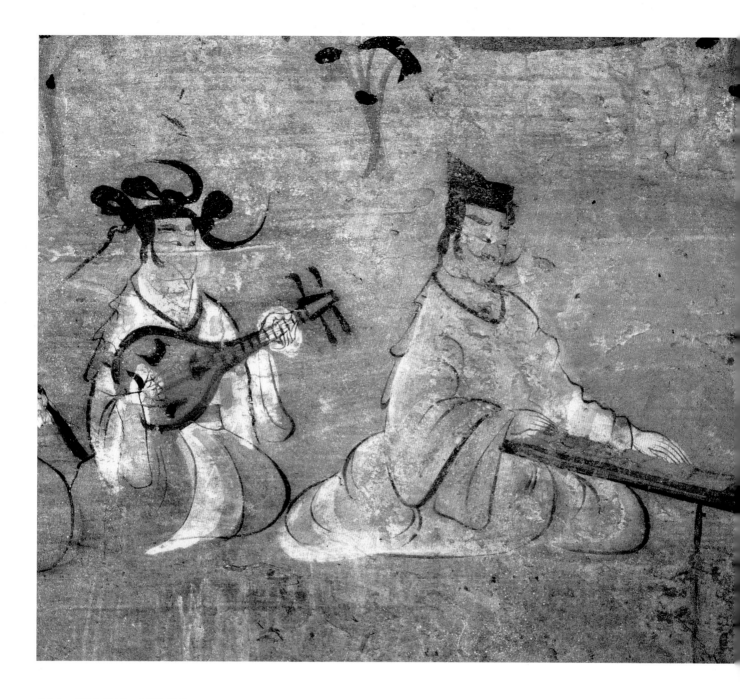

126. 乐舞图（局部）

十六国（304～439年）

高约30厘米、宽约50厘米

1977年甘肃省酒泉市果园乡丁家闸5号墓出土。原址保存。

此图为上页乐舞图局部。

<div align="right">（撰文、摄影：郭永利）</div>

Music, Dancing and Acrobatics Performance (Detail)

Sixteen-States Period (304-439 CE)

Height ca. 30 cm; Width ca. 50 cm

Unearthed from Tomb M5 at Dingjiazha of Guoyuanxiang in Jiuquan, Gansu, in 1997. Preserved on the original site.

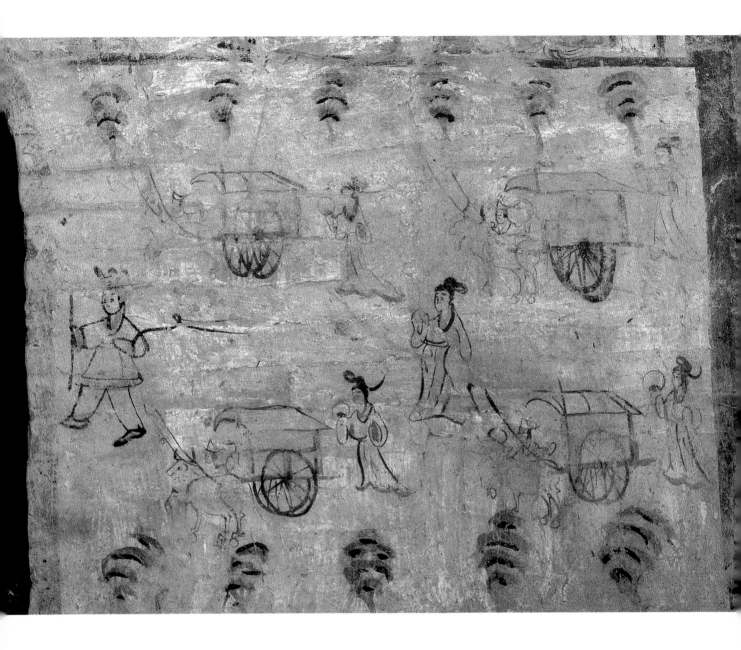

127. 女墓主出行图

十六国（304～439年）

高约85、宽约110厘米

1977年甘肃省酒泉市果园乡丁家闸5号墓出土。原址保存。

墓向92°。位于墓葬前室西壁下层的北端。壁画是在墓壁先抹一层草拌泥层后，再涂一层细黄土泥皮，再于其上绘画。画面是由女婢和牛车组成的女墓主出行图。共绘了四辆车，每车均有驭夫和女婢，在最前端有一位女性导从，中间还有一位女婢身形较为高大，应为身份较高的女婢。此图体现了女墓主的身份和地位。

（撰文、摄影：郭永利）

Procession of the Female Tomb Occupant

Sixteen-States Period (304-439 CE)

Height ca. 85 cm; Width ca. 110 cm

Unearthed from Tomb M5 at Dingjiazha of Guoyuanxiang in Jiuquan, Gansu, in 1997. Preserved on the original site.

128. 西王母图

十六国（304～439年）

高约150、宽约300厘米

1977年甘肃省酒泉市果园乡丁家闸5号墓出土。原址保存。

墓向92°。位于墓葬前室西壁的上层。壁画是在墓壁先抹一层草拌泥层后，再涂一层细黄土泥皮，再于其上绘画。西王母头梳髻，肩有双翼，正面拱手端坐于云柱座上。身旁有侍女手持曲柄华盖侍立。头顶上有月，再上为倒悬的龙首。云柱座两侧为三足乌和九尾狐，下部为连绵的昆仑山，山顶有飞翔着的三青鸟。周围绘大朵的云气。

（撰文、摄影：郭永利）

Xiwangmu (Queen Mother of the West)

Sixteen-States Period (304-439 CE)

Height ca. 150 cm; Width ca. 300 cm

Unearthed from Tomb M5 at Dingjiazha of Guoyuanxiang in Jiuquan, Gansu, in 1997. Preserved on the original site.

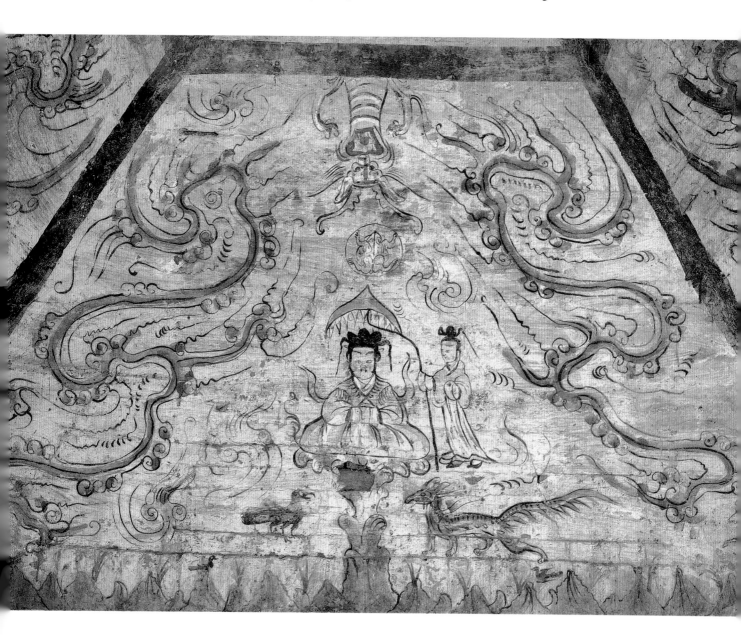

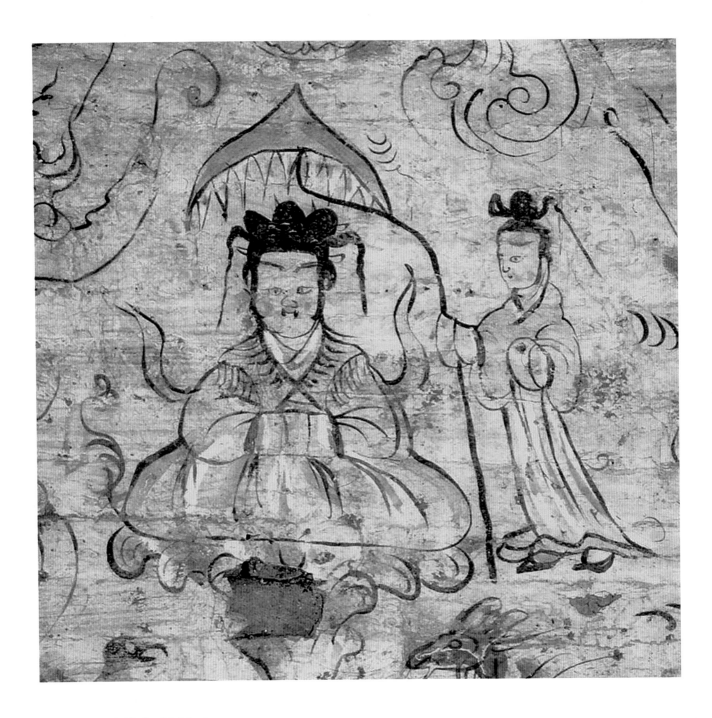

129. 西王母图（局部）

十六国（304～439年）

1977年甘肃省酒泉市果园乡丁家闸5号墓出土。原址保存。

墓向92°。位于墓葬前室西壁的上层。壁画是在墓壁先抹一层草拌泥层后，再涂一层细黄土泥皮，再于其上绘画。西王母头梳髻，肩有双翼，正面拱手端坐于云柱座上。身旁有侍女手持曲柄华盖侍立。头顶上有月，再上为倒悬的龙首。云柱座两侧为三足乌和九尾狐，下部为连绵的昆仑山，山顶有飞翔着的三青鸟。周围绘大朵的云气。

（撰文、摄影：郭永利）

Xiwangmu (Queen Mother of the West)(Detail)

Sixteen-States Period (304-439 CE)

Unearthed from Tomb M5 at Dingjiazha of Guoyuanxiang in Jiuquan, Gansu, in 1997. Preserved on the original site.

130. 东王公图

十六国（304～439年）

高约150、宽约300厘米

1977年甘肃省酒泉市果园乡丁家闸5号墓出土。原址保存。

墓向92°。位于墓葬前室东壁的上层。壁画是在墓壁先抹一层草拌泥层后，再涂一层细黄土泥皮，再于其上绘画。东王公头戴三尖状冠，肩部有双翼，拱手正面端坐于云柱座上，下面为连绵的昆仑山。头顶有日，日中有三足乌，再上有倒悬的龙首。周围是大朵的云气。

（撰文、摄影：郭永利）

Dongwanggong (King Father of the East)

Sixteen-States Period (304-439 CE)

Height ca. 150 cm; Width ca. 300 cm

Unearthed from Tomb M5 at Dingjiazha of Guoyuanxiang in Jiuquan, Gansu, in 1997. Preserved on the original site.

131. 飞马图

十六国（304～439年）

高约150、宽约300厘米

1977年甘肃省酒泉市果园乡丁家闸5号墓出土。原址保存。

墓向92°。位于墓葬前室南壁的上层。壁画是在墓壁先抹一层草拌泥层后，再涂一层细黄土泥皮，再于其上绘画。一匹白马，鬃、蹄、尾及头部、眼鼻均为红色，正奋力向前飞奔。画面顶部绘倒悬的龙首，下面为连绵的昆仑山，周围绘云气。

（撰文、摄影：郭永利）

Galloping White Horse

Sixteen-States Period (304-439 CE)

Height ca. 150 cm; Width ca. 300 cm

Unearthed from Tomb M5 at Dingjiazha of Guoyuanxiang in Jiuquan, Gansu, in 1997. Preserved on the original site.

132.扬场图

十六国（304～439年）

高约85、宽约100厘米

1977年甘肃省酒泉市果园乡丁家闸5号墓出土。原址保存。

墓向92°。位于墓葬前室南壁中层。壁画是在墓壁先抹一层草拌泥层后，再涂一层细黄土泥皮，再于其上绘画。画面中一座坞前，有几堆三角形状的粮食堆，一个着尖顶帽的男子手扬叉在扬场，粮堆前绘出几只鸡，增加了生活趣味。

（撰文、摄影：郭永利）

Winnowing

Sixteen-States Period (304-439 CE)

Height ca. 85 cm; Width ca. 100 cm

Unearthed from Tomb M5 at Dingjiazha of Guoyuanxiang in Jiuquan, Gansu, in 1997. Preserved on the original site.

133.社树图

十六国（304～439年）

高约85、宽约100厘米

1977年甘肃省酒泉市果园乡丁家闸5号墓出土。原址保存。

墓向92°。位于墓葬前室南壁底层。壁画是在墓壁先抹一层草拌泥层后，再涂一层细黄土泥皮，再于其上绘画。面中绘有一棵社树，有繁茂巨大的树冠，其上有鹦鹉、青鸟和一只正在攀树向下张望的玃。树下有一平台，平台有柱支撑，柱头有斗拱，台上有一棵女手持帚正在扫平台，平台两侧均绘小树，小树与大树形成鲜明的对比。

<div align="right">（撰文：郭永利　摄影：张宝玺）</div>

Tree of She (God of Soil) Shrine

Sixteen-States Period (304-439 CE)

Height ca. 85 cm; Width ca. 100 cm

Unearthed from Tomb M5 at Dingjiazha of Guoyuanxiang in Jiuquan, Gansu, in 1997. Preserved on the original site.

134.仁鹿图

十六国（304～439年）

高约70、宽约100厘米

1977年甘肃省酒泉市果园乡丁家闸5号墓出土。原址保存。

墓向92°。位于墓葬前室北壁上层中央。壁画是在墓壁先抹一层草拌泥层后，再涂一层细黄土泥皮，再于其上绘画。白鹿大角后扬，奋蹄飞驰。下面为昆仑山，周围绘云气。

<div align="right">（撰文、摄影：郭永利）</div>

Kind Deer

Sixteen-States Period (304-439 CE)

Height ca. 70 cm; Width ca. 100 cm

Unearthed from Tomb M5 at Dingjiazha of Guoyuanxiang in Jiuquan, Gansu, in 1997. Preserved on the original site.

135.捕鸟图

十六国（304～439年）

高约30、宽约60厘米

1977年甘肃省酒泉市果园乡丁家闸5号墓出土。原址保存。

墓向92°。位于墓葬前室北壁上层中央。壁画是在墓壁先抹一层草拌泥层后，再涂一层细黄土泥皮，再于其上绘画。一位老者居于穹庐内，正张网罗鸟，网前站立着一只鹰。下面为连绵的昆仑山，山间可见有牛、羊及飞鸟等祥瑞动物。

（撰文、摄影：郭永利）

Trapping Birds

Sixteen-States Period (304-439 CE)

Height ca. 30 cm; Width ca. 60 cm

Unearthed from Tomb M5 at Dingjiazha of Guoyuanxiang in Jiuquan, Gansu, in 1977. Preserved on the original site.

136.羽人图

十六国（304～439年）

高约30、宽约60厘米

1977年甘肃省酒泉市果园乡丁家闸5号墓出土。原址保存。

墓向92°。位于墓葬前室北壁上层。壁画是在墓壁先抹一层草拌泥层后，再涂一层细黄土泥皮，再于其上绘画。羽人为妇女模样，头梳高髻，脑后飘长发，肩有双翼，正在向上飞升。

（撰文、摄影：郭永利）

Winged Immortal

Sixteen-States Period (304-439 CE)

Height ca. 30 cm; Width ca. 60 cm

Unearthed from Tomb M5 at Dingjiazha of Guoyuanxiang in Jiuquan, Gansu, in 1977. Preserved on the original site.

▲ 137.通幰车

十六国（304～439年）

高约80、宽约90厘米

1977年甘肃省酒泉市果园乡丁家闸5号墓出土。原址保存。

墓向92°。位于墓葬前室北壁中层。壁画是在墓壁先抹一层草拌泥层后，再涂一层细黄土泥皮，再于其上绘画。车前有一人持鞭站立，车后有一牛闲卧。车上张青幰，皂轮。《晋书·舆服志》："通幰车，驾牛，犹如今犊车制，但举其幰通覆车上也。诸王三公并乘之。"由此来看，墓主身份较高。

（撰文：郭永利 摄影：张宝玺）

Tongxian (Completely Curtained) Ox Cart

Sixteen-States Period (304-439 CE)

Height ca. 80 cm; Width ca. 90 cm

Unearthed from Tomb M5 at Dingjiazha of Guoyuanxiang in Jiuquan, Gansu, in 1977. Preserved on the original site.

138.树下射鸟图 ▶

十六国（304～439年）

高约50、宽约40厘米

1977年甘肃省酒泉市果园乡丁家闸5号墓出土。原址保存。

墓向92°。位于墓葬前室北壁中层。壁画是在墓壁先抹一层草拌泥层后，再涂一层细黄土泥皮，再于其上绘画。坞门前有棵大树，一男子立于门前，手持弓向树上的鸟射去。

（撰文：郭永利 摄影：陈志安 彭华士）

Shooting Perched Bird

Sixteen-States Period (304-439 CE)

Height ca. 50 cm; Width ca. 40 cm

Unearthed from Tomb M5 at Dingjiazha of Guoyuanxiang in Jiuquan, Gansu, in 1977. Preserved on the original site.

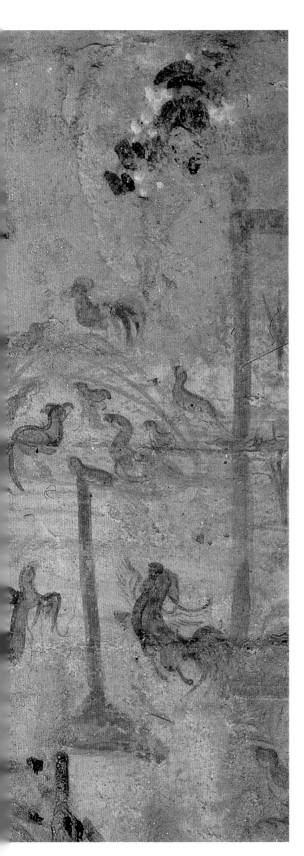

139.坞与斗鸡图

十六国（304～439年）

高约50、宽约65厘米

1977年甘肃省酒泉市果园乡丁家闸5号墓出土。原址保存。

墓向92°。位于墓葬前室北壁下层。壁画是在墓壁先抹一层草拌泥层后，再涂一层细黄土泥皮，再于其上绘画。画面中绘一座坞，坞中有高大的望楼，一披发仆人立于开着的坞门处。坞旁有鸡架，坞门前两只鸡正在相斗，极有生活气息。

（撰文：郭永利 摄影：张宝玺）

Roosters Fighting in Front of a Wu-Castle

Sixteen-States Period (304-439 CE)

Height ca. 50 cm; Width ca. 65 cm

Unearthed from Tomb M5 at Dingjiazha of Guoyuanxiang in Jiuquan, Gansu, in 1977. Preserved on the original site.

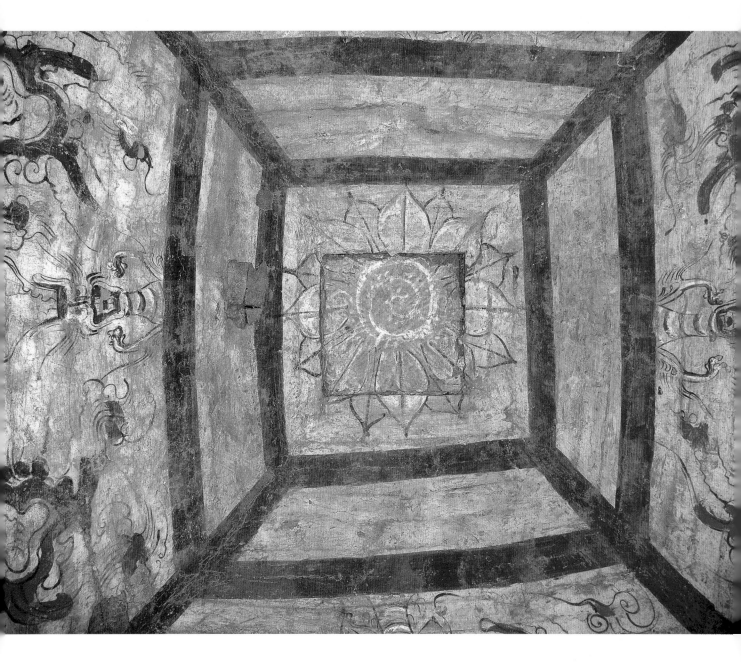

140.藻井图

十六国（304～439年）

高约50、宽约50厘米

1977年甘肃省酒泉市果园乡丁家闸5号墓出土。原址保存。

墓向92°。位于前室顶部中央的藻井处。壁画是在墓壁先抹一层草拌泥层后，再涂一层细黄土泥皮，再于其上绘画。井心绘复瓣莲花图案。

（撰文：郭永利 摄影：张宝玺）

Caisson Ceiling with Lotus Design

Sixteen-States Period (304-439 CE)

Height ca. 50 cm; Width ca. 50 cm

Unearthed from Tomb M5 at Dingjiazha of Guoyuanxiang in Jiuquan, Gansu, in 1977. Preserved on the original site.

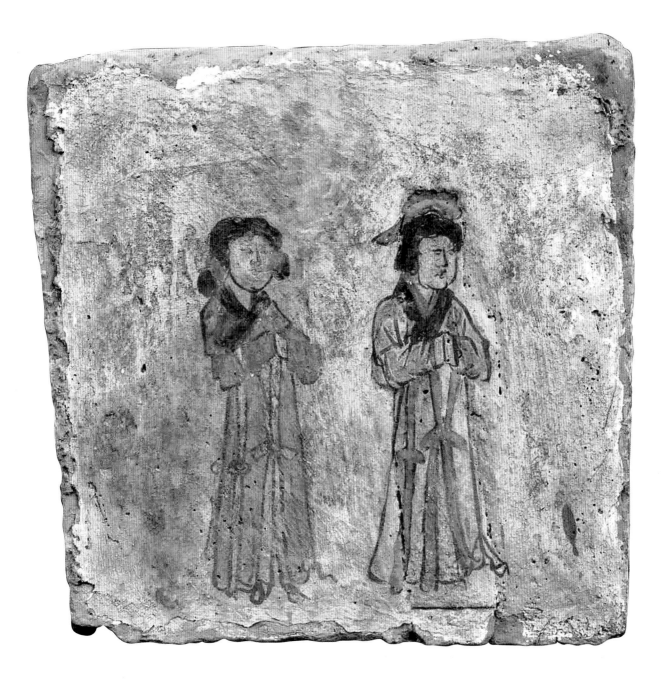

141.侍女图

金（1115～1234年）

高30.1、宽29.5厘米

甘肃省渭源县出土。现存于甘肃省博物馆。

砖面涂白垩，人物均以墨线勾勒轮廓，内填彩。图中二女侍，年长者居右，头顶挽髻，裹红巾，身着交领右衽白色长衫，腰间垂红色绦带，袖手而立；年幼者居左，梳左右双髻，上着红色交领右衽短襦，下着浅绿色长裙，腰间垂白色绦带，袖手而立。

（撰文：郭永利　摄影：甘肃省博物馆）

Maids

Jin (1115-1234 CE)

Height 30.1 cm; Width 29.5 cm

Unearthed from tomb at Weiyuan, Gansu. Preserved in Gansu Museum.

142.楼阁吉祥花卉图

金（1115～1234年）

1996年甘肃省清水县贾川乡出土。原址保存。

墓为东西向。墓室为仿木结构方形单室砖雕壁画墓。墓室四壁砖雕左右对称，以中间一排彩绘仰莲装饰带为界，大致分为上下两大部分。此图表现上部的山花向前式仿木构门楼形式，装饰有建筑彩绘。门楼两侧以彩绘砖雕和壁画并用配合的形式表现孝行题材；下部装饰折枝花卉、劳作人物（舂米、推磨）和动物题材的彩绘砖雕。从该墓的形制与壁画装饰风格推测，属金末墓葬。

（撰文：郭永利　摄影：南宝生）

Façade of Grandiose Mansion Decorated with Floral Patterns

Jin (1115-1234 CE)

Unearthed from tomb at Jiachuanxiang in Qingshui, Gansu, in 1996. Preserved on the original site.

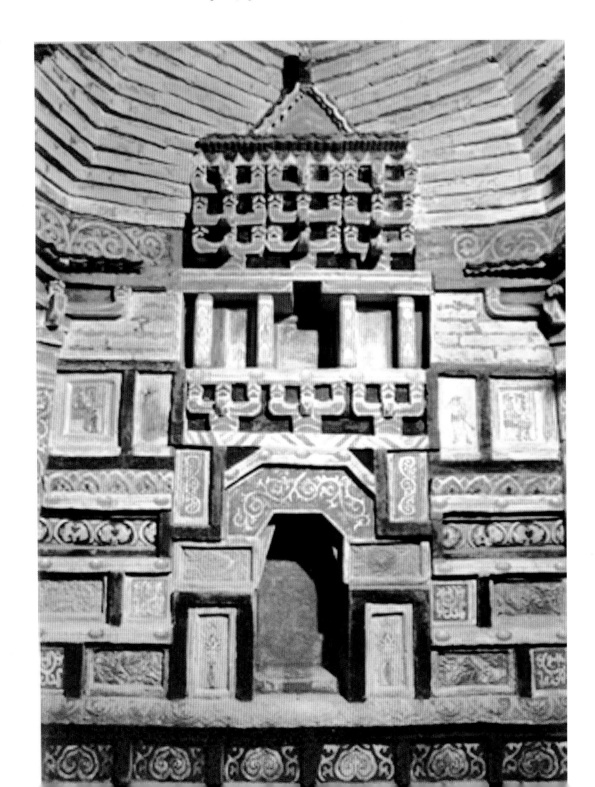

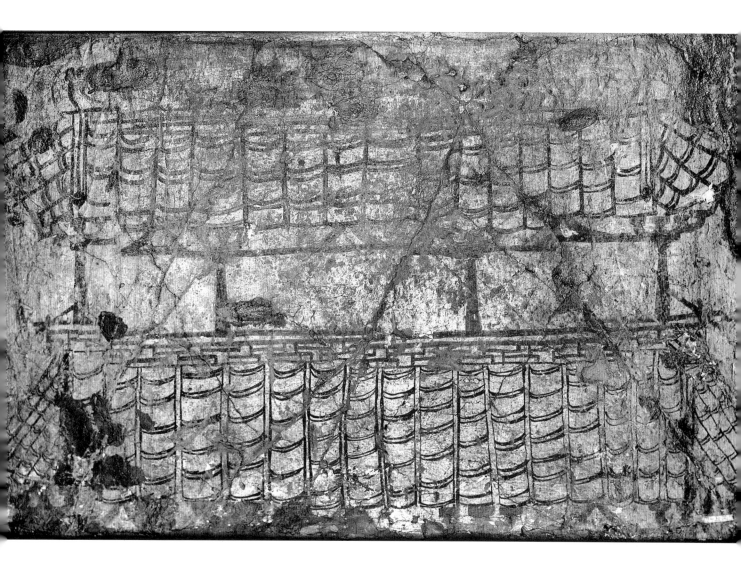

143.门楼图（一）

北周天和四年（569年）

高76、宽140厘米

1983年宁夏回族自治区固原市原州区西郊乡深沟村李贤夫妇合葬墓出土。现存于宁夏固原博物馆。

墓向175°。位于第一过洞口上方。门楼为双层。上层屋顶为庑殿式，正面三开间。柱头承托阑额，斗拱为一斗三升，补间人字拱，下部为单勾栏。下层屋顶、柱头、斗拱结构皆与上层同。

（撰文：姚蔚玲 摄影：边东冬）

Gatehouse (1)

4th Year of Tianhe Era, Northern Zhou (569 CE)

Height 76 cm; Width 140 cm

Unearthed from the joint tomb of Li Xian and his wife at Shengoucun of Xijiaoxiang in Yuanzhou District of Guyuan, Ningxia, in 1983. Preserved in Guyuan Museum in Ningxia.

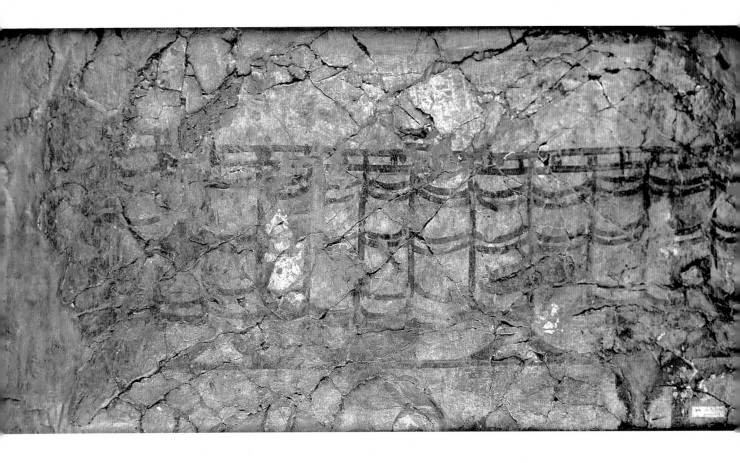

144.门楼图（二）（局部）

北周天和四年（569年）

高60、宽140厘米

1983年宁夏回族自治区固原市原州区西郊乡深沟村李贤夫妇合葬墓出土。现存于宁夏固原博物馆。

墓向175°。位于第二过洞口上方。门楼为单层。屋顶为庑殿式，正面三开间。柱头承托阑额，斗拱为一斗三升，补间人字拱。

（撰文：姚蔚玲　摄影：边东冬）

Gatehouse (2) (Detail)

4th Year of Tianhe Era, Northern Zhou (569 CE)

Unearthed from the joint tomb of Li Xian and his wife at Shengoucun of Xijiaoxiang in Yuanzhou District of Guyuan, Ningxia, in 1983. Preserved in Guyuan Museum in Ningxia.

145.武士图（一）（摹本）

北周天和四年（公元569年）

高160厘米

1983年宁夏回族自治区固原市原州区西郊乡深沟村李贤夫妇合葬墓出土。现存于宁夏固原博物馆。

墓向175°。位于第一过洞口外墓道西壁。武士头戴高冠，圆脸，络腮胡须，大耳垂肩。内穿袴褶服，外着圆领宽袖风衣，下摆成圆弧形垂，足穿麻履。双手拄仪刀，呈站立守卫状。

（临摹：中央美院师生　撰文：姚蔚玲

摄影：边东冬）

Warrior (1) (Replica)

4th Year of Tianhe Era, Northern Zhou (569 CE)

Height 160 cm

Unearthed from the joint tomb of Li Xian and his wife at Shengoucun of Xijiaoxiang in Yuanzhou District of Guyuan, Ningxia, in 1983. Preserved in Guyuan Museum in Ningxia.

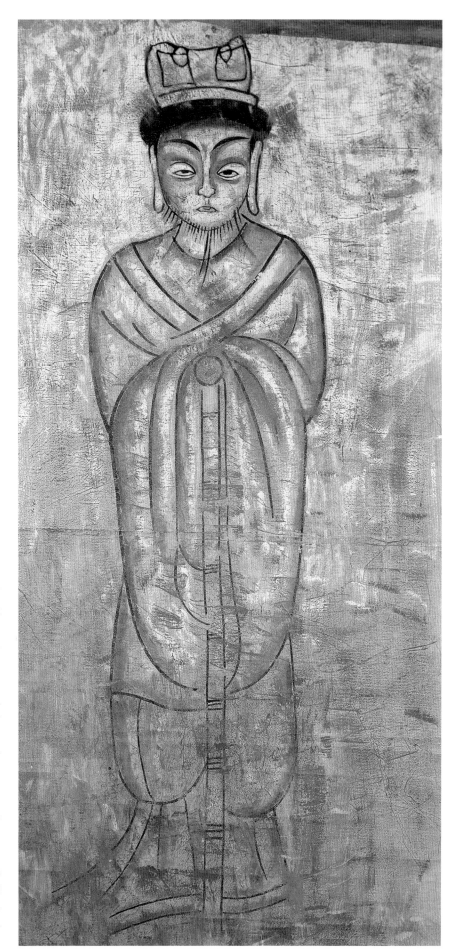

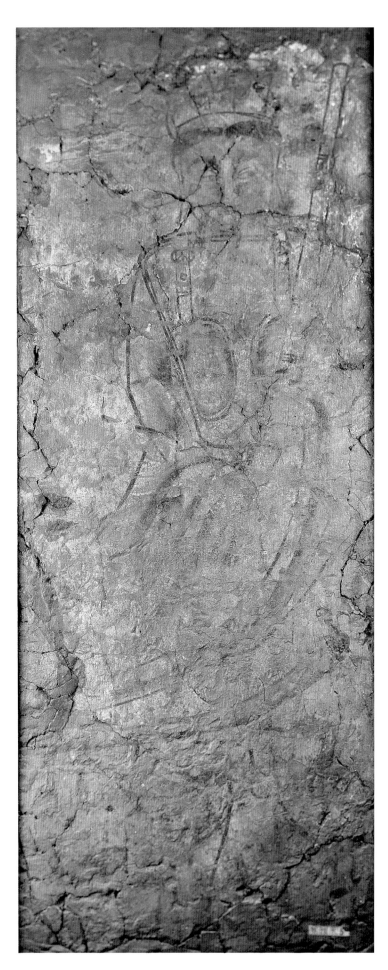

146.武士图（二）

北周天和四年（569年）

高140厘米

1983年宁夏回族自治区固原市原州区西郊乡深沟村李贤夫妇合葬墓出土。现存于宁夏固原博物馆。

墓向175°。位于第一过洞东壁。武士头戴冠，面相丰满，留三绺胡须，大耳垂肩。内穿袴褶服，宽袖，摆下垂，身着裲裆明光铠，腰束带，足穿尖头麻履。双手置胸前，左手反握刀柄，刀身向上斜靠左肩，呈站立守卫状。

（撰文：姚蔚玲 摄影：边东冬）

Warrior (2)

4th Year of Tianhe Era, Northern Zhou (569 CE)

Height 140 cm

Unearthed from the joint tomb of Li Xian and his wife at Shengoucun of Xijiaoxiang in Yuanzhou District of Guyuan, Ningxia, in 1983. Preserved in Guyuan Museum in Ningxia.

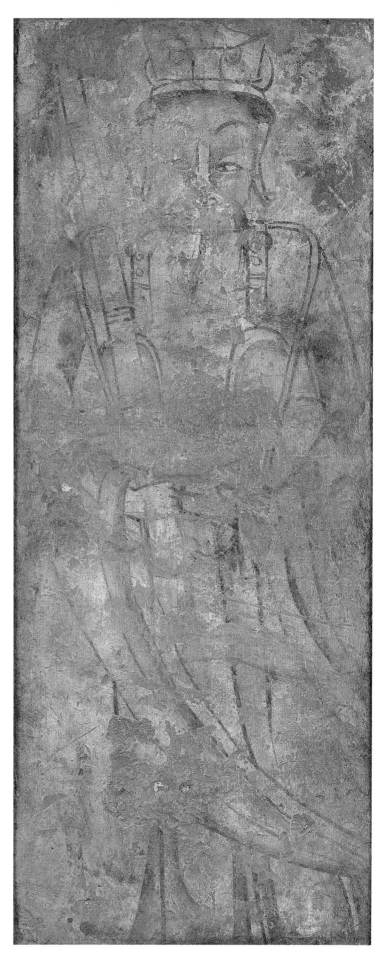

147.武士图（三）

北周天和四年（569年）

高140厘米

1983年宁夏回族自治区固原市原州区西郊乡深沟村李贤夫妇合葬墓出土。现存于宁夏固原博物馆。

墓向175°。位于第一过洞西壁。武士头戴冠，面相丰满，留三绺胡须，大耳垂肩。内穿袴褶服，宽袖，摆下垂，身着裲裆明光铠，腰束带，膝下加缚，足穿尖头麻履。双手置胸前，右手反握刀柄，刀身向上斜靠右肩，呈站立守卫状。

（撰文：姚蔚玲 摄影：程云侠）

Warrior (3)

4th Year of Tianhe Era, Northern Zhou (569 CE)

Height 140 cm

Unearthed from the joint tomb of Li Xian and his wife at Shengoucun of Xijiaoxiang in Yuanzhou District of Guyuan, Ningxia, in 1983. Preserved in Guyuan Museum in Ningxia.

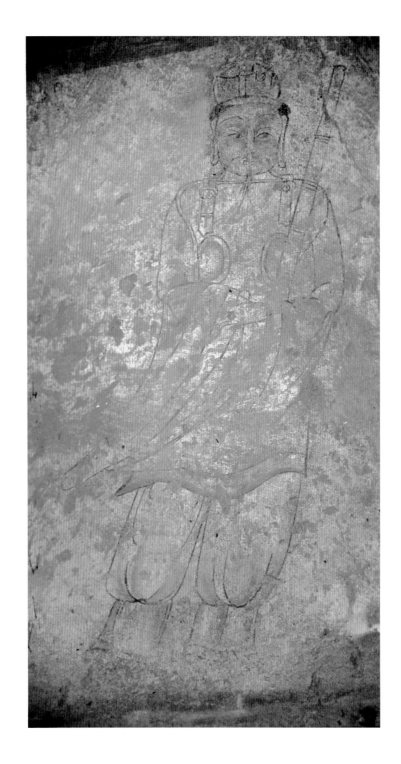

148.武士图（四）

北周天和四年（569年）

高160~170厘米

1983年宁夏回族自治区固原市原州区西郊乡深沟村李贤夫妇合葬墓出土。现存于宁夏固原博物馆。

墓向175°。位于第一天井东壁。武士头戴冠，面相丰满，留三绺胡须，大耳垂肩。内穿袴褶服，宽袖，身着裲裆明光铠，腰束带，足穿麻履。双手置胸前，左手腕夹住刀柄，刀身向上斜靠左肩，呈站立守卫姿势。

（撰文：姚蔚玲 摄影：宁夏文物考古研究所）

Warrior (4)

4th Year of Tianhe Era, Northern Zhou (569 CE)

Height 160-170 cm

Unearthed from the joint tomb of Li Xian and his wife at Shengoucun of Xijiaoxiang in Yuanzhou District of Guyuan, Ningxia, in 1983. Preserved in Guyuan Museum in Ningxia.

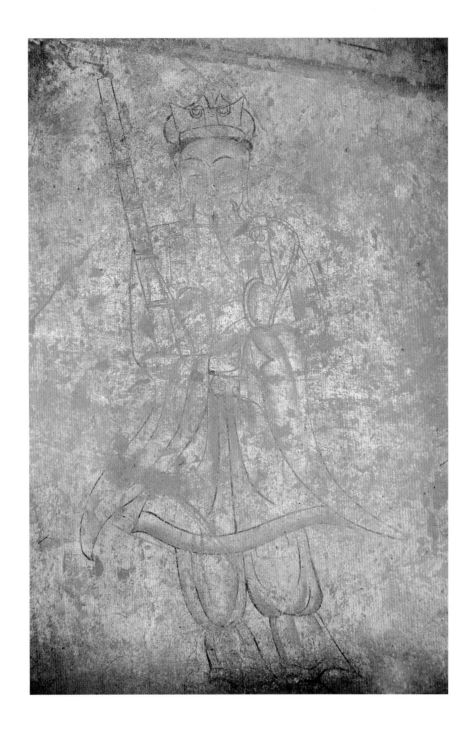

149. 武士图（五）

北周天和四年（569年）

高160～170厘米

1983年宁夏回族自治区固原市原州区西郊乡深沟村李贤夫妇合葬墓出土。现存于宁夏固原博物馆。

墓向175°。位于第一天井西壁。武士头戴冠，面相丰满，留三绺胡须，大耳垂肩。内穿袴褶服，宽袖，下摆敞开，身着裲裆明光铠，膝下束带，足穿麻履。双手置胸前，右臂夹住刀柄，刀身向上斜靠右肩，呈站立守卫姿势。

（撰文：姚蔚玲 摄影：宁夏文物考古研究所）

Warrior (5)

4th Year of Tianhe Era, Northern Zhou (569 CE)

Height 160-170 cm

Unearthed from the joint tomb of Li Xian and his wife at Shengoucun of Xijiaoxiang in Yuanzhou District of Guyuan, Ningxia, in 1983. Preserved in Guyuan Museum in Ningxia.

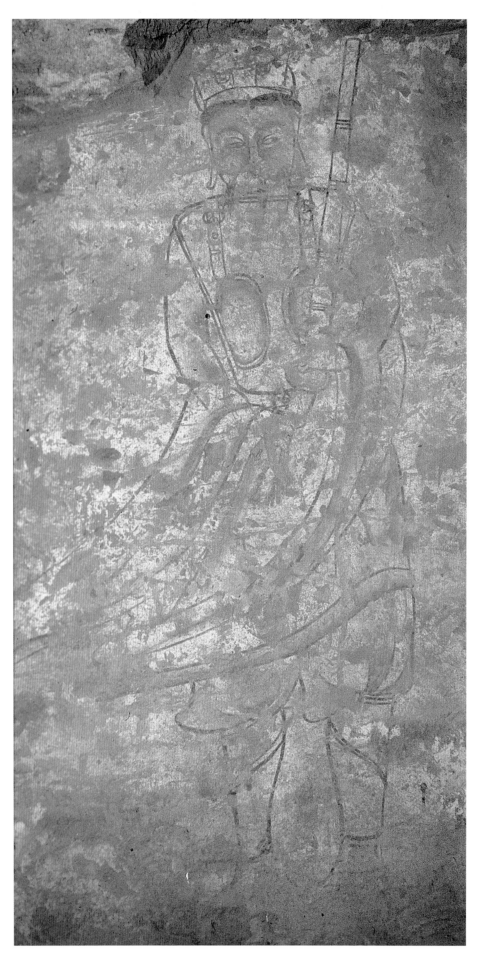

150.武士图（六）

北周天和四年（569年）

高140厘米

1983年宁夏回族自治区固原市原州区西郊乡深沟村李贤夫妇合葬墓出土。现存于宁夏固原博物馆。

墓向175°。位于第二过洞东壁。武士头戴冠，面相丰满，留三绺胡须，大耳垂肩。内穿袴褶服，宽袖，衣摆向右飘拂下垂，身着裲裆明光铠，腰束带，膝下加缚，足穿方头麻履。右手拿刀穗，左手握刀柄，刀身向上斜靠左肩，呈站立守卫状。

（撰文：姚蔚玲　摄影：宁夏文物
考古研究所）

Warrior (6)

4th Year of Tianhe Era, Northern Zhou (569 CE)

Height 140 cm

Unearthed from the joint tomb of Li Xian and his wife at Shengoucun of Xijiaoxiang in Yuanzhou District of Guyuan, Ningxia, in 1983. Preserved in Guyuan Museum in Ningxia.

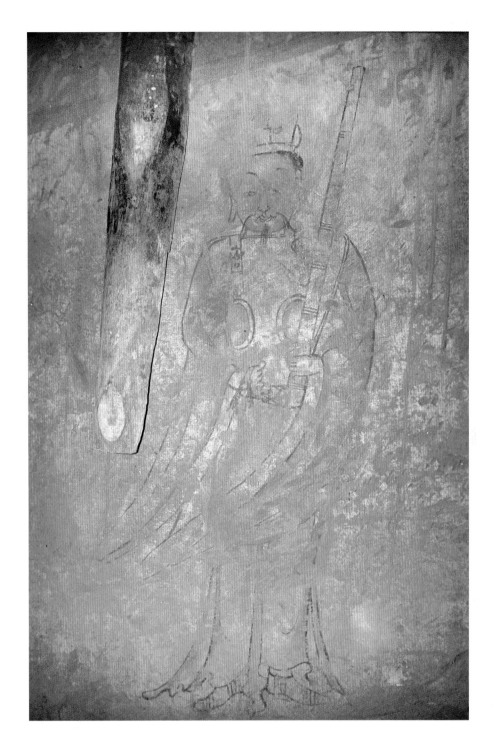

151.武士图（七）

北周天和四年（569年）

高160～170厘米

1983年宁夏回族自治区固原市原州区西郊乡深沟村李贤夫妇合葬墓出土。现存于宁夏固原博物馆。

墓向175°。位于第二天井东壁。武士头戴冠，面相丰满，留三绺胡须，大耳垂肩。内穿袴褶服，宽袖，身着裲裆明光铠，腰束带，足穿麻履。双手置胸前，左手腕夹住刀柄，刀身向上斜靠左肩，呈站立守卫姿势。

（撰文：姚蔚玲 摄影：宁夏文物考古研究所）

Warrior (7)

4th Year of Tianhe Era, Northern Zhou (569 CE)

Height 160-170 cm

Unearthed from the joint tomb of Li Xian and his wife at Shengoucun of Xijiaoxiang in Yuanzhou District of Guyuan, Ningxia, in 1983. Preserved in Guyuan Museum in Ningxia.

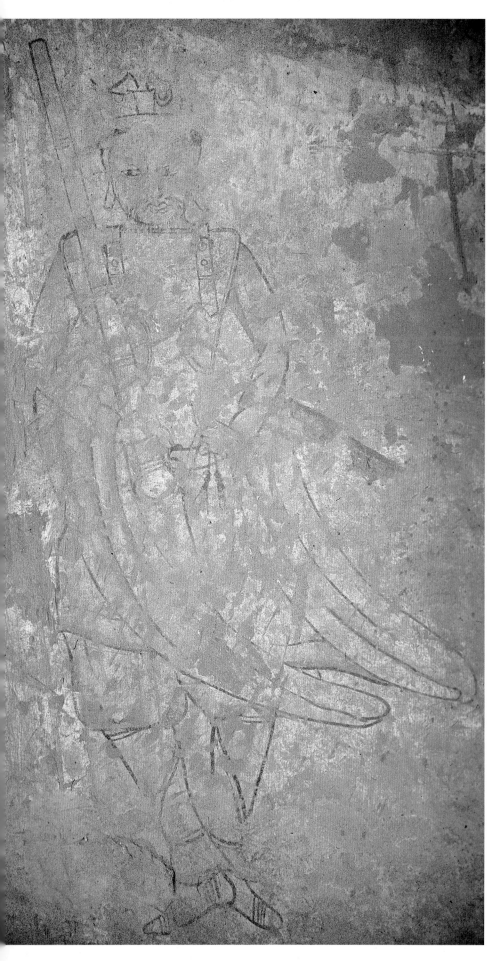

152.武士图（八）

北周天和四年（569年）

高160～170厘米

1983年宁夏回族自治区固原市原州区西郊乡深沟村李贤夫妇合葬墓出土。现存于宁夏固原博物馆。

墓向175°。位于第二天井西壁。武士头戴冠，面相丰满，留三绺胡须，大耳垂肩。内穿袴褶服，宽袖，下摆敞开，身着裲裆明光铠，膝下束带，足穿麻履。双手置胸前，左臂夹住刀柄，刀身向上斜靠右肩，呈站立守卫姿势。

（撰文：姚蔚玲　摄影：宁夏文物考古
研究所）

Warrior (8)

4th Year of Tianhe Era, Northern Zhou (569 CE)

Height 160-170 cm

Unearthed from the joint tomb of Li Xian and his wife at Shengoucun of Xijiaoxiang in Yuanzhou District of Guyuan, Ningxia, in 1983. Preserved in Guyuan Museum in Ningxia.

153.武士图（九）

北周天和四年（569年）

高140厘米

1983年宁夏回族自治区固原市原州区西郊乡深沟村李贤夫妇合葬墓出土。现存于宁夏固原博物馆。

墓向175°。位于第三过洞东壁。武士头戴冠，面相丰满，留三绺胡须，大耳垂肩。内穿袴褶服，宽袖，身着裲裆明光铠，足穿麻履。双手置胸前，左手反握刀柄，刀身向上斜靠左肩，呈站立守卫姿势。

（撰文：姚蔚玲 摄影：程云侠）

Warrior (9)

4th Year of Tianhe Era, Northern Zhou (569 CE)

Height 140 cm

Unearthed from the joint tomb of Li Xian and his wife at Shengoucun of Xijiaoxiang in Yuanzhou District of Guyuan, Ningxia, in 1983. Preserved in Guyuan Museum in Ningxia.

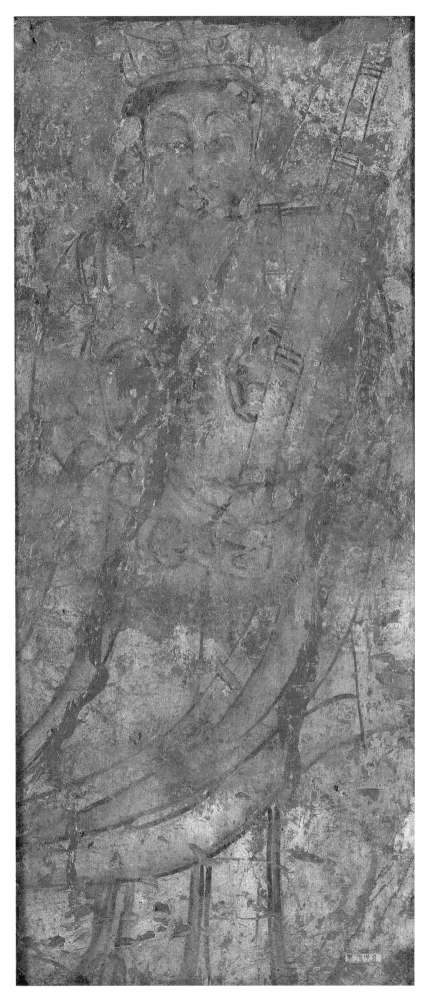

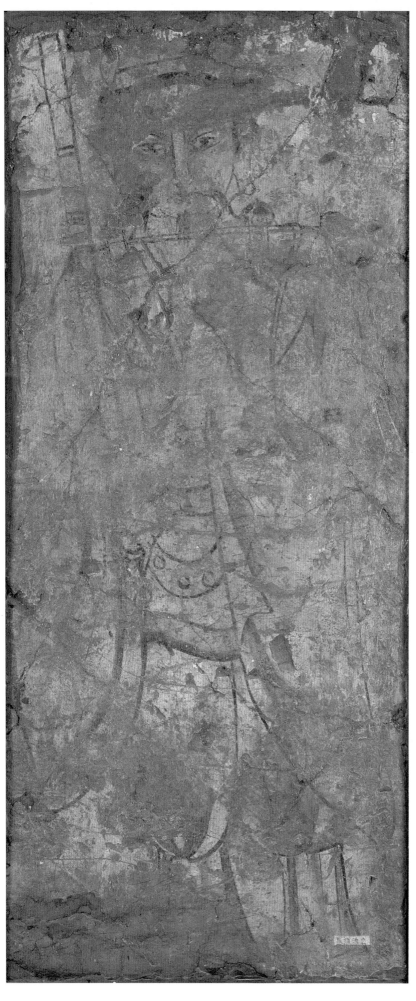

154.武士图（十）

北周天和四年（569年）

高140厘米

1983年宁夏回族自治区固原市原州区西郊乡深沟村李贤夫妇合葬墓出土。现存于宁夏固原博物馆。

墓向175°。位于第三过洞西壁。武士头戴冠，面相丰满，留三绺胡须，大耳垂肩。内穿袴褶服，宽袖，身着裲裆明光铠，足穿麻履。双手置胸前，左手拿物，右手反握刀柄，刀身向上斜靠右肩，呈站立守卫姿势。

（撰文：姚蔚玲 摄影：程云侠）

Warrior (10)

4th Year of Tianhe Era, Northern Zhou (569 CE)

Height 140 cm

Unearthed from the joint tomb of Li Xian and his wife at Shengoucun of Xijiaoxiang in Yuanzhou District of Guyuan, Ningxia,in 1983. Preserved in Guyuan Museum in Ningxia.

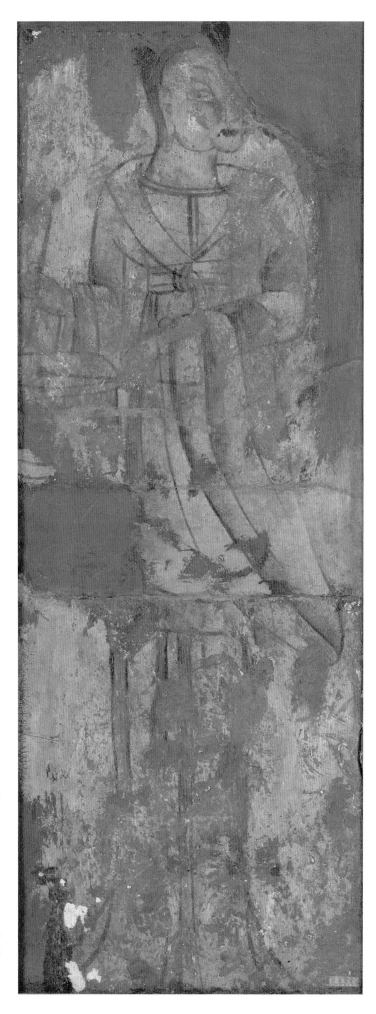

155.侍从伎乐图（一）

北周天和四年（569年）

高146厘米

1983年宁夏回族自治区固原市原州区西郊乡深沟村李贤夫妇合葬墓出土。现存于宁夏固原博物馆。

墓向175°。位于墓室南壁东端。侍女大耳，面部丰满，头梳双髻。内穿圆领衫，外着宽袖服，下裹裙。右侧腰间有小圆鼓，鼓的上下两端有莲瓣纹装饰，中间有带。其双手执槌击鼓，头向一侧偏转。

（撰文：姚蔚玲 摄影：程云侠）

Attending Drummer (1)

4th Year of Tianhe Era, Northern Zhou (569 CE)

Height 146 cm

Unearthed from the joint tomb of Li Xian and his wife at Shengoucun of Xijiaoxiang in Yuanzhou District of Guyuan, Ningxia, in 1983. Preserved in Guyuan Museum in Ningxia.

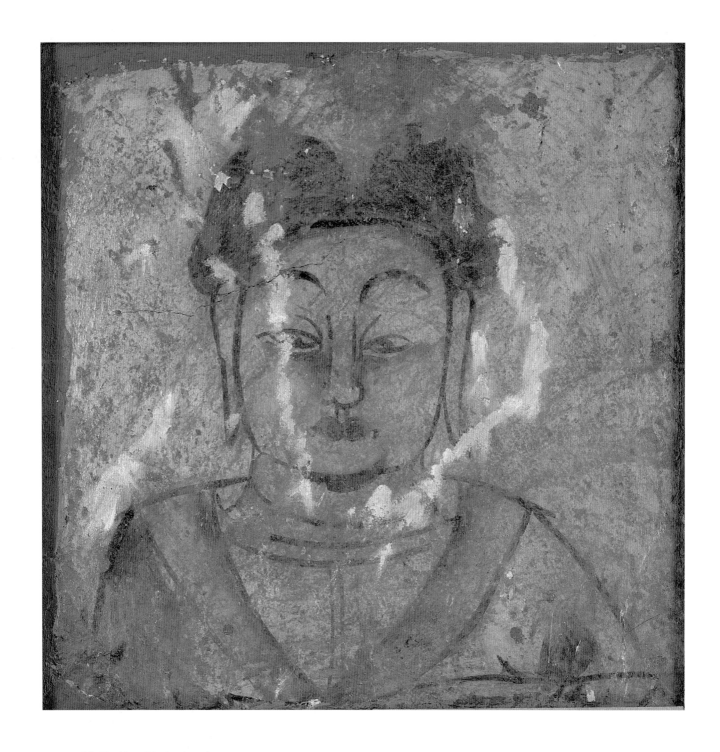

156.侍从伎乐图（二）

北周天和四年（569年）

高51厘米

1983年宁夏回族自治区固原市原州区西郊乡深沟村李贤夫妇合葬墓出土。现存于宁夏固原博物馆。

墓向175°。位于墓室南壁南端。已残，现存胸以上。侍女大耳垂肩，面相丰满，头梳双发髻。内穿圆领衫，外着交领服。

（撰文：姚蔚玲 摄影：程云侠）

Maid (2)

4th Year of Tianhe Era, Northern Zhou (569 CE)

Height 51 cm

Unearthed from the joint tomb of Li Xian and his wife at Shengoucun of Xijiaoxiang in Yuanzhou District of Guyuan, Ningxia, in 1983. Preserved in Guyuan Museum in Ningxia.

157.侍从伎乐图（三）

北周天和四年（569年）

高146厘米

1983年宁夏回族自治区固原市原州区西郊乡深沟村李贤夫妇合葬墓出土。现存于宁夏固原博物馆。

墓向175°。位于墓室西壁南端第一幅。侍女大耳垂肩，面相丰满，头梳双髻。内穿圆领衫，外着无领宽袖服，腰系带，下裹裙。右手执拂尘，左手于腹前握一物。

（撰文：姚蔚玲 摄影：边东冬）

Maid with Whisk (3)

4th Year of Tianhe Era, Northern Zhou (569 CE)

Height 146 cm

Unearthed from the joint tomb of Li Xian and his wife at Shengoucun of Xijiaoxiang in Yuanzhou District of Guyuan, Ningxia, in 1983. Preserved in Guyuan Museum in Ningxia.

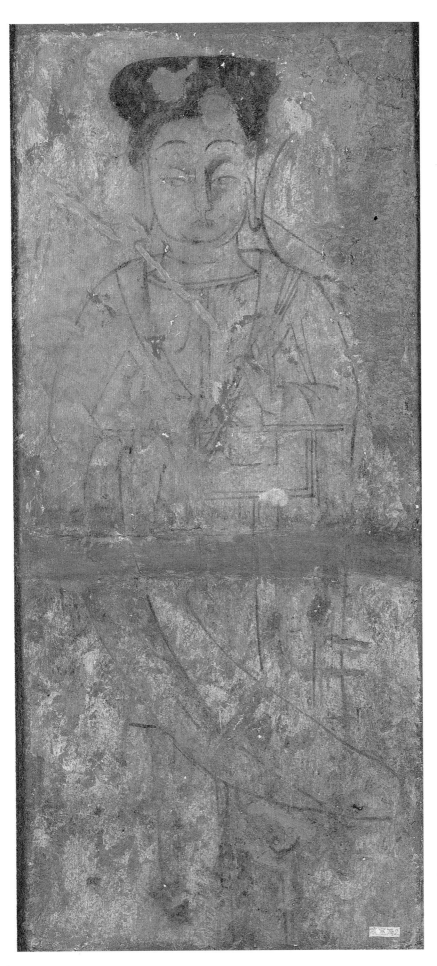

158.侍从伎乐图（四）

北周天和四年（569年）

高146厘米

1983年宁夏回族自治区固原市原州区西郊乡深沟村李贤夫妇合葬墓出土。现存于宁夏固原博物馆。

墓向175°。位于墓室西壁南端第二幅。侍女大耳垂肩，面相丰满，头梳高髻。内穿圆领衫，外着无领宽袖服，腰系带，下裹裙。右手握物屈至上腹前，左手持团扇。

（撰文：姚蔚玲 摄影：程云侠）

Maid with Silk Fan (4)

4th Year of Tianhe Era, Northern Zhou (569 CE)

Height 146 cm

Unearthed from the joint tomb of Li Xian and his wife at Shengoucun of Xijiaoxiang in Yuanzhou District of Guyuan, Ningxia, in 1983. Preserved in Guyuan Museum in Ningxia.

159.侍从伎乐图（五）

北周天和四年（569年）

高62厘米

1983年宁夏回族自治区固原市原州区西郊乡深沟村李贤夫妇合葬墓出土。现存于宁夏固原博物馆。

墓向175°。位于墓室东壁南端。已残，现存部分躯体，伎乐女着长裙，腰束带。腰前挂一细腰鼓，左手拍击鼓面。

（撰文：姚蔚玲 摄影：宁夏文物考古研究所）

Attending Drummer (5)

4th Year of Tianhe Era, Northern Zhou (569 CE)

Height 62 cm

Unearthed from the joint tomb of Li Xian and his wife at Shengoucun of Xijiaoxiang in Yuanzhou District of Guyuan, Ningxia, in 1983. Preserved in Guyuan Museum in Ningxia.

160.侍卫图（局部）

北周建德四年（575年）

高38厘米

1996年宁夏回族自治区固原市原州区西郊乡大堡村田弘夫妇合葬墓出土。现存于宁夏固原博物馆。

墓向170°。位于墓室西壁南侧。残存三人头部。人物细眉，高鼻，有须，颊部涂红。头戴黑色小帻，侧有小笄穿过。

（撰文：姚蔚玲 摄影：卫忠）

Guards (Detail)

4th Year of Jiande Era, Northern Zhou (575 CE)

Height 38 cm

Unearthed from the joint tomb of Tian Hong and his wife at Dabucun of Xijiaoxiang in Yuanzhou District of Guyuan, Ningxia, in 1996.

Preserved in Guyuan Museum in Ningxia.

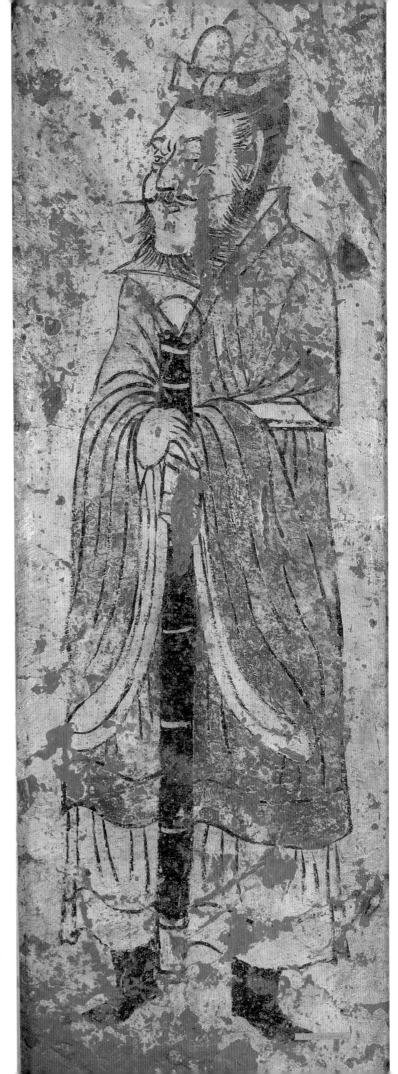

161.执刀武士图（一）

隋大业五年（609年）

高160厘米

1987年宁夏回族自治区固原市原州区南郊乡小马庄村史射勿墓出土。现存于宁夏固原博物馆。

墓向160°。位于第一过洞与第一天井西壁第一幅。人物深目高鼻，颧骨凸出，有须。头戴冠，身着红色交领宽袍，下穿白色宽裤，足蹬乌靴，双脚呈八字状站立。双手前举，执环首刀。

（撰文：姚蔚玲 摄影：程云侠）

Warrior Holding Sword (1)

5th Year of Daye Era, Sui (609 CE)

Height 160 cm

Unearthed from Shi Shewu's tomb at Mazhuangcun of Nanjiaoxiang in Yuanzhou District of Guyuan, Ningxia, in 1987. Preserved in Guyuan Museum in Ningxia.

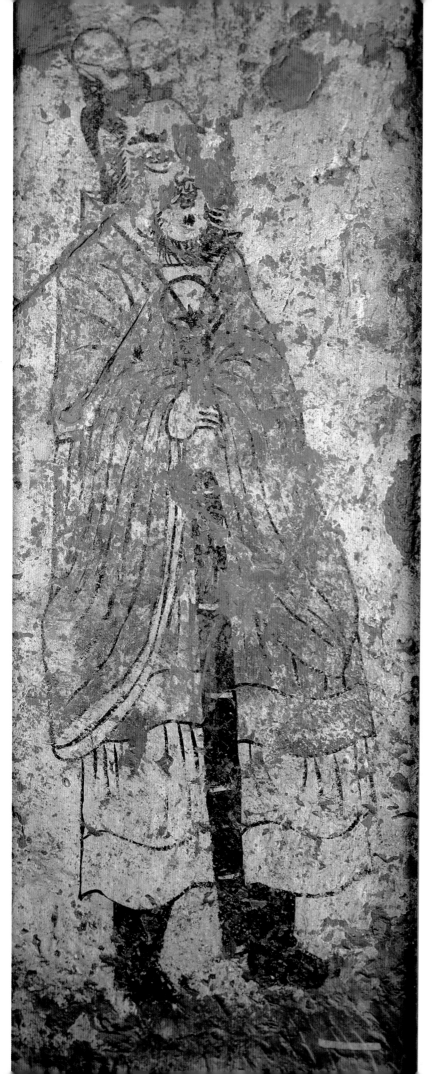

162. 执刀武士图（二）

隋大业五年（609年）

高156厘米

1987年宁夏回族自治区固原市原州区南郊乡小马庄村史射勿墓出土。现存于宁夏固原博物馆。

墓向160°。位于第一过洞与第一天井东壁第一幅。人物深目高鼻，左眼略残，有须。头戴冠，身着红色交领宽袖长袍，下穿白色宽裤，足蹬乌靴。双手前举，执环首刀，侧身而立。

（撰文：姚蔚玲　摄影：边东冬）

Warrior Holding Sword (2)

5th Year of Daye Era, Sui (609 CE)

Height 156 cm

Unearthed from Shi Shewu's tomb at Mazhuangcun of Nanjiaoxiang in Yuanzhou District of Guyuan, Ningxia, in 1987. Preserved in Guyuan Museum in Ningxia.

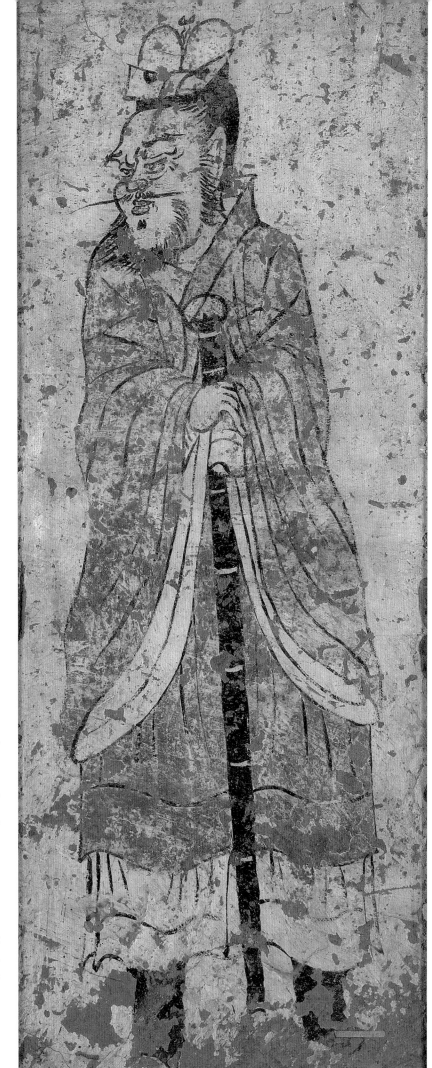

163.执刀武士图（三）

隋大业五年（609年）

高164厘米

1987年宁夏回族自治区固原市原州区南郊乡小马庄村史射勿墓出土。现存于宁夏固原博物馆。

墓向160°。位于第一天井东壁第二幅。人物深目，高鼻，有须。头戴冠，身着红色交领宽袖长袍，下穿宽口裤，足蹬乌靴。双手执环首刀，回视，侧身而立。

（撰文：姚蔚玲 摄影：程云侠）

Warrior Holding Sword (3)

5th Year of Daye Era, Sui (609 CE)

Height 164 cm

Unearthed from Shi Shewu's tomb at Mazhuangcun of Nanjiaoxiang in Yuanzhou District of Guyuan, Ningxia, in 1987. Preserved in Guyuan Museum in Ningxia.

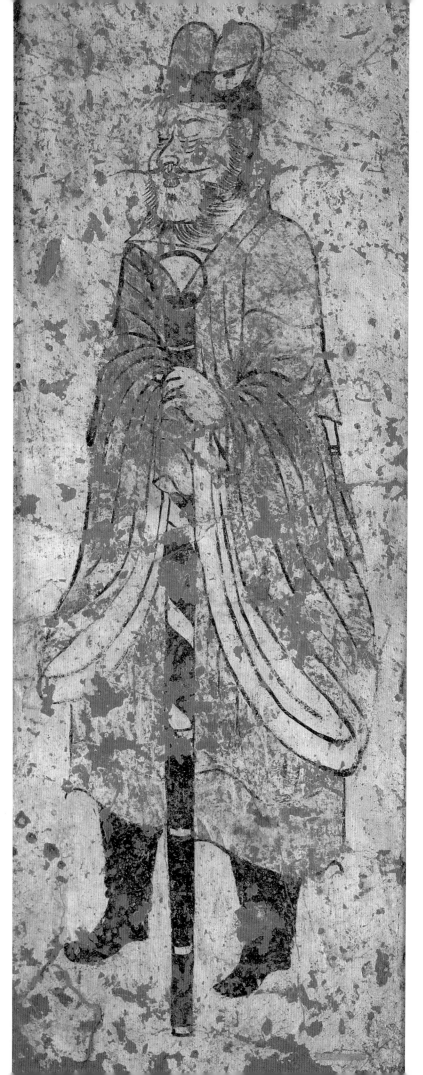

164. 执刀武士图（四）

隋大业五年（609年）

高155厘米

1987年宁夏回族自治区固原市原州区南郊乡小马庄村史射勿墓出土。现存于宁夏固原博物馆。

墓向160°。位于第一天井西壁第二幅。人物深目，高鼻，双唇紧闭，有须。头戴冠，身着红色交领长袍，下穿红色宽口裤，足蹬乌靴。双手于胸前执环首刀，侧身而立。

（撰文：姚蔚玲　摄影：程云侠）

Warrior Holding Sword (4)

5th Year of Daye Era, Sui (609 CE)

Height 155 cm

Unearthed from Shi Shewu's tomb at Mazhuangcun of Nanjiaoxiang in Yuanzhou District of Guyuan, Ningxia, in 1987. Preserved in Guyuan Museum in Ningxia.

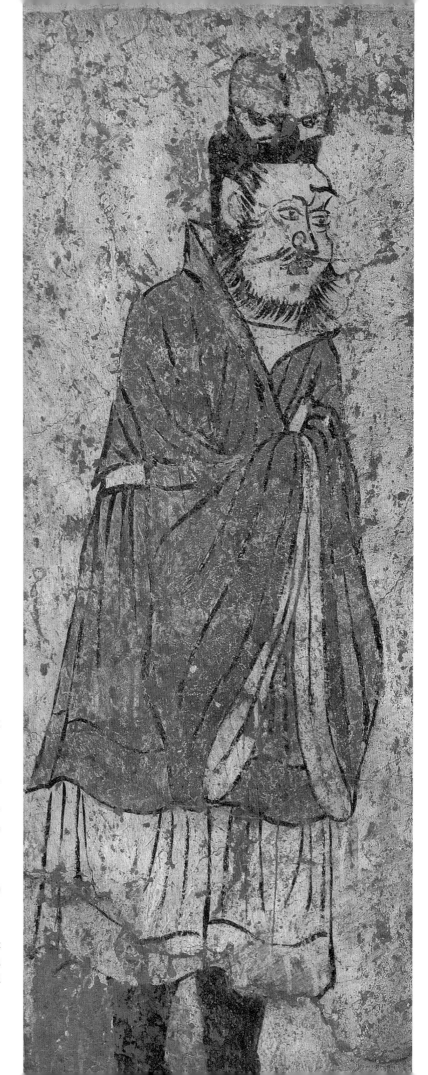

165. 执笏武士图（一）

隋大业五年（609年）

高140厘米

1987年宁夏回族自治区固原市原州区南郊乡
小马庄村史射勿墓出土。现存于宁夏固原博
物馆。

墓向160°。位于第二过洞与第二天井之间，
西壁第一幅。人物浓眉，深目，高鼻，有
须。头戴冠，身着红色交领宽袍，下穿白色
宽口裤，腰束带，足蹬乌靴。双手于胸前执
笏板，侧身而立。

（撰文：姚蔚玲 摄影：程云侠）

Official Holding Hand-tablet (1)

5th Year of Daye Era, Sui (609 CE)

Height 140 cm

Unearthed from Shi Shewu's tomb at
Mazhuangcun of Nanjiaoxiang in Yuanzhou
District of Guyuan, Ningxia, in 1987. Preserved
in Guyuan Museum in Ningxia.

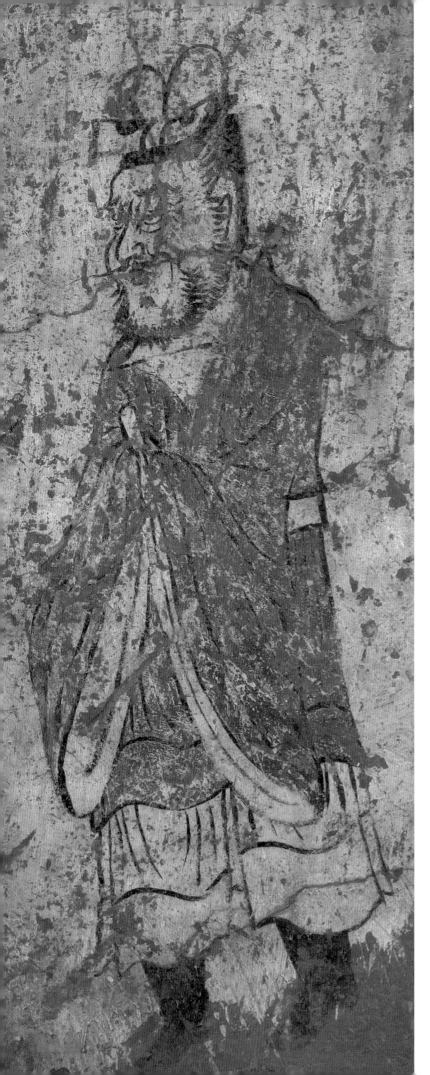

166.执笏武士图（二）

隋大业五年（609年）

高135厘米

1987年宁夏回族自治区固原市原州区南郊乡小马庄村史射勿墓出土。现存于宁夏固原博物馆。

墓向160°。位于第二过洞与第二天井之间，东壁第一幅。人物浓眉，深目，高鼻，有须。头戴冠，身着红色交领宽袍，下穿白色宽口裤，腰束带，足蹬乌靴。双手于胸前执笏板，侧身而立。

（撰文：姚蔚玲 摄影：程云侠）

Official Holding Hand-tablet (2)

5th Year of Daye Era, Sui (609 CE)

Height 135 cm

Unearthed from Shi Shewu's tomb at Mazhuangcun of Nanjiaoxiang in Yuanzhou District of Guyuan, Ningxia, in 1987. Preserved in Guyuan Museum in Ningxia.

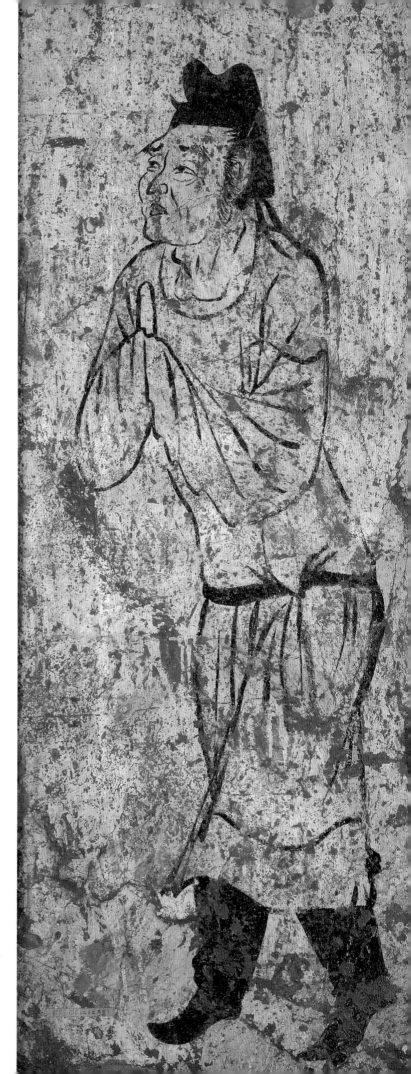

167. 执笏武士图（三）

隋大业五年（609年）

高120厘米

1987年宁夏回族自治区固原市原州区南郊乡小马庄村史
射勿墓出土。现存于宁夏固原博物馆。

墓向160°。位于第二天井西壁第二幅。人物尖鼻，无
须。头戴两脚幞头，幞头两脚垂于肩上。身着白色圆领
长袍，腰束带，足蹬乌靴。双手前拱，执笏板作进谒
状。

（撰文：姚蔚玲 摄影：程云侠）

Official Holding Hand-tablet (3)

5th Year of Daye Era, Sui (609 CE)

Height 120 cm

Unearthed from Shi Shewu's tomb at Mazhuangcun of
Nanjiaoxiang in Yuanzhou District of Guyuan, Ningxia, in
1987. Preserved in Guyuan Museum in Ningxia.

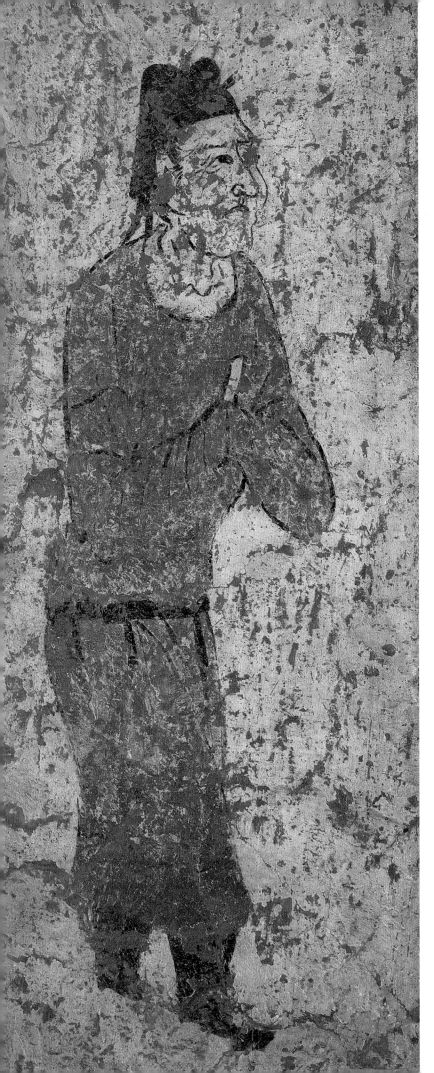

168. 执笏宦者图

隋大业五年（609年）

高120厘米

1987年宁夏回族自治区固原市原州区南郊乡小马庄村史射勿墓出土。现存于宁夏固原博物馆。

墓向160°。位于第二天井东壁第二幅。人物颧骨突出，无须。头戴两脚幞头，幞头两脚垂于脑后。身着红色圆领长袍，腰束带，足蹬乌靴。双手前拱，执笏板作进谒状。

（撰文：姚蔚玲　摄影：程云侠）

Eunuch Holding Hand-tablet

5th Year of Daye Era, Sui (609 CE)

Height 120 cm; Width

Unearthed from Shi Shewu's tomb at Mazhuangcun of Nanjiaoxiang in Yuanzhou District of Guyuan, Ningxia, in 1987. Preserved in Guyuan Museum in Ningxia.

169.侍女图

隋大业五年（609年）

高78厘米

1987年宁夏回族自治区固原市原州区南郊乡小马庄村史射勿墓出土。现存于宁夏固原博物馆。

墓向160°。位于墓室西壁南侧。现存可辨别的有五人，一人完好，其余四人仅头部略残，胸以下基本完整。皆梳高髻，着齐胸红条长裙。

（撰文：姚蔚玲 摄影：程云侠）

Maids

5th Year of Daye Era, Sui (609 CE)

Height 78 cm

Unearthed from Shi Shewu's tomb at Mazhuangcun of Nanjiaoxiang in Yuanzhou District of Guyuan, Ningxia, in 1987. Preserved in Guyuan Museum in Ningxia.

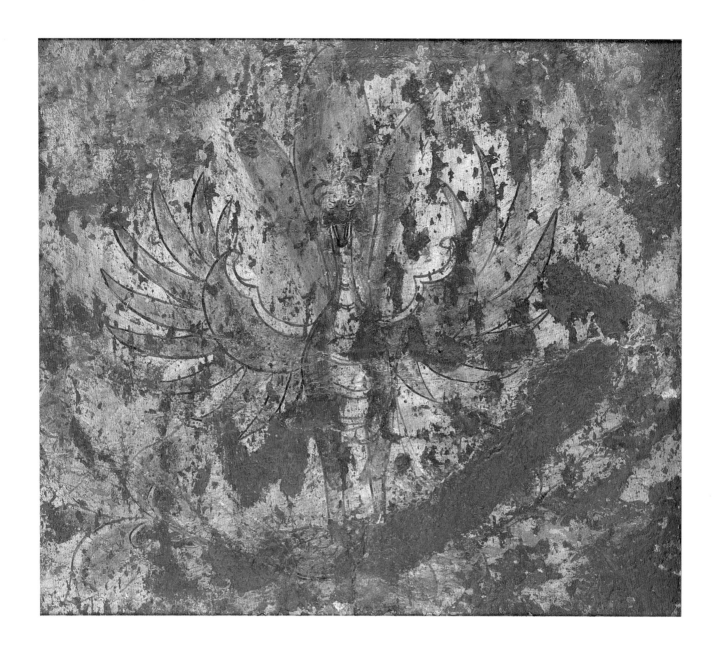

170.朱雀图

唐麟德元年（664年）

高112、宽114厘米

1985年宁夏回族自治区固原市原州区南郊乡羊坊村史索岩夫妇合葬墓出土。现存于宁夏固原博物馆。

墓向175°。位于第五过洞上方。朱雀下部是一幅蔓枝莲花，中有一花叶组成的莲花台。朱雀挺胸，双翼对称，向上张开呈半环状，正面直立于花台之上，呈腾飞之势。

（撰文：姚蔚玲 摄影：程云侠）

Scarlet Bird

1st Year of Linde Era, Tang (665 CE)

Height 112 cm; Width 114 cm

Unearthed from the joint tomb of Shi Suoyan and his wife at Yangfangcun of Nanjiaoxiang in Yuanzhou District of Guyuan, Ningxia, in 1985. Preserved in Guyuan Museum in Ningxia.

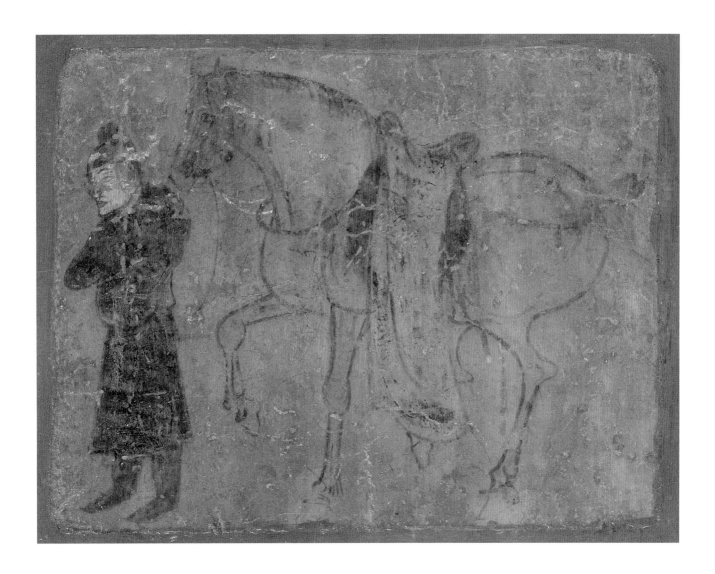

171.牵马图（一）

唐圣历二年（699年）

人高58、马高69、马长72厘米

1986年宁夏回族自治区固原市原州区南郊乡羊坊村梁元珍墓出土。现存于宁夏固原博物馆。

墓向160°。位于第一天井东壁。人物高鼻深目，颧骨凸起。头戴幞头，身着圆领窄袖长袍，腰束带，足穿乌靴。双手于胸前执物，面北，侧身站立。马嘴微张，背置鞍鞯，上搭鞍袱，马尾紧束上翘，右侧两腿提起后勾。

（撰文：姚蔚玲 摄影：程云侠）

Horse and Groom (1)

2nd Year of Shengli Era, Tang (699 CE)

Groom tall 58 cm; Horse tall 69 cm; Width 72 cm

Unearthed from Liang Yuanzhen's tomb at Yangfangcun of Nanjiaoxiang in Yuanzhou District of Guyuan, Ningxia, in 1986. Preserved in Guyuan Museum in Ningxia.

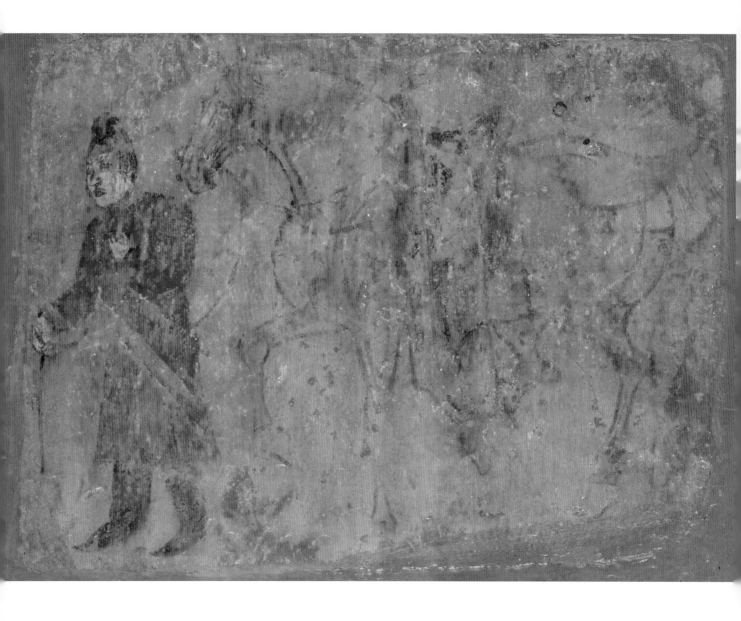

172.牵马图（二）

唐圣历二年（699年）

人高60、马高68、长76厘米

1986年宁夏回族自治区固原市原州区南郊乡羊坊村梁元珍墓出土。现存于宁夏固原博物馆。

墓向160°。位于第二天井东壁。人物双目直视，头戴幞头，身着圆领窄袖长袍，足穿乌靴。左手上举至胸前执缰，右手提缰，面北，侧身站立。马嘴微张，背置鞍鞯，上搭鞍袱，马尾紧束，左侧两腿提起后勾。

（撰文：姚蔚玲 摄影：程云侠）

Horse and Groom (2)

2nd Year of Shengli Era, Tang (699 CE)

Groom tall 60 cm; Horse tall 68 cm; Width 76 cm

Unearthed from Liang Yuanzhen's tomb at Yangfangcun of Nanjiaoxiang in Yuanzhou District of Guyuan, Ningxia, in 1986. Preserved in Guyuan Museum in Ningxia.

173.牵马图（三）

唐圣历二年（699年）

人高70、马高78、长85厘米

1986年宁夏回族自治区固原市原州区南郊乡羊坊村梁元珍墓出土。现存于宁夏固原博物馆。

墓向160°。位于第三天井东壁。人物头戴软脚幞头，身着圆领长袍，腰束带，足穿乌靴，双手于胸前执缰，侧身作行走状。马嘴微张，背置鞍鞯，鞯下有障泥，鞍上搭鞍袱，马尾紧束，右侧前腿提起后勾。

（撰文：姚蔚玲　摄影：程云侠）

Horse and Groom (3)

2nd Year of Shengli Era, Tang (699 CE)

Groom tall 70 cm; Horse tall 78 cm; Width 85 cm

Unearthed from Liang Yuanzhen's tomb at Yangfangcun of Nanjiaoxiang in Yuanzhou District of Guyuan, Ningxia, in 1986. Preserved in Guyuan Museum in Ningxia.

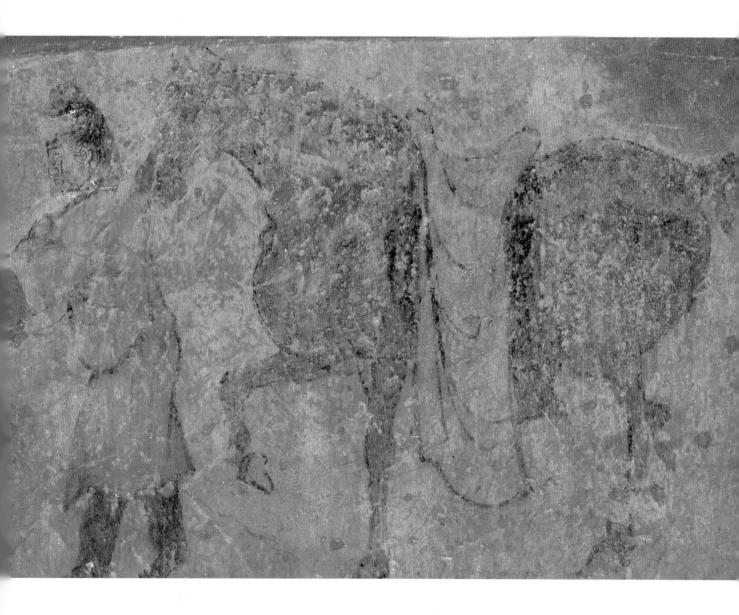

174.牵马图（四）

唐圣历二年（699年）

人高60、马高72、长72厘米

1986年宁夏回族自治区固原市原州区南郊乡羊坊村梁元珍墓出土。现存于宁夏固原博物馆。

墓向160°。位于第一天井西壁。人物头戴幞头，脑后似有软角，身着圆领长袍，腰束带，足穿乌靴，双手拱于胸前，作行走状。马首微扬，颈部修长，其背置鞍鞯，上搭鞍袱，臀部肥圆，马尾上挽，左侧两腿提起后勾。

（撰文：姚蔚玲　摄影：程云侠）

Horse and Groom (4)

2nd Year of Shengli Era, Tang (699 CE)

Groom tall 60 cm; Horse tall 72 cm; Width 72 cm

Unearthed from Liang Yuanzhen's tomb at Yangfangcun of Nanjiaoxiang in Yuanzhou District of Guyuan, Ningxia, in 1986. Preserved in Guyuan Museum in Ningxia.

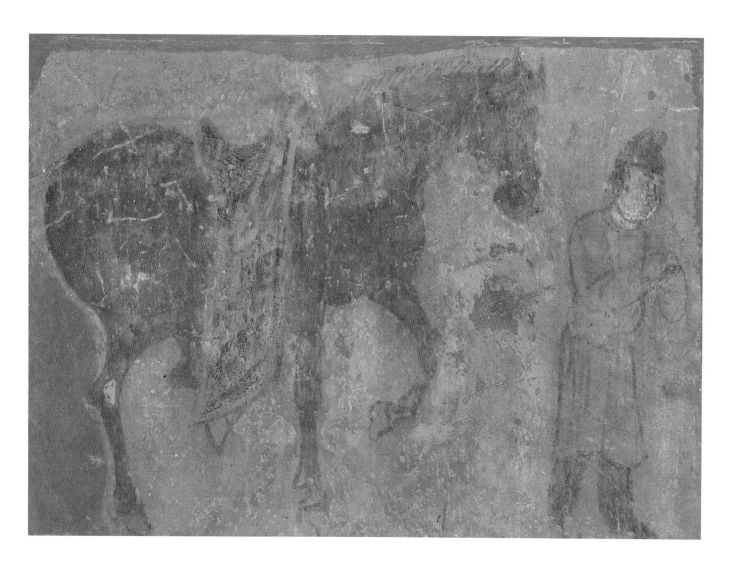

175.牵马图（五）

唐圣历二年（699年）

人高60、马高78、长78厘米

1986年宁夏回族自治区固原市原州区南郊乡羊坊村梁元珍墓出土。现存于宁夏固原博物馆。

墓向160°。位于第二天井西壁。人物头戴软脚幞头，身着圆领窄袖长袍，腰束带，足穿乌靴，双手握缰绳拱于胸前。马颈修长，耳较大，其有鞍鞴，上搭鞍袱，臀部肥圆，尾鬃束起，左侧两腿提起后勾。

（撰文：姚蔚玲 摄影：程云侠）

Horse and Groom (5)

2nd Year of Shengli Era, Tang (699 CE)

Groom tall 60 cm; Horse tall 78 cm; Width 78 cm

Unearthed from Liang Yuanzhen's tomb at Yangfangcun of Nanjiaoxiang in Yuanzhou District of Guyuan, Ningxia, in 1986. Preserved in Guyuan Museum in Ningxia.

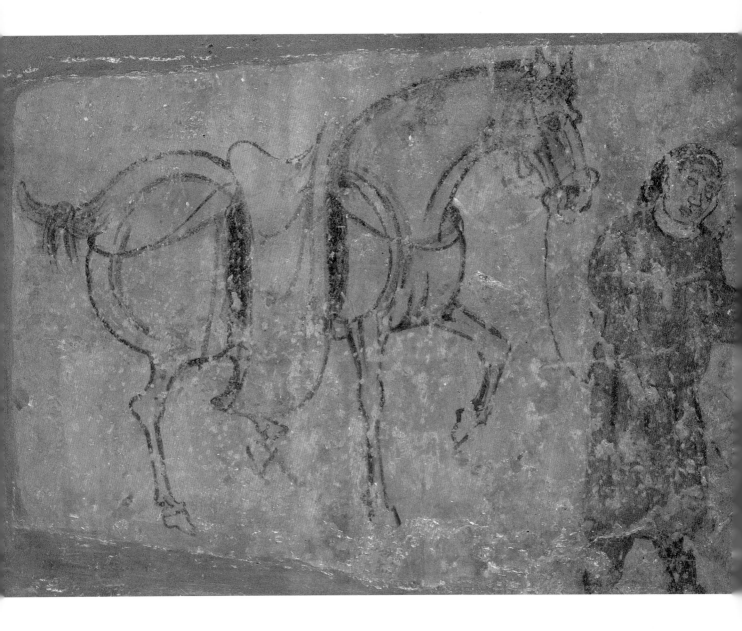

176.牵马图（六）

唐圣历二年（699年）

人高68、马高71、长84厘米

1986年宁夏回族自治区固原市原州区南郊乡羊坊村梁元珍墓出土。现存于宁夏固原博物馆。

墓向160°。位于第三天井西壁。人物头发由前向后梳理，在脑后挽起发髻，身着圆领长袍，腰束带，足穿乌靴，双手袖于胸前，手中握有马缰及马鞭，鞭杆有缠绕物。马的姿式及形象均与前马相同。

（撰文：姚蔚玲 摄影：程云侠）

Horse and Groom (6)

2nd Year of Shengli Era, Tang (699 CE)

Groom tall 68 cm; Horse tall 71 cm; Width 84 cm

Unearthed from Liang Yuanzhen's tomb at Yangfangcun of Nanjiaoxiang in Yuanzhou District of Guyuan, Ningxia, in 1986. Preserved in Guyuan Museum in Ningxia.

177.牵马图（七）

唐圣历二年（699年）

人高79、马高75、长76厘米

1986年宁夏回族自治区固原市原州区南郊乡羊坊村梁元珍墓出土。现存于宁夏固原博物馆。

墓向160°。位于甬道东壁。人物头戴幞头，身着圆领长袍，腰束带，足穿乌靴，右手上举牵马鞚，左手插于腰际，侧身站立。马颈修长，背置鞍鞯，鞍上搭袱，马尾紧束。牵马图前还绘有一人，上半身缺失，仅存长袍下摆及右脚乌靴。

（撰文：姚蔚玲 摄影：程云侠）

Horse and Groom (7)

2nd Year of Shengli Era, Tang (699 CE)

Groom tall 79 cm; Horse tall 75 cm; Width 76 cm

Unearthed from Liang Yuanzhen's tomb at Yangfangcun of Nanjiaoxiang in Yuanzhou District of Guyuan, Ningxia, in 1986. Preserved in Guyuan Museum in Ningxia.

178.牵马图（八）

唐圣历二年（699年）

人残高49、马高69、头部残长64厘米

1986年宁夏回族自治区固原市原州区南郊乡羊坊村梁元珍墓出土。现存于宁夏固原博物馆。

墓向160°。位于甬道西壁。人物身着红色长袍，腰束带，下着条裤，裤脚束起，足蹬黑靴，靴尖翘起。

（撰文：姚蔚玲 摄影：程云侠）

Horse and Groom (8)

2nd Year of Shengli Era, Tang (699 CE)

Groom tall 49 cm (Remaining Part); Horse tall 69 cm; Width 64 cm (at Top)

Unearthed from Liang Yuanzhen's tomb at Yangfangcun of Nanjiaoxiang in Yuanzhou District of Guyuan, Ningxia, in 1986. Preserved in Guyuan Museum in Ningxia.

179.执扇图

唐圣历二年（699年）

高116厘米

1986年宁夏回族自治区固原市原州区南郊乡羊坊村梁元
珍墓出土。现存于宁夏固原博物馆。

墓向160°。位于甬道西壁牵马图前。执扇人为一女子，
梳双角发髻，着圆领长袍，腰束带，袍摆下露长裤，
足穿黑鞋。双手于胸前握团扇，扇杆较长，扇面呈椭圆
形，似有扇骨。

<div align="right">（撰文：姚蔚玲 摄影：边东冬）</div>

Maid Holding Fan

2nd Year of Shengli Era, Tang (699 CE)

Height 116 cm

Unearthed from Liang Yuanzhen's tomb at Yangfangcun of
Nanjiaoxiang in Yuanzhou District of Guyuan, Ningxia, in
1986. Preserved in Guyuan Museum in Ningxia.

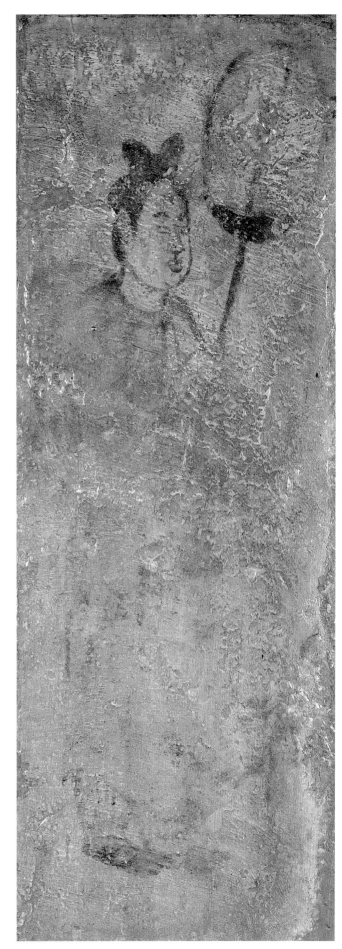

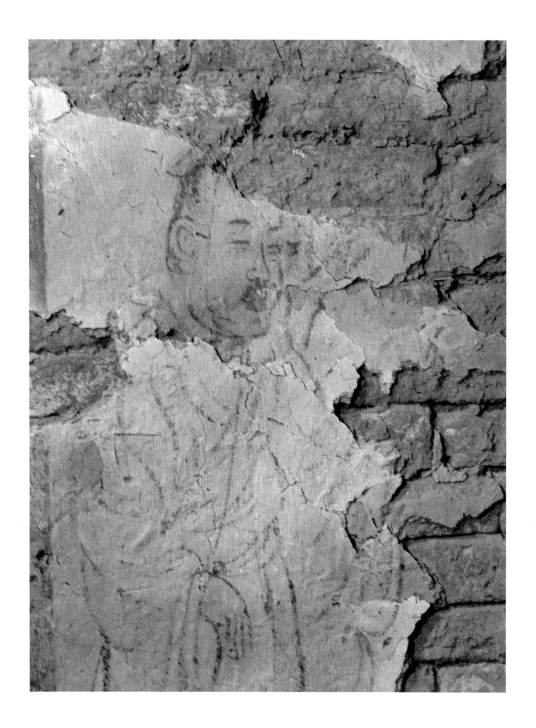

180. 树下老人图（一）

唐圣历二年（699年）

残高40厘米

1986年宁夏回族自治区固原市原州区南郊乡羊坊村梁元珍墓出土。现存于宁夏固原博物馆。
墓向160°。位于墓室西壁第一幅。老者冠部已残，上唇蓄须，闭口涂红。身着交领宽袖长
袍，腰系宽带。左手上举，右手略弯。

（撰文：姚蔚玲　摄影：宁夏文物考古研究所）

Elder Under the Tree (1)

2nd Year of Shengli Era, Tang (699 CE)

Remaining Height 40 cm

Unearthed from Liang Yuanzhen's tomb at Yangfangcun of Nanjiaoxiang in Yuanzhou District of
Guyuan, Ningxia, in 1986. Preserved in Guyuan Museum in Ningxia.

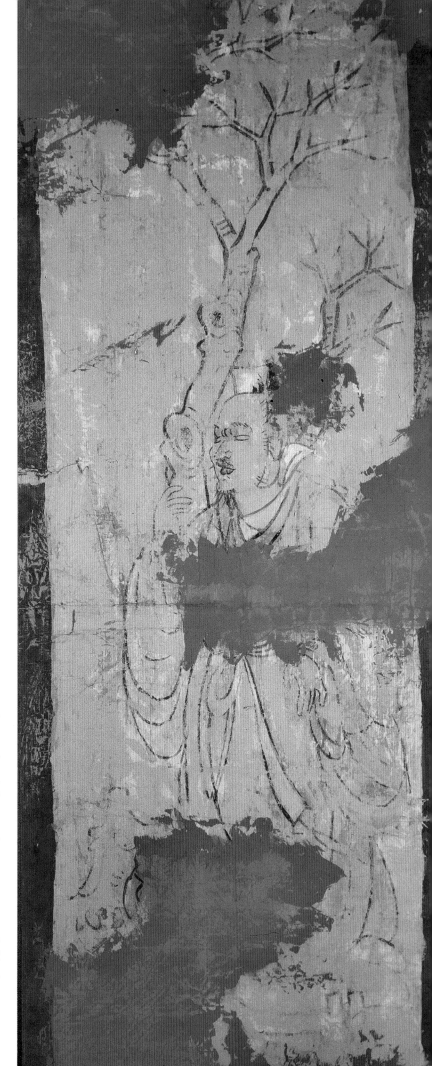

181. 树下老人图（二）（摹本）

唐圣历二年（699年）

高91厘米

1986年宁夏回族自治区固原市原州区南郊乡羊坊村梁元珍墓出土。现存于宁夏固原博物馆。

墓向160°。位于墓室西壁第二幅。中央为一枯树，树下有一老者侧身而立。其双目注视前方，鼻子高直，口微合，蓄须。头戴方形小冠，身着交领长袍，腰束带。右手上举至胸前，左手稍提。

（临摹：中央美院师生　撰文：姚蔚玲

摄影：边东冬）

Elder Under the Tree (2) (Replica)

2nd Year of Shengli Era, Tang (699 CE)

Height 91 cm

Unearthed from Liang Yuanzhen's tomb at Yangfangcun of Nanjiaoxiang in Yuanzhou District of Guyuan, Ningxia, in 1986. Preserved in Guyuan Museum in Ningxia.

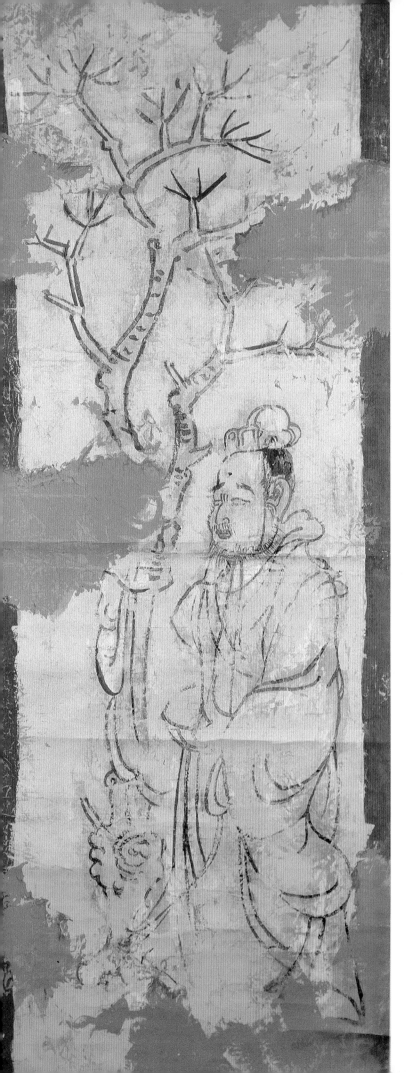

182.树下老人图（三）（摹本）

唐圣历二年（699年）

高85厘米

1986年宁夏回族自治区固原市原州区南郊乡羊坊村梁元
珍墓出土。现存于宁夏固原博物馆。

墓向160°。位于墓室西壁第四幅。中央为一枯树，树
下有一老者侧身而立。其双目注视前方，上唇蓄须。似
戴进贤冠，身着交领宽袍。左手执一卷书，右手上举作
指物状。

（临摹：中央美院师生　撰文：姚蔚玲　摄影：边东冬）

Elder Under the Tree (3) (Replica)

2nd Year of Shengli Era, Tang (699 CE)

Height 85 cm

Unearthed from Liang Yuanzhen's tomb at Yangfangcun of
Nanjiaoxiang in Yuanzhou District of Guyuan, Ningxia, in
1986. Preserved in Guyuan Museum in Ningxia.

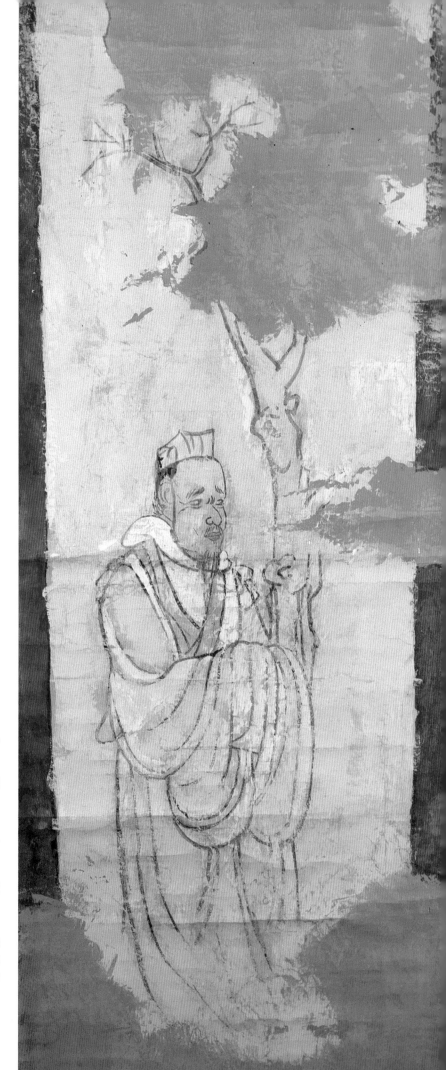

183. 树下老人图（四）（摹本）

唐圣历二年（699年）

高90厘米

1986年宁夏回族自治区固原市原州区南郊乡羊坊村梁元珍墓出土。现存于宁夏固原博物馆。

墓向160°。位于墓室西壁第五幅，画面保存较好。中有一枯树，树下立一老者。其头戴方冠，身着黄色交领长袍，双手笼袖于胸前。

（临摹：中央美院师生　撰文：姚蔚玲

摄影：边东冬）

Elder Under the Tree (4) (Replica)

2nd Year of Shengli Era, Tang (699 CE)

Height 90 cm

Unearthed from Liang Yuanzhen's tomb at Yangfangcun of Nanjiaoxiang in Yuanzhou District of Guyuan, Ningxia, in 1986. Preserved in Guyuan Museum in Ningxia.

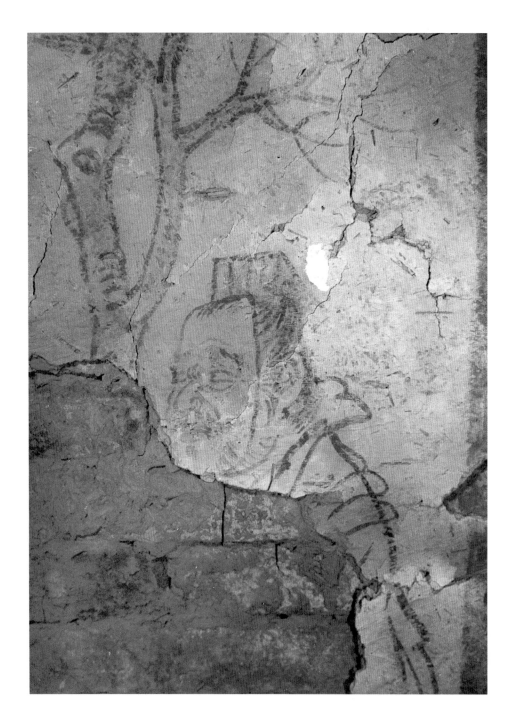

184.树下老人图（五）

唐圣历二年（699年）

残高40厘米

1986年宁夏回族自治区固原市原州区南郊乡羊坊村梁元珍墓出土。现存于宁夏固原博物馆。

墓向160°。位于墓室北壁第二幅。中央为一枯树，树冠有枝杈，树身较粗。树下立一老者，面呈方形，发挽起，戴方冠，面目较苍老，双鬓有须，闭口涂红。

（撰文：姚蔚玲　摄影：宁夏文物考古研究所）

Elder Under the Tree (5)

2nd Year of Shengli Era, Tang (699 CE)

Remaining Height 40 cm

Unearthed from Liang Yuanzhen's tomb at Yangfangcun of Nanjiaoxiang in Yuanzhou District of Guyuan, Ningxia, in 1986. Preserved in Guyuan Museum in Ningxia.

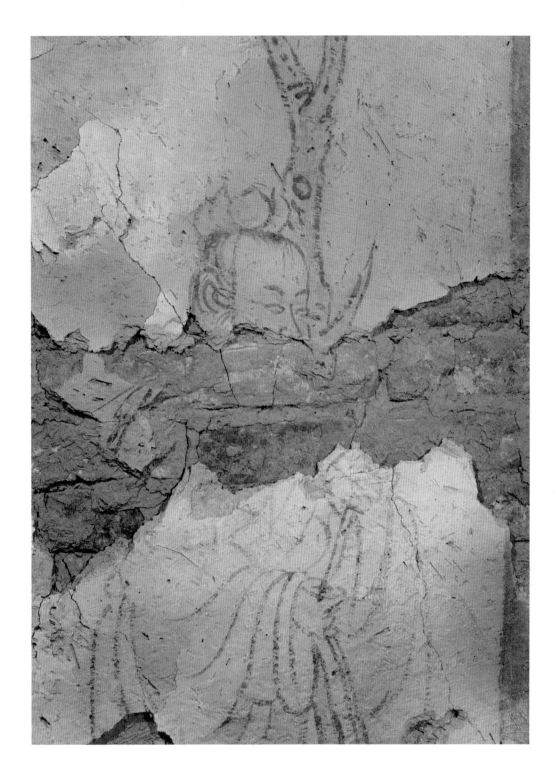

185.树下老人图（六）

唐圣历二年（公元699年）

高40厘米

1986年宁夏回族自治区固原市原州区南郊乡羊坊村梁元珍墓出土。现存于固原博物馆。

墓向160°。位于墓室北壁第三幅。中有一枯树，树下立一老者。头戴莲花形冠，面目较年轻。身着宽袍，袍袖宽大，右手举于胸前执一物，左手执折扇等物。

（撰文：姚蔚玲　摄影：宁夏文物考古研究所提供）

Elder Under the Tree (6)

2nd Year of Shengli Era, Tang (699 CE)

Height 40 cm

Unearthed from Liang Yuanzhen's tomb at Yangfangcun of Nanjiaoxiang in Yuanzhou District of Guyuan, Ningxia, in 1986. Preserved in Guyuan Museum in Ningxia.

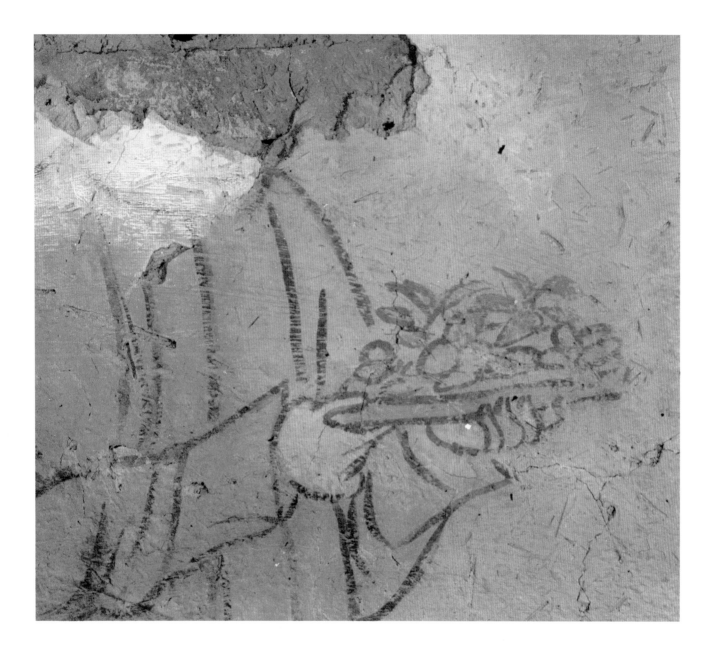

186.侍女图（局部）

唐圣历二年（699年）

残高36厘米

1986年宁夏回族自治区固原市原州区南郊乡羊坊村梁元珍墓出土。现存于宁夏固原博物馆。

墓向160°。位于墓室东壁。侍者头部已残缺，身着圆领长袍，袍袖较窄，双手捧果盘。

（撰文：姚蔚玲 摄影：宁夏文物考古研究所）

Maid Holding Fruit Tray (Detail)

2nd Year of Shengli Era, Tang (699 CE)

Surviving height 36 cm

Unearthed from Liang Yuanzhen's tomb at Yangfangcun of Nanjiaoxiang in Yuanzhou District of Guyuan, Ningxia, in 1986. Preserved in Guyuan Museum in Ningxia.

187. 男装侍女图（局部）

唐圣历二年（699年）

残高34厘米

1986年宁夏回族自治区固原市原州区南郊乡羊坊村梁元珍墓出土。现存于宁夏固原博物馆。

墓向160°。位于墓室东壁。侍者下身着条状裤，裤脚束起，足蹬红色皮履或线履，右脚残，只存左脚。

（撰文：姚蔚玲　摄影：宁夏文物考古研究所）

Maid in Male Costume (Detail)

2nd Year of Shengli Era, Tang (699 CE)

Surviving height 34 cm

Unearthed from Liang Yuanzhen's tomb at Yangfangcun of Nanjiaoxiang in Yuanzhou District of Guyuan, Ningxia, in 1986. Preserved in Guyuan Museum in Ningxia.

▲ 188. 如来像

魏晋十六国（220～439年）

高100、残宽122厘米

1993年新疆维吾尔自治区于田县达里雅布依乡喀喇墩第62号佛寺遗址出土。现存于新疆文物考古研究所。

位于"回"字形佛寺东北部内回廊的壁面上，用红、黄、白等色绘制而成，系在坍塌的墙体堆积中清理出土。

（撰文：于志勇　摄影：刘玉生）

Tathagata

Wei-Jin and Sixteen States Period (220-439 CE)

Height 100 cm; Surviving width 122 cm

Unearthed from Buddhist temple site No.62 at Karadong of Daliyabuyixiang in Yutian, Xinjiang, in 1993. Preserved in Institute of Archaeology and Cultural Relics in Xinjiang.

189. 如来像 ▶

魏晋十六国（220～439年）

残高55、宽37厘米

1993年新疆维吾尔自治区于田县达里雅布依乡喀喇墩第61号佛寺遗址出土。现存于新疆文物考古研究所。

位于"回"字形佛寺东北部内回廊的壁面上，用红、黄、白等色绘制而成。系在坍塌的墙体堆积中清理出土。

（撰文：于志勇　摄影：刘玉生）

Tathagata

Wei-Jin and Sixteen States Period (220-439 CE)

Surviving height 55 cm; Width 37 cm

Unearthed from Buddhist temple site No.61 at Karadong of Daliyabuyixiang in Yutian, Xinjiang, in 1993. Preserved in the Institute of Archaeology and Cultural Relics in Xinjiang.

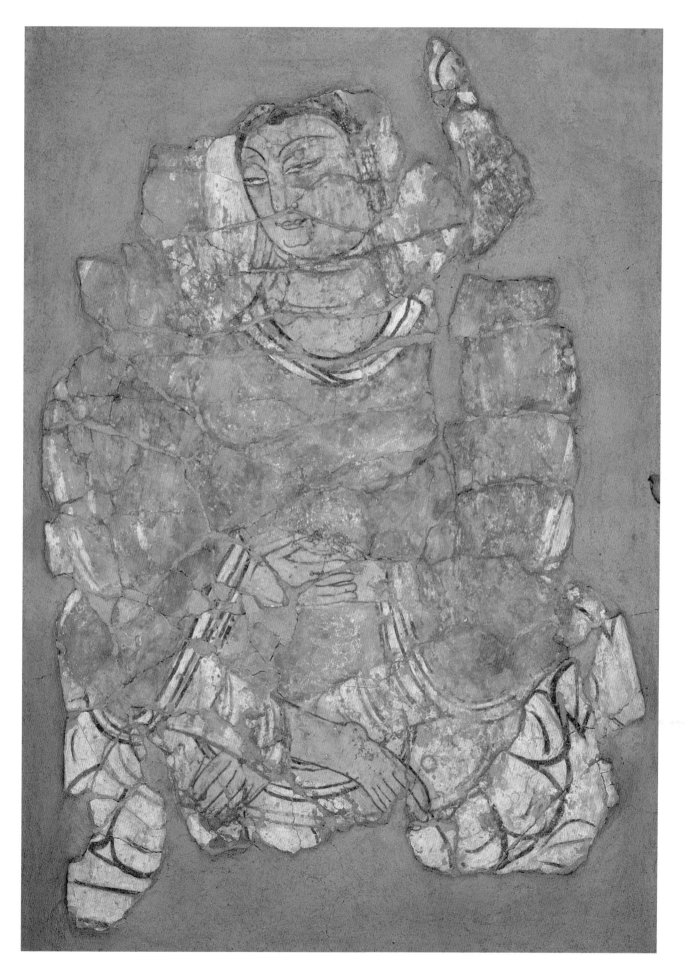

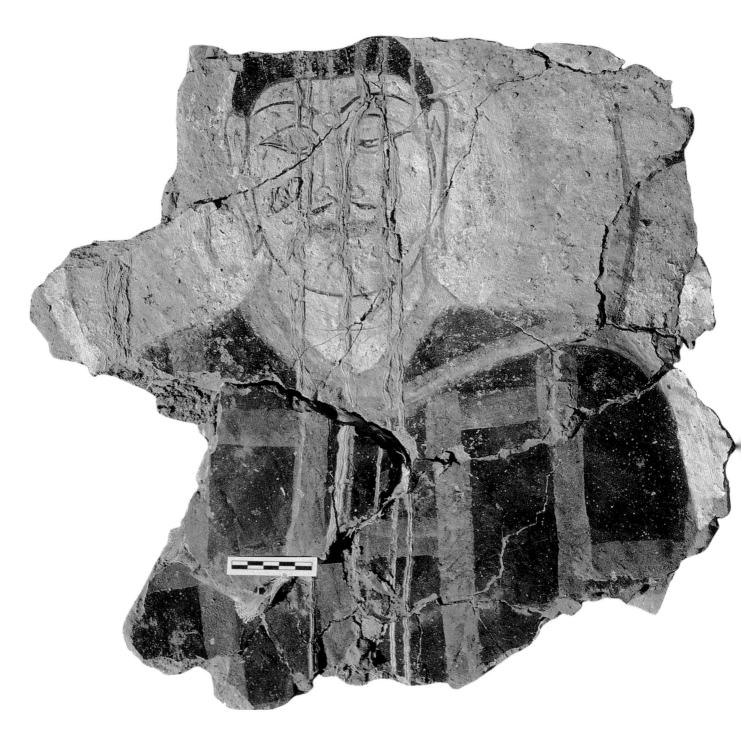

190. 如来坐像（局部）

西晋（265～316年）

长39厘米、宽43厘米

1995年新疆维吾尔自治区民丰县尼雅遗址N5佛寺遗址出土。现存于新疆文物考古研究所。

图像原绘于"回"字形佛寺东北部内回廊的壁面上，用黑、白色施绘而成。系在坍毁倒塌的墙体堆积中清理出土。

<div align="right">（撰文：于志勇　摄影：刘玉生）</div>

Seated Tathagata (Detail)

Western Jin (265-316 CE)

Remaining Height 39 cm; Width 43 cm

Unearthed from N5 Buddhist temple site of Niya site at Minfeng in Xinjiang, in 1995. Preserved in the Institute of Archceology and Cultural Relics in Xinjiang.

191. 门吏图

西晋（265～316年）

2003年新疆维吾尔自治区若羌县楼兰古城北LE古城附近壁画墓出土。原址保存。

墓葬前室东西长400、南北宽350、高170厘米，后室长宽各为280厘米，墓室前后室四壁满绘壁画。此壁画位于前室门右侧壁面，绘两个人物（头部画面漫漶），一为跪坐捧物门吏，身着青黑色袍服，扎配饰红色腰带，双手做捧物状。此人物右侧，绘一双手置于腹前，为着红色广袖通肩袈裟式袍服的僧人形象（似为右侧众宴饮者图案之部分）。

（撰文：于志勇 摄影：刘玉生）

Petty Official

Western Jin (265-316 CE)

Unearthed from mural tomb near LE Site which is north to Loulan Ancient City in Ruoqiang, Xinjiang, in 2003. Preserved on the original site.

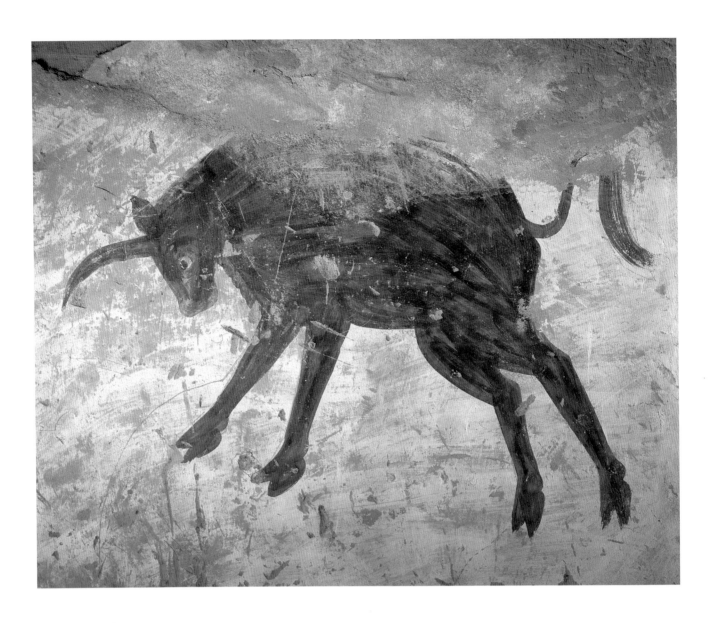

▲192.獬豸图

西晋（265～316年）

2003年新疆维吾尔自治区若羌县楼兰古城北LE古城附近壁画墓出土。原址保存。

门左侧壁面黑彩绘出的獬豸图案，眉目朱彩。

（撰文：于志勇　摄影：刘玉生）

Xiezhi (Unicorn)

Western Jin (265-316 CE)

Unearthed from mural tomb near LE Site which in north to Loulan Ancient City in Ruoqiang, Xinjiang, in 2003. Preserved on the original site.

193.前室中心柱莲花图及前室右壁宴▶ 饮图

西晋（265～316年）

2003年新疆维吾尔自治区若羌县楼兰古城北LE古城附近壁画墓出土。原址保存。

墓葬为前后室，前室中心部位为方形底座的圆形中心立柱，上面满绘莲花纹。前室右壁绘宴饮场景。

（撰文：于志勇　摄影：刘玉生）

Lotus Designs on the Central Pillar and Feasting Scene on the Right Wall of the Ante Chamber

Western Jin (265-316 CE)

Unearthed from mural tomb near LE Site which in north to Loulan Ancient City in Ruoqiang, Xinjiang, in 2003. Preserved on the original site.

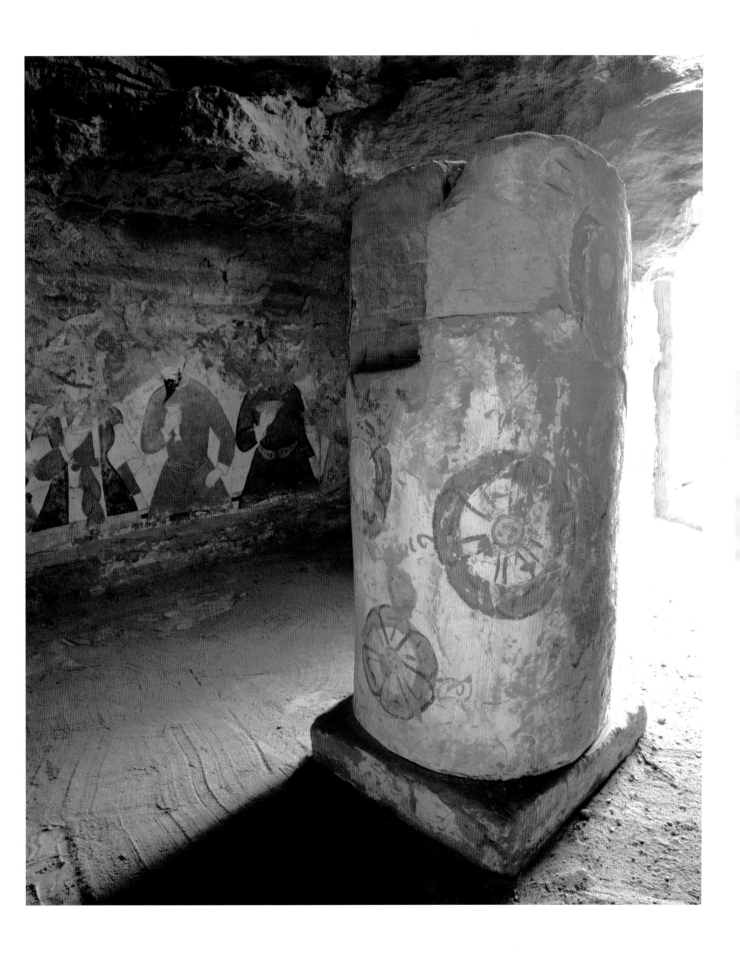

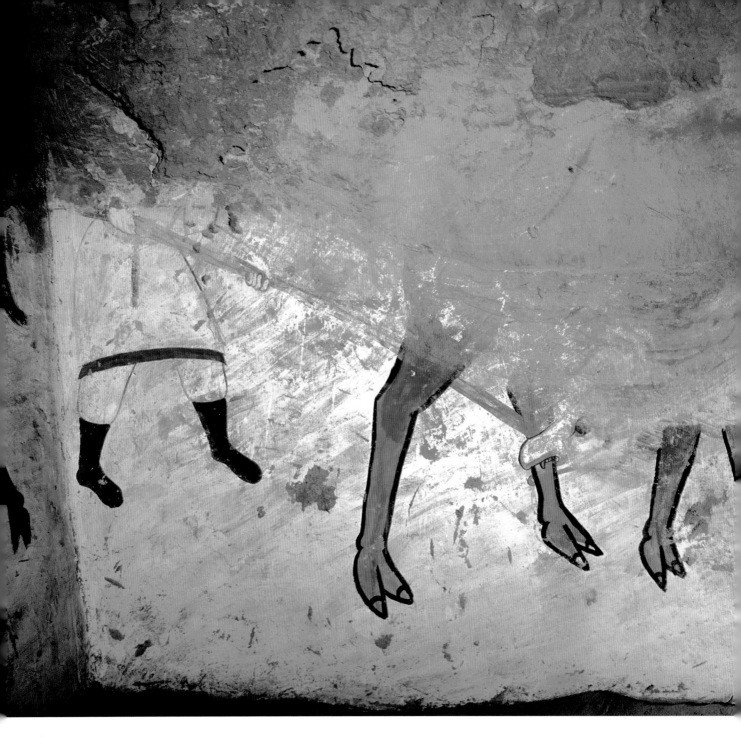

194.侍者斗驼图

西晋（265～316年）

2003年新疆维吾尔自治区若羌县楼兰古城北LE古城附近壁画墓出土。原址保存。

前室左壁绘侍者、斗骆驼图案，两个穿白衣黑靴的仆人执木棒正在拉开斗咬中的白骆驼和赭色骆驼。

（撰文：于志勇　摄影：刘玉生）

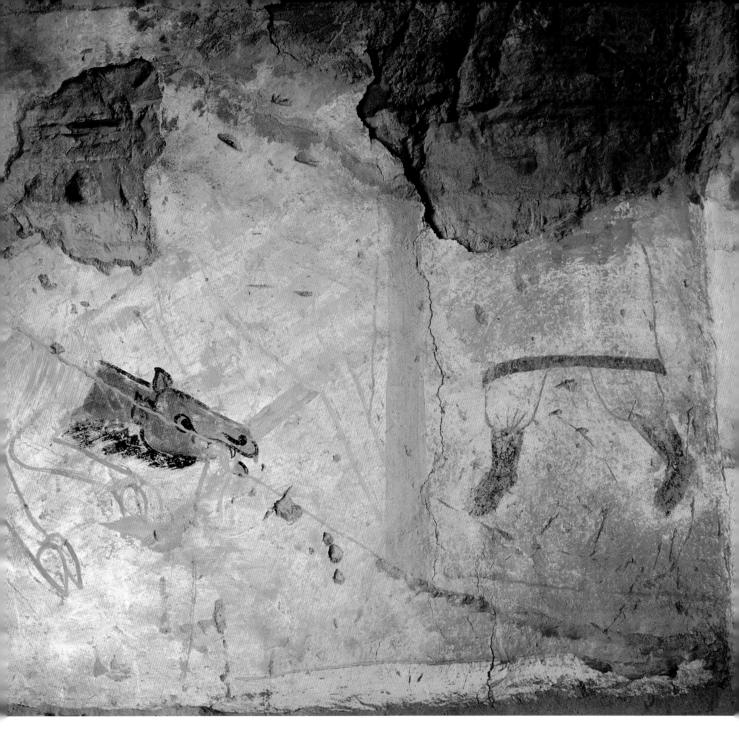

Attendants and Fighting Camels

Western Jin (265-316 CE)

Unearthed from mural tomb near LE Stie which in north to Loulan Ancient City in Ruoqiang, Xinjiang, in 2003. Preserved on the original site.

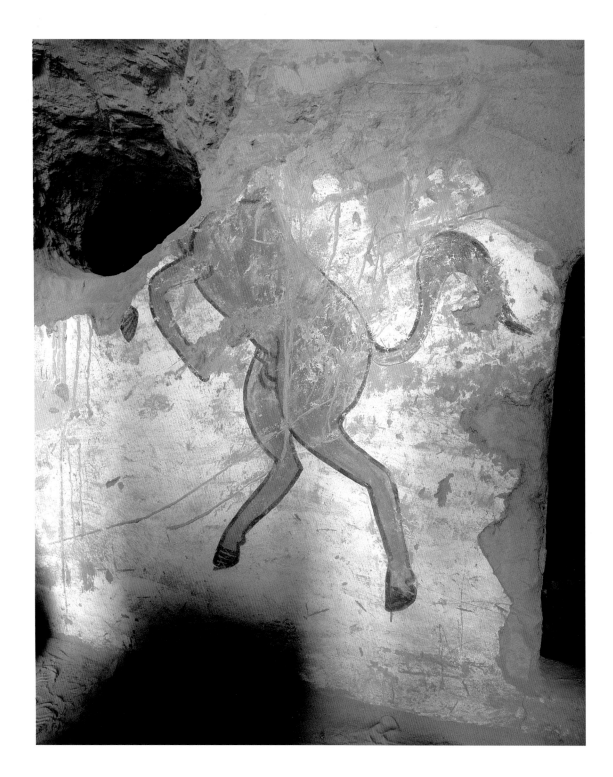

195. 斗马图

西晋（265～316年）

2003年新疆维吾尔自治区若羌县楼兰古城北LE古城附近壁画墓出土。原址保存。

前室后壁左侧绘有一匹两前足腾起、后足蹬地的雄马，马的对面也绘有一匹前蹄腾起的马，两马头部分的图案已残损。前室与后室连通的门上部，线刻出一双耳罐，门的右侧，绘一幅与斗驼图中形态相同的着白袍黑靴的仆人形象。

（撰文：于志勇　摄影：刘玉生）

Horse Fighting

Western Jin (265-316 CE)

Unearthed from mural tomb near LE Site which in north to Loulan Ancient City in Ruoqiang, Xinjiang, in 2003. Preserved on the original site.

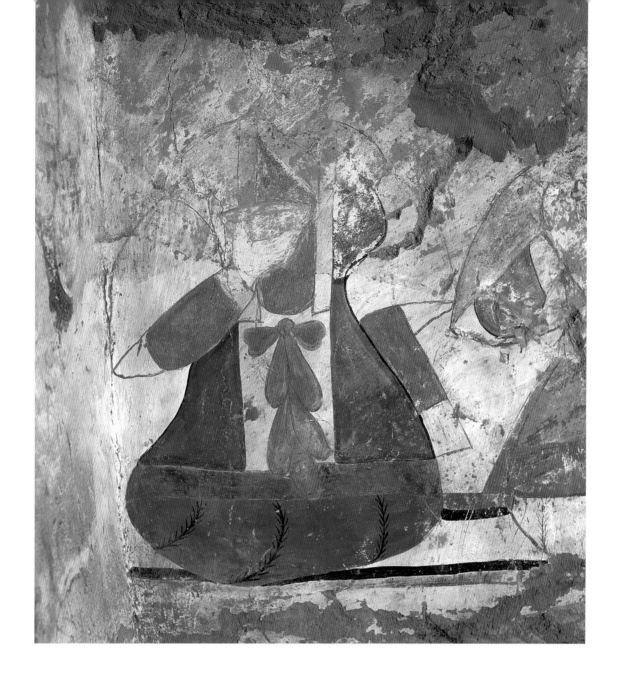

196. 人物宴饮图（局部一）

西晋（265～316年）

2003年新疆维吾尔自治区若羌县楼兰古城北LE古城附近壁画墓出土。原址保存。

右壁绘有六个人物形象，画面左半部绘有三位女性，右半部绘有三位男性，形态各异，做两两交谈状，或执杯，或端钵（叵罗）。中部男子蓄八字连鬓长须，貌类胡人。画面中男性均着圆领窄袖套头衫，腰系玉饰革带。女性上身着偏襟小袖内衣，外罩喇叭口半袖衫，下着褶裙，胸前配饰花结。在左起第三人的头部上部，存有墨书佉卢文字，可能是施绘者或该位置人物的名氏。墓葬壁画在整体形式技巧、造型布局等方面显示出了较高的水平，充分使用红、青、赭、白色，色调明快，全景式构图场景宏大，活泼而鲜明，技法或细劲挺拔，或粗犷豪放，人物刻画和塑造较河西地区墓葬壁画之中的人物造型更准确、工整、细腻，脱离了汉画的稚拙和程式化，组画中人物神情描绘凝练、细致。前室东壁所绘三位女性褶裙（或坐垫）的绘画技法，与尼雅遗址N5佛寺出土的佛像壁画风格酷似，也与米兰遗址发现的壁画在技法和图案上有相似之处。此图像为左起第一人物，女性，上身着偏襟小袖内衣，外罩喇叭口半袖衫，下著褶裙，胸前配饰花结，右手持钵（叵罗），与其左侧女性作交谈状。

（撰文：于志勇　摄影：刘玉生）

Figure in Feasting Scene (Detail 1)

Western Jin (265-316 CE)

Unearthed from mural tomb near LE Site which in north to Loulan Ancient City in Ruoqiang, Xinjiang, in 2003. Preserved on the original site.

197.人物宴饮图（局部二）

西晋（265～316世纪）

2003年新疆维吾尔自治区若羌县楼兰古城北LE古城附近壁画墓出土。原址保存。

此图为右壁画面左半部第二人物，女性，上身着偏襟小袖内衣，外罩喇叭口半袖衫，下着褶裙，胸前配饰花结，执杯，与其右侧女性作交谈状，在左起第二人的头部上部，存有墨书佉卢文字，可能是施绘者或该位置人物的名氏。

（撰文：于志勇　摄影：刘玉生）

Figure in Feasting Scene (Detail 2)

Western Jin (265-316 CE)

Unearthed from mural tomb near LE Site which in north to Loulan Ancient City in Ruoqiang, Xinjiang, in 2003. Preserved on the original site.

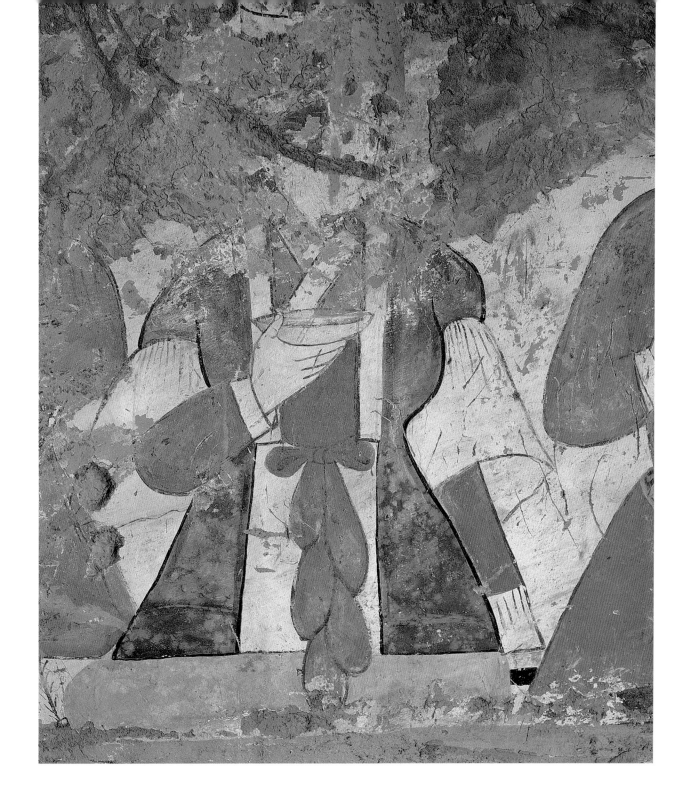

198. 人物宴饮图（局部三）

西晋（265～316年）

2003年新疆维吾尔自治区若羌县楼兰古城北LE古城附近壁画墓出土。原址保存。

此图为右壁画面左半部第三人物，女性，上身着偏襟小袖内衣，外罩喇叭口半袖衫，下着褶裙，胸前配饰花结，执钵
（叵罗），与其左侧执杯的美髯男性作交谈状。

（撰文：于志勇　摄影：刘玉生）

Figure in Feasting Scene (Detail 3)

Western Jin (265-316 CE)

Unearthed from mural tomb near LE Site which in north to Loulan Ancient City in Ruoqiang, Xinjiang, in 2003. Preserved on the
original site.

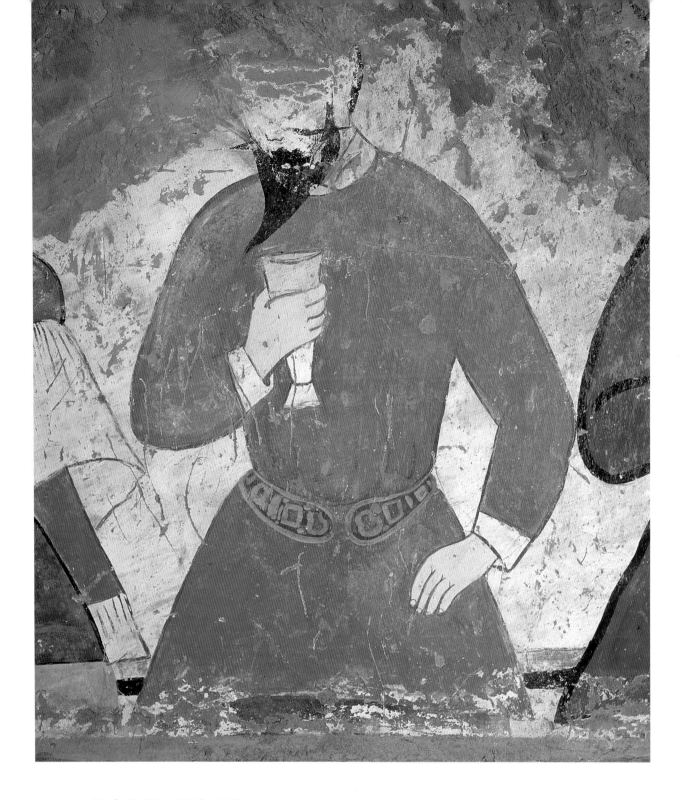

199. 人物宴饮图（局部四）

西晋（265～316年）

2003年新疆维吾尔自治区若羌县楼兰古城北LE古城附近壁画墓出土。原址保存。

此图为右壁画面左起第四人物，男性，络腮胡须，着圆领窄袖套头衫，腰系玉饰带钩，执杯，与其左侧执钵（叵罗）的女性作交谈状。

<div align="right">（撰文：于志勇　摄影：刘玉生）</div>

Figure in Feasting Scene (Detail 4)

Western Jin (265-316 CE)

Unearthed from mural tomb near LE Site which in north to Loulan Ancient City in Ruoqiang, Xinjiang, in 2003. Preserved on the original site.

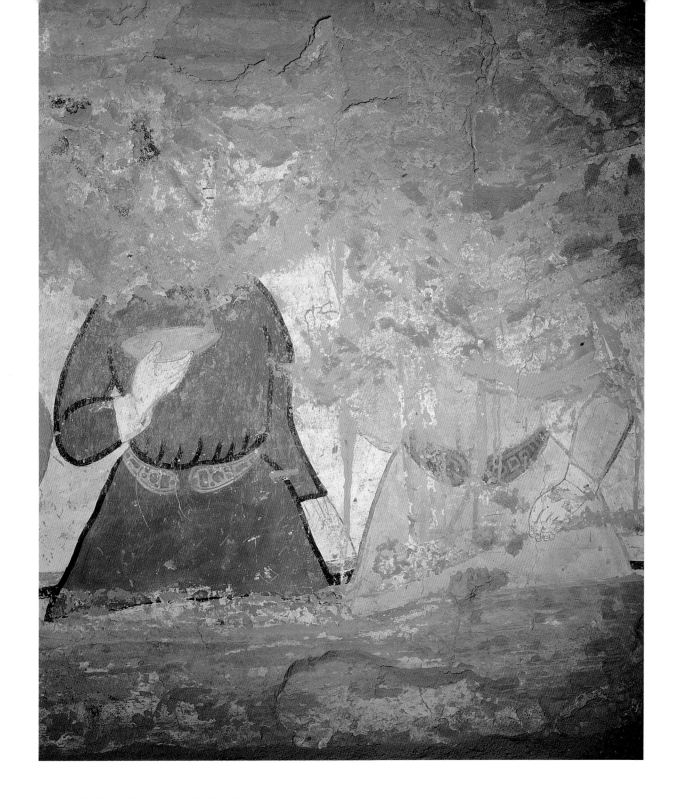

200. 人物宴饮图（局部五）

西晋（265～316年）

2003年新疆维吾尔自治区若羌县楼兰古城北LE古城附近壁画墓出土。原址保存。

此图为右壁画面左起第五、第六个人物，均为男性，面貌漫漶不清楚，着圆领窄袖套头衫，腰系玉饰带铐，执杯和钵（叵罗），作交谈状。

（撰文：于志勇　摄影：刘玉生）

Figures in Feasting Scene (Detail 5)

Western Jin (265-316 CE)

Unearthed from mural tomb near LE Site which in north to Loulan Ancient City in Ruoqiang, Xinjiang, in 2003. Preserved on the original site.

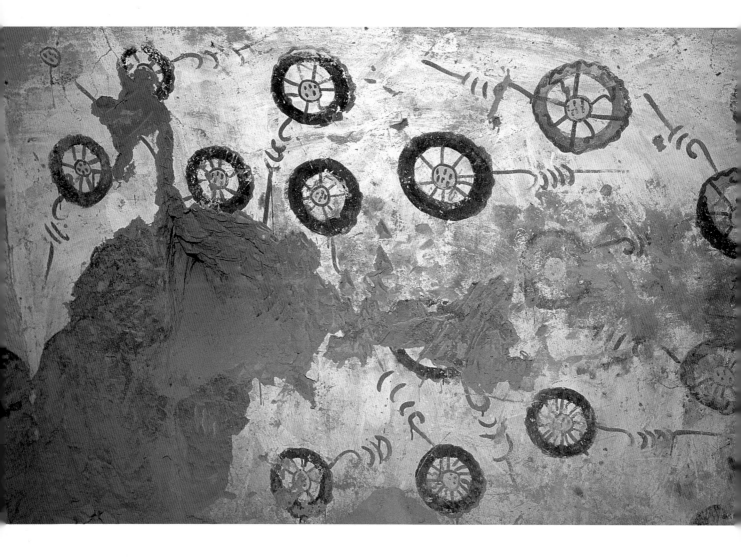

201.莲花图（一）

西晋（265～316年）

2003年新疆维吾尔自治区若羌县楼兰古城北LE古城附近壁画墓出土。原址保存。

位于后室四周壁上，满绘星团状莲花纹。

（撰文：于志勇　摄影：刘玉生）

Lotus Flower Design (1)

Western Jin (265-316 CE)

Unearthed from mural tomb near LE Site which in north to Loulan Ancient City in Ruoqiang, Xinjiang, in 2003. Preserved on the original site.

202.莲花图（二）

西晋（265～316年）

2003年新疆维吾尔自治区若羌县楼兰古城北LE古城附近壁画墓出土。原址保存。

位于后室四周壁上，满绘星团状莲花纹。

（撰文：于志勇　摄影：刘玉生）

Lotus Flower Design (2)

Western Jin (265-316 CE)

Unearthed from mural tomb near LE Site which in north to Loulan Ancient City in Ruoqiang, Xinjiang, in 2003. Preserved on the original site.

203. 庄园生活图

前凉（320～376年）

高70厘米、长216厘米

2006年新疆维吾尔自治区吐鲁番市阿斯塔那墓地西区605号墓出土。原址保存。

位于墓室后壁。仿照布质画卷，壁画四角绘有象征画布挂索的黑色四角形。画面从左至右依次为庄园日常生活、墓主家族及田地。中间绘帷帐内墓主画面，帷帐上部两侧各绘一人首形像，左侧像旁题"月像"，右侧像旁题"日□（像）"汉字。在男主人右侧是星宿图，从右至左分别墨书"三台"、"北斗"等汉字。

（撰文、摄影：鲁礼鹏）

Scene of Manor Life

Former Liang State (320-376 CE)

Height 76 cm; Width 216 cm

Unearthed from tomb M605 in west Zone of Astana cemetery in Turfan, Xinjiang, in 2006. Preserved on the original site.

204.墓主人生活纸画

东晋（317~420年）

高46.2、宽105厘米

1964年新疆维吾尔自治区吐鲁番市阿斯塔那墓地13号墓出土。现存于新疆博物馆。

此图发现时贴于墓室壁上，共有六块小纸拼接而成。画面正中绘垂流苏的覆斗帐，帐下男主人持团扇跪坐榻上，其妻右侧跪坐。主图左侧为两棵果树下绘鞍马和马夫，右侧上部绘田地和农具，下部绘婢女和炊事。画面左上角绘圆月，右上角绘太阳。该画以写实的手法表现了墓主人生前奢华的生活。

（撰文：于志勇 摄影：刘玉生）

Tomb Occupant's Daily Life Under the Tree (Paper Rough Sktech)

Eastern Jin (317-420 CE)

Height 46.2 cm; Width 105 cm

Unearthed from Tomb M13 in of Astana cemetery in Turfan, Xinjiang, in 1964. Preserved in the Museum of Xinjing Uygur Autonomous Region.

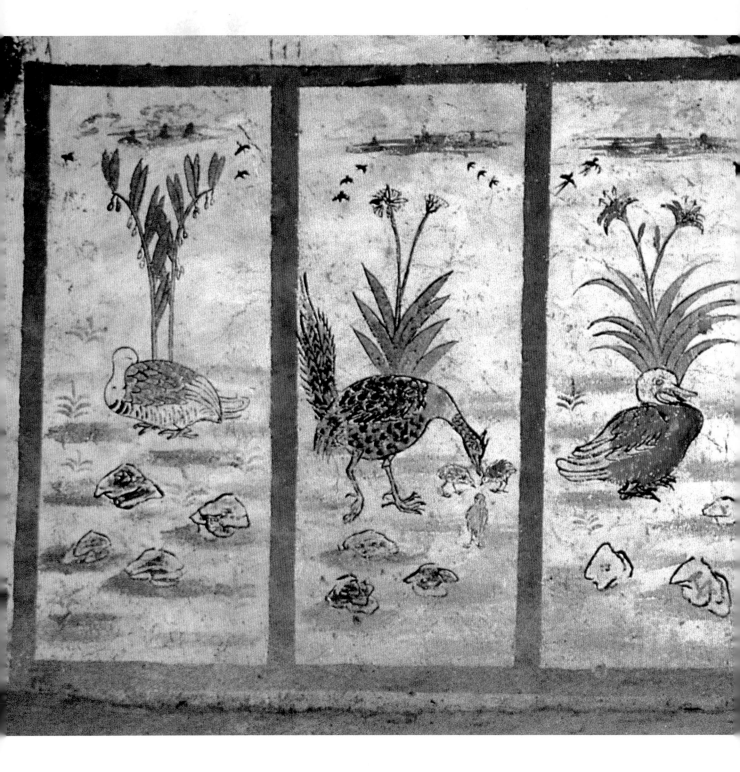

205.六屏花鸟图

唐（618～907年）

高150、宽375厘米。

1972年新疆维吾尔自治区吐鲁番市阿斯塔那墓地217号墓出土。原址保存。

位于洞室墓墓室后壁，为六屏幅式，以红色边框相隔。图中有野鸡、野鸭、鸳鸯等配以一株兰花、百合等花草，下为一片草地，点缀着小石块，远处有青山，天空中有飞行的大雁。画面色彩富丽。

<div align="right">（撰文：于志勇　摄影：刘玉生）</div>

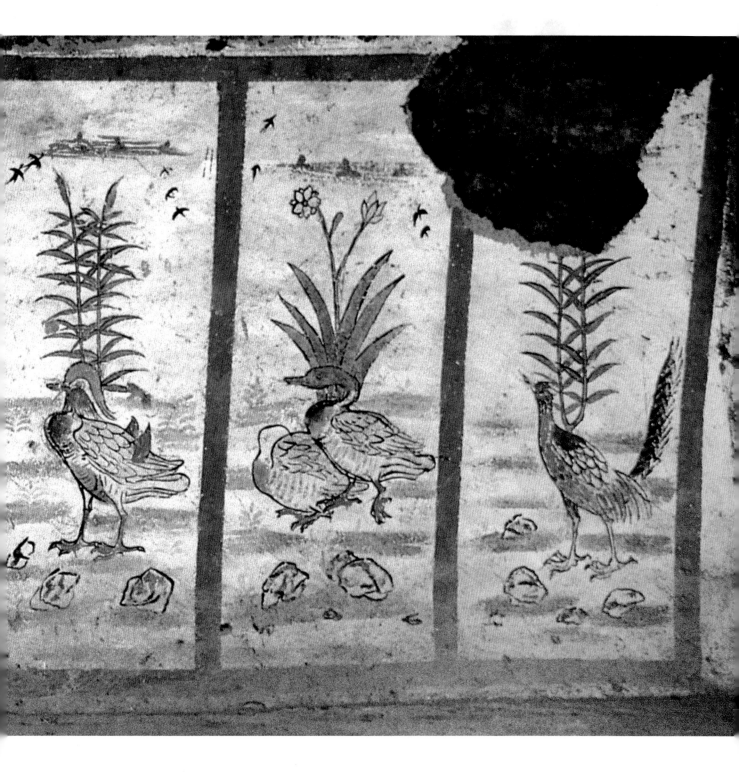

Six-Panel Screen-shaped Mural of Flower-and-Bird Motif

Tang (618-907 CE)

Height 150 cm; Width 375 cm

Unearthed from Tomb M217 of Astana cemetery in Turfan, Xinjiang, in 1972. Preserved on the original site.

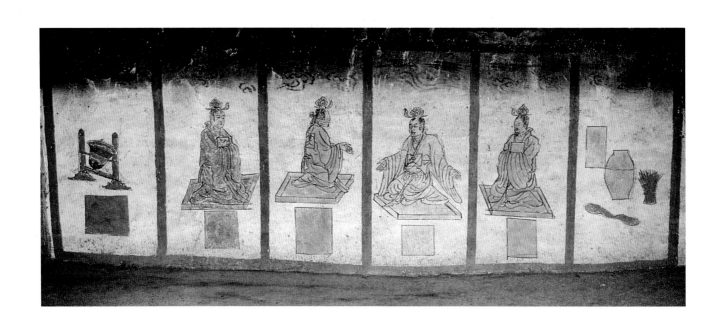

206.六屏式鉴诫图

唐（618～907年）

高145、宽400厘米

1972年新疆维吾尔自治区吐鲁番市阿斯塔那墓地216号墓出土。原址保存。

位于洞室墓墓室后壁，为六屏幅式，均为训诫典故。第二、三、四、五幅绘头着花冠、身着交领袍服的人物，姿态各异，前胸后背写有"石人"、"金人"、"土人"二字。"金人"、"石人"分别典出《说苑·敬慎篇》、晋孙楚《反金人铭》。右侧题材为扑满、丝束与青草，分别寓意做事审慎、清廉。

（撰文：于志勇 摄影：刘玉生）

Six-Panel Screen-shaped Mural of Admonishing Scene

Tang (618-907 CE)

Height 145 cm; Width 400 cm

Unearthed from Tomb M216 of Astana cemetery in Turfan, Xinjiang, in 1972. Preserved on the original site.

207.六屏式鉴诫图（局部一）

唐（618～907年）

高145厘米

1972年新疆维吾尔自治区吐鲁番市阿斯塔那墓地216号墓出土。原址保存。

位于洞室墓墓室后壁，为六屏幅式，均为训诫典故。此为六屏式图之局部。

（撰文：于志勇　摄影：刘玉生）

Six-Panel Screen-shaped Mural of Admonishing Scene (Detail 1)

Tang (618-907 CE)

Height 145 cm

Unearthed from Tomb M216 of Astana cemetery in Turfan, Xinjiang, in 1972. Preserved on the original site.

208.六屏式鉴诫图（局部二）

唐（618～907年）

高145厘米

1972年新疆维吾尔自治区吐鲁番市阿斯塔那墓地216号墓出土。原址保存。

位于洞室墓墓室后壁，为六屏幅式，均为训诫典故。此为六屏式图之局部。

（撰文：于志勇　摄影：刘玉生）

Six-Panel Screen-shaped Mural of Admonishing Scene (Detail 2)

Tang (618-907 CE)

Height 145 cm

Unearthed from Tomb M216 of Astana cemetery in Turfan, Xinjiang, in 1972. Preserved on the original site.

209.六屏式鉴诫图 （局部三）

唐（618～907年）

高145厘米

1972年新疆维吾尔自治区吐鲁番市阿斯塔那墓地216号墓出土。原址保存。

位于洞室墓墓室后壁，为六屏幅式，均为训诫典故。此为六屏式图之局部。

（撰文：于志勇　摄影：刘玉生）

Six-Panel Screen-shaped Mural of Admonishing Scene (Detail 3)

Tang (618-907 CE)

Height 145 cm

Unearthed from Tomb M216 of Astana cemetery in Turfan, Xinjiang, in 1972. Preserved on the original site.

210.六屏式鉴诫图（局部四）

唐（618～907年）

高145厘米

1972年新疆维吾尔自治区吐鲁番市阿斯塔那墓地
216号墓出土。原址保存。

位于洞室墓墓室后壁，为六屏幅式，均为训诫典
故。此为六屏式图之局部。

（撰文：于志勇　摄影：刘玉生）

Six-Panel Screen-shaped Mural of Admonishing Scene (Detail 4)

Tang (618-907 CE)

Height 145 cm

Unearthed from Tomb M216 of Astana cemetery in Turfan, Xinjiang, in 1972. Preserved on the original site.

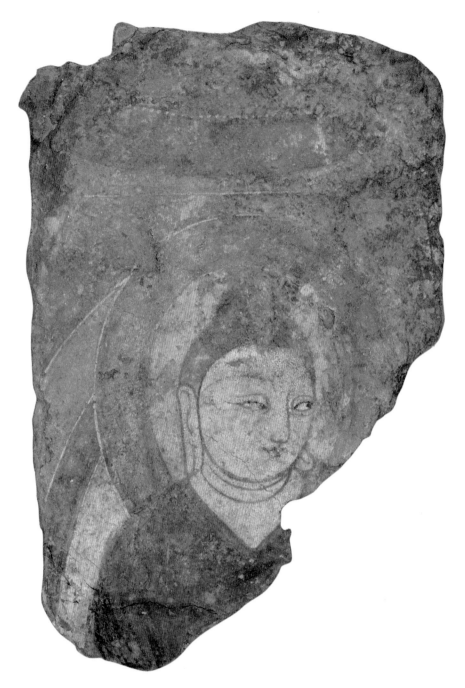

211.如来图（一）

唐（618~907年）

高约45厘米、宽30厘米

2002年新疆维吾尔自治区策勒县丹丹乌里克佛寺遗址出土。现存于新疆文物考古研究所。

图像绘于佛寺回廊的壁面上，系在被沙掩埋的倾倒的墙体上清理出土。可能是围绕主尊佛像的一幅如来造像，整幅壁画佛像线描流畅，紧密绵劲，富有弹性，是佛教壁画遗存中的精湛之作。

（撰文：于志勇　摄影：刘玉生）

Tathagata (1)

Tang (618-907 CE)

Height ca. 45 cm; Width ca. 30 cm

Unearthed from Dandan Oiliq Buddhist temple site in Qira, Xinjiang, in 2002. Preserved in the Institute of Archaeology and Cultural Relics in Xinjiang.

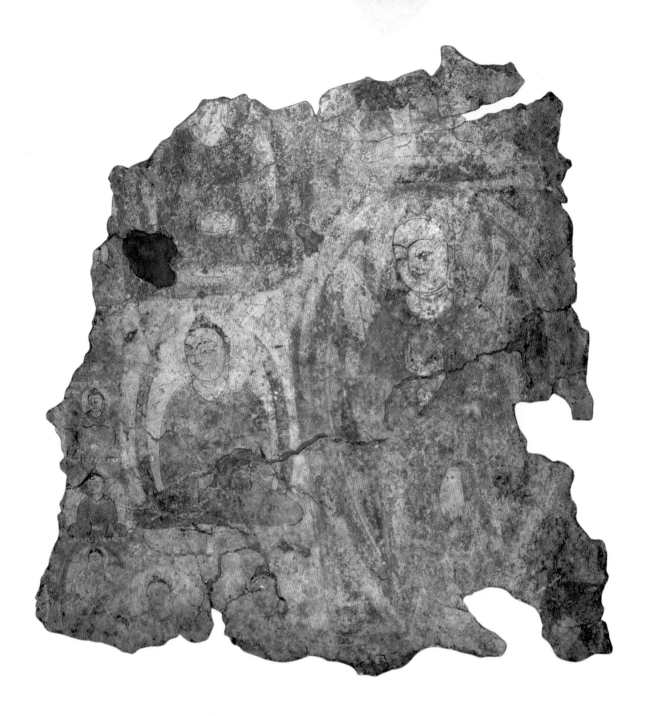

212.如来图（二）

唐（618～907年）

高约105厘米、宽100厘米

2002年新疆维吾尔自治区策勒县丹丹乌里克佛寺遗址出土。现存于新疆文物考古研究所。

图像绘于佛寺回廊的壁面上，系在被沙掩埋的倾倒的墙体上清理出土。图像右侧的上部残存一立佛的下半部，其下为一幅面较大的立佛像（有焰肩、背光及夹光）。壁画左侧绘有上下、左右排列的大小禅定坐佛。所有佛像均目视其身体的右方，表明这幅壁画是一主尊佛周围的众佛的一部分。

<div align="right">（撰文：于志勇　摄影：刘玉生）</div>

Tathagata (2)

Tang (618-907 CE)

Height ca. 105 cm; Width ca. 100 cm

Unearthed from Dandan Oiliq Buddhist temple site in Qira, Xinjiang, in 2002. Preserved in the Institute of Archaeology and Cultural Relics in Xinjiang.

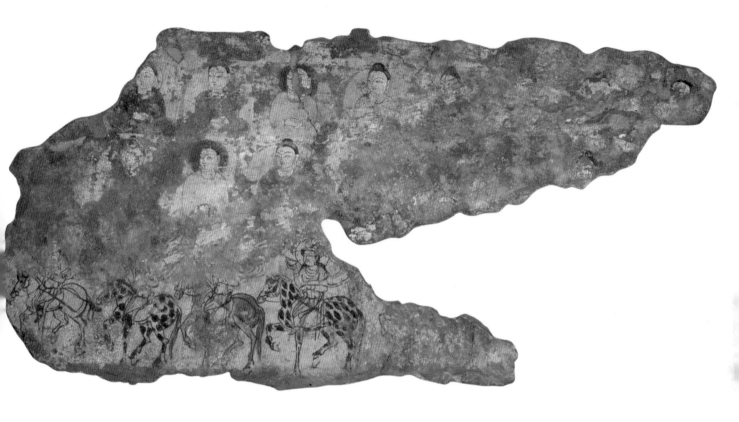

213.如来及骑马人物图

唐（618～907年）

高约50厘米、宽100厘米

2002年新疆维吾尔自治区策勒县丹丹乌里克佛寺遗址出土。现存于新疆文物考古研究所。

壁画绘于佛寺回廊的壁面上，系在被沙掩埋的倾倒的墙体上清理出土。图像上部为左右排列的千佛，下部为列队骑马向前行进的人物图像，骑马的人物均绘有圆形头光，有可能是神或圣者的形象。壁画的表面残存极少的金箔残迹。壁画绘制精美，色彩鲜艳，人物造型生动。

（撰文：于志勇 摄影：刘玉生）

Thousand-Buddha and Mounted Procession

Tang (618-907 CE)

Height ca. 50 cm; Width 100 cm

Unearthed from Dandan Oiliq Buddhist temple site in Qira, Xinjiang, in 2002. Preserved in the Institute of Archaeology and Cultural Relics in Xinjiang.

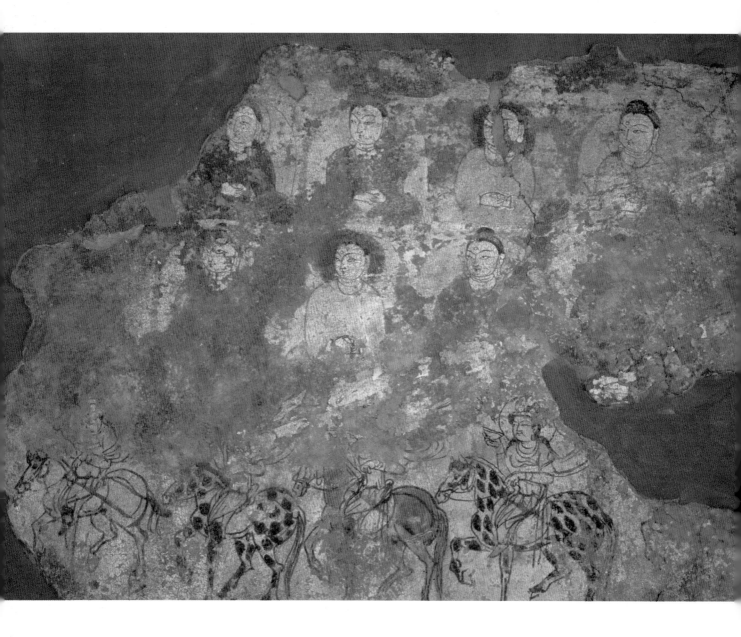

214.如来及骑马人物图（局部）

唐（618～907年）

高约50厘米

2002年新疆维吾尔自治区策勒县丹丹乌里克佛寺遗址出土。现存于新疆文物考古研究所。

上部为两列千佛形象；下部残存有五位骑马人物，高约18厘米，人和马的轮廓均墨绘，四匹完整形态的马一为白色，一为褐色，另外为黑色斑纹。

（撰文：于志勇　摄影：刘玉生）

Thousand-Buddha and Mounted Procession (Detail)

Tang (618-907 CE)

Height ca. 50 cm

Unearthed from Dandan Oiliq Buddhist temple site in Qira, Xinjiang, in 2002. Preserved in the Institute of Archaeology and Cultural Relics in Xinjiang.

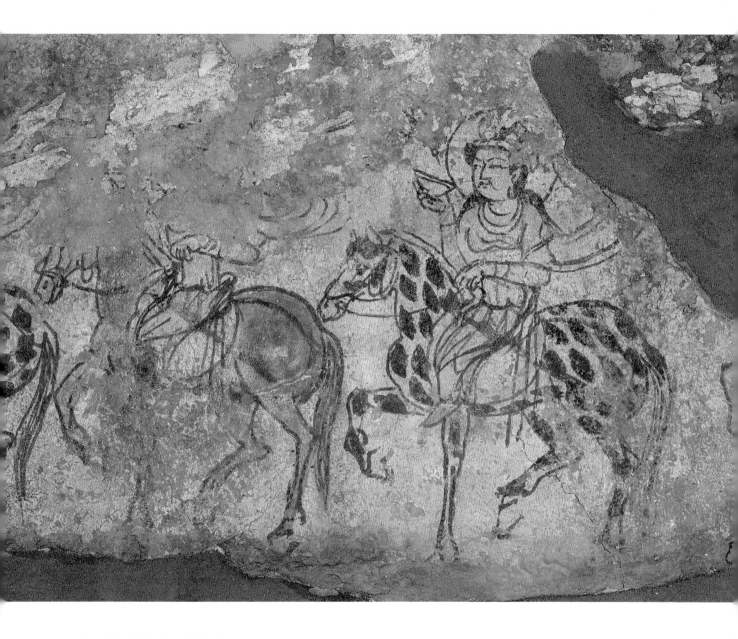

215.骑马人物图（局部）

唐（618～907年）

2002年新疆维吾尔自治区策勒县丹丹乌里克佛寺遗址出土。现存于新疆文物考古研究所。

画面右侧骑斑纹马者在整个图像之中保存最为完好，骑者左手持缰，右手上举一钵形器，钵形器的上方绘有一急速俯冲下来的黑色小鸟。这一图案与20世纪初英国探险家斯坦因从丹丹乌里克遗址盗掘的彩绘木板画上的题材内容完全相同。

（撰文：于志勇 摄影：刘玉生）

Mounted Procession (Detail)

Tang (618-907 CE)

Unearthed from Dandan Oiliq Buddhist temple site in Qira, Xinjiang, in 2002. Preserved in the Institute of Archaeology and Cultural Relics in Xinjiang.

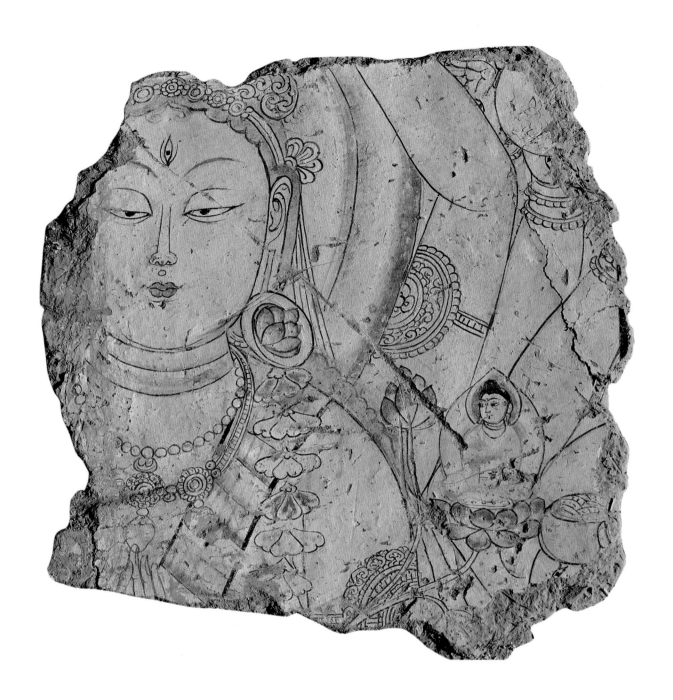

216. 千手观音壁画残片

唐（618～907年）

高约61、宽60厘米

2007年新疆维吾尔自治区策勒县达玛沟乡北10公里喀拉墩1号佛寺遗址出土。现存于策勒县文物管理所。

残存千手观音的头、胸和左臂部分。

<div align="right">（撰文：于志勇　摄影：刘玉生）</div>

Sahasrabhuja Avalokiteśvara (Fragment)

Tang (618-907 CE)

Height ca. 61 cm; Width 60 cm

Unearthed from No.1 Buddhist temple site at Karadong 10 kilometres north to Damago in Cele, Xinjiang, in 2007. Preserved in Cele County cultural Relics Administration.